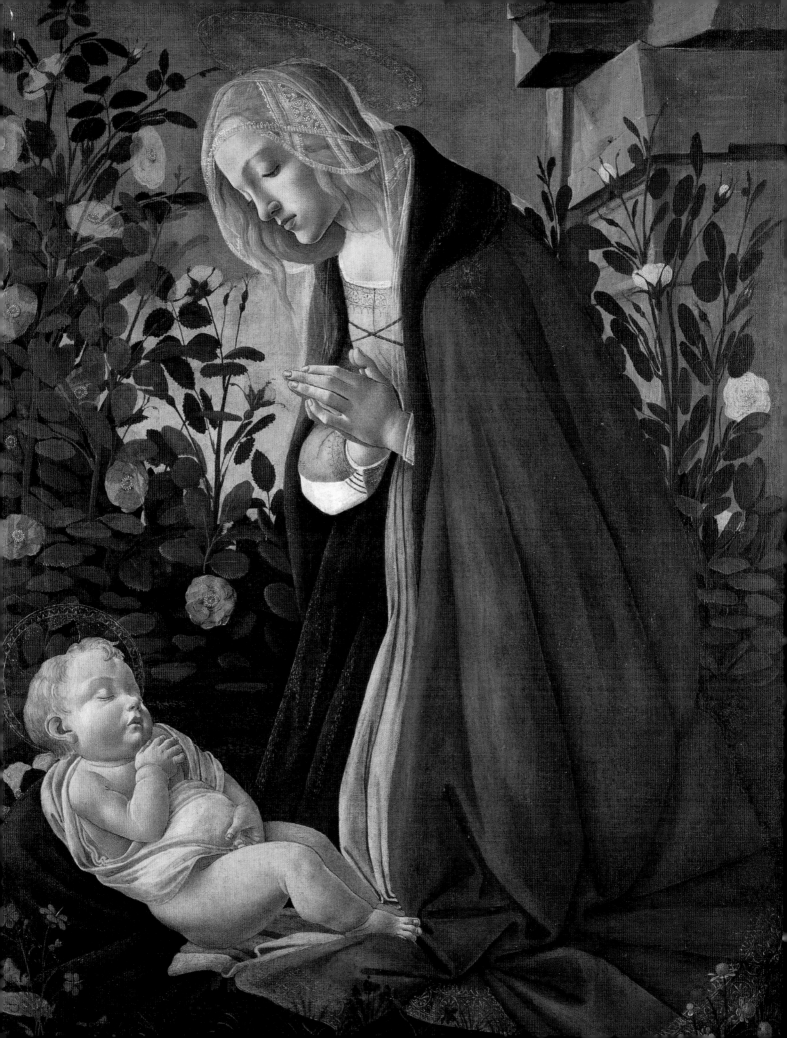

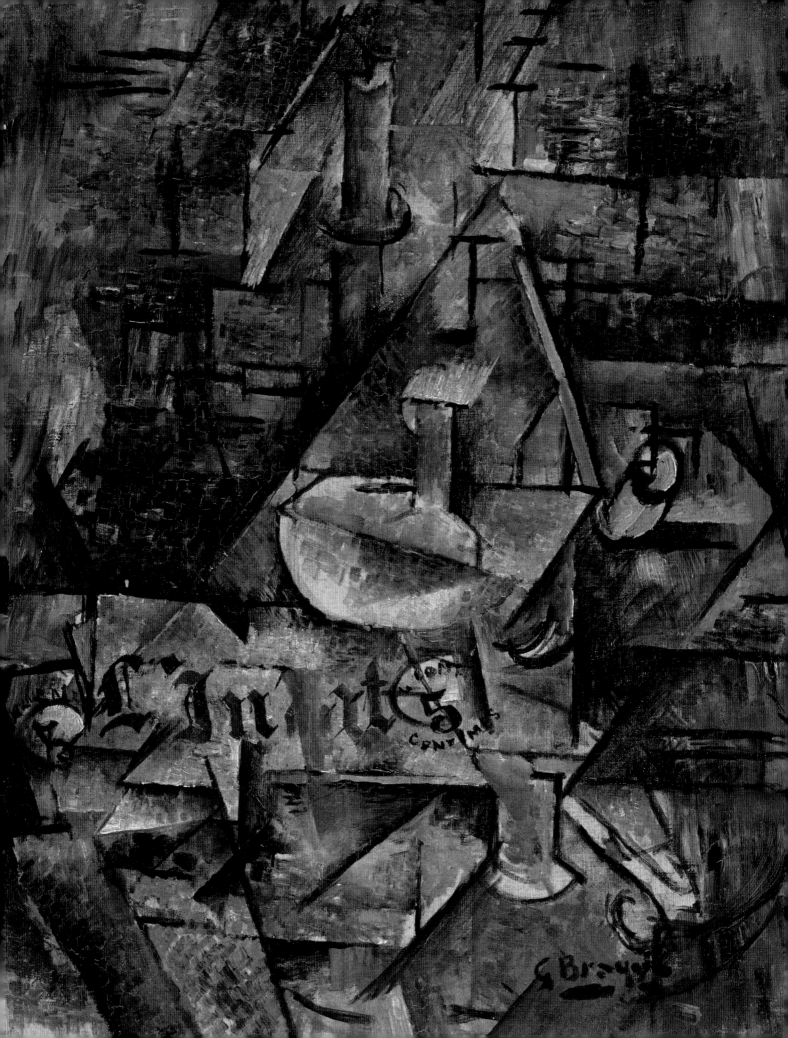

Botticelli to Braque

Masterpieces from the National Galleries of Scotland

National Galleries of Scotland
in association with the
Fine Arts Museums of San Francisco
and the
Kimbell Art Museum

Foreword

In the exhibition *Botticelli to Braque: Masterpieces from the National Galleries of Scotland*, visitors will see fifty-five paintings from the three institutions that compose the National Galleries of Scotland—the Scottish National Gallery, founded in 1850 and housed in an impressive building designed by William Henry Playfair (1789–1857); the Scottish National Portrait Gallery, which opened in 1889; and the Scottish National Gallery of Modern Art, which opened in 1960. Bringing together masterpieces from three separate museums into one presentation will offer our public an experience that is possible only during the exhibition. The show includes an array of works from some of the best-known and well-loved European and American artists and spans more than 400 years of art history, thereby stimulating reflection upon the impressive record of acquisitions made by the National Galleries of Scotland.

Botticelli to Braque features a variety of artists, periods, and styles, though each of the works is marked by its exceptional quality. The selection's earliest paintings include primarily religious and mythological subjects: Sandro Botticelli's serene Virgin; the sensuous gods and goddesses of Tiziano Vecellio (called Titian) and Paolo Veronese; a depiction of piety in *Saint Sebastian Bound for Martydrom*, 1620–1 by the royal favourite Sir Anthony van Dyck; and Rembrandt van Rijn's beguiling *A Woman in Bed* of about 1645–6, which combines the sacred and the profane. The exhibition concludes with works of abstracted visual vocabularies from the early twentieth century: the minimalist precision of Piet Mondrian's *Composition with Double Line and Yellow*, 1932; a geometrically conceptualized still life by Georges Braque; and a work from Pablo Picasso's Blue Period. In addition, our visitors will find a range of eighteenth- and nineteenth-century masterpieces, including landscapes, portraits, and still lifes, that exemplify the remarkable scope of the collections held by the National Galleries of Scotland.

Perhaps the painting that best represents the celebratory spirit of this exhibition is our signature image, *Reverend Robert Walker Skating on Duddingston Loch*, about 1795 by the Scottish artist Sir Henry Raeburn. This engaging depiction of a subject posed seemingly effortlessly in mid-skate has come to symbolize the Scottish Enlightenment, and it is sure to charm viewers of all ages. Similarly, it is our hope that our respective displays of the fifty-five specially selected treasures will engage and surprise visitors with equal pleasure.

At the Fine Arts Museums, special thanks are given to our early donors: Presenting Sponsors, Cynthia Fry Gunn and John A. Gunn and Diane B. Wilsey; President's Circle donor, the San Francisco Auxiliary of the Fine Arts Museums; Curator's Circle donors, The Bernard Osher Foundation and the Ednah Root Foundation; Patron's Circle donors, George and Marie Hecksher; and Supporter's Circle donors, Andy and Carrick McLaughlin and Mrs George Hopper Fitch. Sincere appreciation is extended further to Diane B. Wilsey, president of the Board of Trustees, for her continuous support and encouragement of our exhibitions programme. Richard Benefield, deputy director, and Julian Cox, founding curator of photography and chief administrative curator, also helped to bring this project to San Francisco. Additional thanks are extended to Esther Bell, curator in charge of European paintings, for expertly guiding *Botticelli to Braque* to fruition. Melissa Buron, associate curator of European paintings, managed the exhibition during its initial planning stages, for which we are grateful. We also acknowledge the valuable efforts of Emerson Bowyer, research assistant, European paintings. Krista Brugnara and Sarah Hammond in the Museums' exhibitions department provided important direction during the organizing and presenting stages of this project. Their efforts were supported further by contributions from our conservation, registration, publications, and graphic design departments.

The Kimbell Art Museum owes its greatest debt of thanks to Kay and Ben Fortson and the members of the Board of Directors of the Kimbell Art Foundation for their unfailing support of the project. George T. M. Shackelford, deputy director, has worked closely with colleagues in Edinburgh since the project's inception and has supervised its presentation in the galleries of the museum's Renzo Piano Pavilion, with the able assistance of Regina Palm. Susan Drake, deputy director of finance and administration, has offered important support for the exhibition's implementation in Fort Worth. Claire Barry, director of conservation, has provided oversight for the care of the paintings, while Patricia Decoster, collections manager/registrar; Larry Eubank, operations manager; Jessica Brandrup, head of marketing and public relations; Megan Smyth, manager of publications; and all their colleagues have contributed their expertise to assure the exhibition's success.

We are, of course, indebted to our colleagues at the National Galleries of Scotland. Our deepest thanks are extended to Sir John Leighton, director-general, National Galleries of Scotland, and the National Galleries of Scotland's Board of Trustees for the foresight, generosity, and collaboration they extended to us in order to share their museums' masterpieces with our audiences.

COLIN B. BAILEY
Director of Museums, Fine Arts Museums of San Francisco

ERIC M. LEE
Director, Kimbell Art Museum

We are delighted to present some of the finest masterworks from the National Galleries of Scotland in the distinguished settings of the de Young in San Francisco and the Kimbell Art Museum in Fort Worth. Both of these great museums are renowned for the quality of their collections and the outstanding contemporary design of their buildings. Herzog and de Meuron's ingenious and striking de Young makes a memorable contribution to the topography of Golden Gate Park, and the recently opened Renzo Piano Pavilion at the Kimbell provides an equally marvellous second venue for our show.

Our own museum buildings all date from the nineteenth century. The Scottish National Gallery opened to the public in 1859 and our Portrait Gallery followed suit in 1889. Both were specifically designed as art museums. Our Gallery of Modern Art is now housed in a campus in the west end of Edinburgh comprising two fine and contrasting buildings, one of which was formerly a school and the other an orphanage.

We have been collecting for over 150 years and, as our selection and the title of our show demonstrate, we are very fortunate to have in our care collections which embrace many of the great names in European art from the Renaissance onwards. We also have the unique privilege of curating the national collection of Scottish art, whose visual traditions are highly distinct from those of our neighbours in England.

It has been a pleasure to work with our friends in San Francisco and Fort Worth on the preparation of this exhibition. At the de Young we thank Director Colin B. Bailey and his staff at the Fine Arts Museums of San Francisco, and at the Kimbell Director Eric Lee and Deputy Director George Shackelford and their colleagues.

On behalf of the National Galleries of Scotland we extend a warm welcome to our American public and hope *Botticelli to Braque* will inspire you to come and visit us in our beautiful country.

SIR JOHN LEIGHTON
Director-General, National Galleries of Scotland

MICHAEL CLARKE
Director, Scottish National Gallery

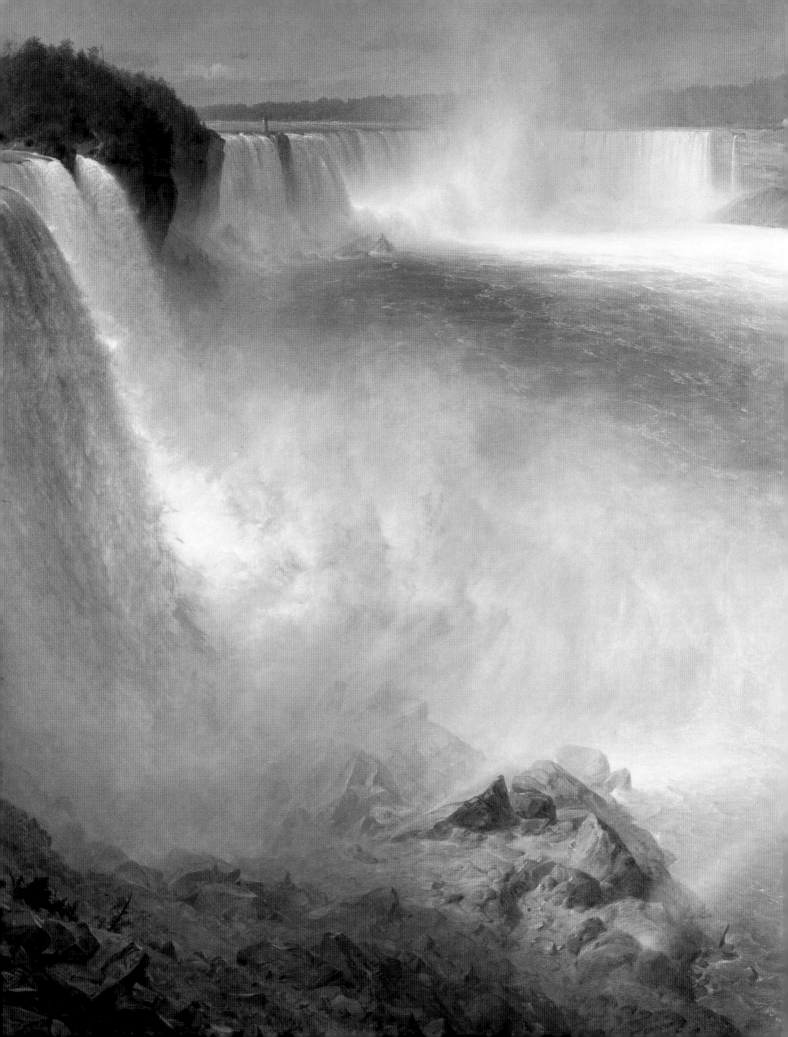

A Short History of the National Galleries of Scotland

The National Galleries of Scotland comprise a federation of three art museums: the Scottish National Gallery, the Scottish National Portrait Gallery and the Scottish National Gallery of Modern Art. They are based in Edinburgh and their combined collections cover Western art from the early Renaissance to the present day.

The oldest of the three, the Scottish National Gallery, is situated at the very heart of Scotland's capital, a city rich in architectural heritage. It houses a world-class collection of paintings, prints and drawings that range in date from the early Renaissance to the end of the nineteenth century. In addition to its fine holdings of European art, in which most of the major names are represented, it contains the national collection of historic Scottish art.

The Gallery's foundation stone was laid in 1850 by H R H Prince Albert, and its doors first opened to the public in 1859. Housed in a neoclassical 'temple of the arts' with Ionic columns, it was designed by one of Scotland's foremost architects, William Henry Playfair (1790–1857), whose other major buildings in Edinburgh include Surgeons' Hall, New College and Donaldson's Hospital. The Gallery's highly distinctive interior comprises, on the main floor, two parallel suites of octagonal rooms separated by discreet round arches. The walls are sumptuously decorated in red, a traditional colour on which to hang old master paintings, set off by a floor covered in a complementary green. The overall effect is one of grandeur, though each individual room achieves a surprising intimacy (fig.2).

In its early days the Gallery was managed by a body known as the 'Board of Manufactures', an abbreviation of the 'Honourable Board of Trustees for Fisheries, Manufactures, and Improvements in Scotland'. This august institution had its origins in the Act of Union of

Fig.1 | Detail from Frederic Edwin Church, *Niagara Falls, from the American Side*, 1867 [cat.35] Scottish National Gallery, Edinburgh [NG 799]

1707 whereby the Parliaments of England and Scotland had been joined. The Board of Manufactures was established to improve the hemp and woollen manufactures and fisheries in Scotland. In 1760 it founded in Edinburgh the Trustees Academy, an art school originally concerned with raising the level of Scottish textile design. By the early nineteenth century the Board's activities were mainly concentrated in the field of the fine arts.

Standing in front of the Scottish National Gallery, with a façade facing directly on to the main thoroughfare of Princes Street, is the building which in many ways can be regarded as its predecessor and is now known as the Royal Scottish Academy. Also designed by Playfair, it has columns in the Doric style and was the result of two building campaigns. Originally more austere in appearance when it opened in 1826 (the porticoes were added later), it began life as the Royal Institution building and housed a body known as the Institution for the Encouragement of the Fine Arts in Scotland (which received its Royal charter in 1827), together with the Board of Manufactures Trustees' Drawing Academy, the Royal Society of Edinburgh and the Scottish Society of Antiquaries. The teaching of art, scholarship, and the exhibiting of art were thus combined under one roof. The Institution, whose membership was made up of noblemen and gentlemen, had the twin aims of arranging exhibitions for the public benefit of old masters drawn from its members' collections and, less consistently, organising shows to promote contemporary art. It undoubtedly followed the lead of the British Institution, which had been founded in London in 1805 with a similar dual brief, and was eventually disbanded in 1867.

Correctly perceiving that the Institution was not doing enough to promote and foster contemporary art, Scottish artists soon set up their own body, the Scottish Academy (Royal charter 1838), which staged exhibitions at various premises in Edinburgh. However, the Academy and the

Fig.2 | The main floor galleries of the Scottish National Gallery, Edinburgh

Institution would soon become uneasy co-occupants of the new Scottish National Gallery, in the first of many administrative manoeuvres that mark its history.

The National Gallery in London had been founded in 1824 and it was natural that Scotland should wish for a similar cultural facility. What is often forgotten is that the London National Gallery originally shared its Trafalgar Square building from 1837 with the Royal Academy, until that body transferred to its current premises in Burlington House in 1868. A similar arrangement was arrived at in Edinburgh when the National Gallery of Scotland (to give it its original title) opened in 1859. The Royal Scottish Academy occupied the eastern side of the building and the Scottish National Gallery was located in the western half. Such was the lack of accord between these two partners that different gas and electric companies were engaged to supply the two halves of the building. This sharing of the Scottish National Gallery building continued until a parliamentary order of 1910 granted the Royal Scottish Academy occupancy of the Institution building, to which it then transferred. However, the management and upkeep of the latter (thereafter to be known as the Royal Scottish Academy building) was vested with the recently created (1906) Board of Trustees of the National Galleries of Scotland, which effectively took over the remaining functions of the Board of Manufactures. Thus a clear demarcation was achieved between the housing of an ever-growing national collection of historic art (the Gallery) and the promotion and exhibiting of contemporary art (the Academy). The other bodies which had till then been housed in the former Institution building were found alternative accommodation.

So much for the initial history of the complex game of institutional musical chairs played out on this central site, which is spectacularly overlooked by Edinburgh Castle and is situated between the Old (medieval and Renaissance) and New (Georgian) Towns of Edinburgh.

What of the pictures that were on display in the early years of the Gallery?

The Royal Institution had collected in its own right, and promptly transferred its collection of paintings to the new Gallery. Prominent among this selection was a group of pictures which had been purchased for the Institution in Genoa in 1831 and included two masterpieces by Van Dyck: *The Lomellini Family*, about 1626–7 and *Saint Sebastian Bound for Martyrdom* (cat.8). The Institution had also attracted gifts of pictures, the most spectacular of which was Giovanni Battista Tiepolo's early 1730s *Finding of Moses*. Hanging alongside the Institution pictures in the new Gallery was the collection of predominantly Dutch and Flemish paintings formed by Sir James Erskine of Torrie (1772–1825) and bequeathed to the University of Edinburgh. The undoubted star of this collection was the great early Jacob van Ruisdael *The Banks of a River*, 1649, which has remained on loan to the Gallery to the present day.

The first major bequest to the new Gallery was of Thomas Gainsborough's late whole-length portrait of *The Honourable Mrs Graham* (fig.3), exhibited at the Royal Academy in 1777. The sitter was a society beauty who had married the Perthshire laird Thomas Graham, later Lord Lynedoch. She died young in 1792. Such was her husband's grief that he could not bear to look at the picture and consigned it for storage to a London picture dealer. Years later his heir, Robert Graham of Redgorton, left it to the Gallery on condition that the picture should never leave Scotland.

The quality and variety of the nascent collection was greatly improved by the 1861 bequest of Lady Murray of Henderland. The origins of this collection lie with the distinguished eighteenth-century Scottish painter Allan Ramsay and, more specifically, with his youngest son General John Ramsay who, after initially intending to leave his pictures to the London National Gallery, revoked his will in 1845 and left the greater part of his collection

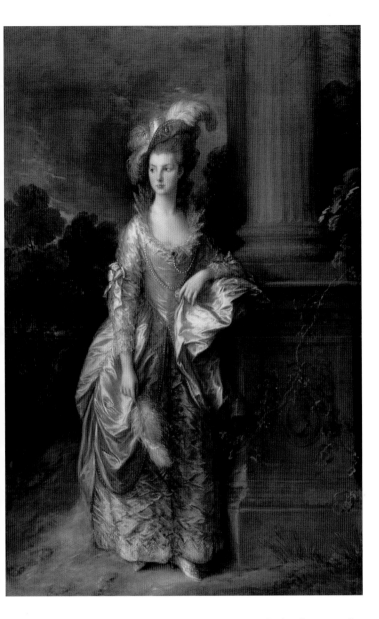

Fig.3 | Thomas Gainsborough, *The Honourable Mrs Graham*, 1775–7
Scottish National Gallery, Edinburgh [NG 332]

Meanwhile, pictures were also displayed on the Academy side of the National Gallery building, often very closely hung. These were divided into 'Ancient Masters' (there was no attempt to separate the various schools such as Italian from Dutch and Flemish) and 'British Artists' (Scottish and English intermixed). Artists elected to full membership of the Academy had to submit their 'diploma' paintings, which then entered the Academy's collection, thereby building up a significant holding of Scottish art over the years. The Academy also collected a few old master paintings, the greatest of which was Jacopo Bassano's *The Adoration of the Kings*, acquired in 1856 and included in the transfer in 1910 to the Scottish National Gallery of many of the Academy's best paintings. This was a quid pro quo that came about directly as a result of the 1910 parliamentary order that granted the Academy tenancy of much larger premises in the former Institution building. With the setting up of the Board of Trustees in 1906, replacing the old Board of Manufactures as the governing body of the Gallery, and the creation of an acquisitions policy that placed due emphasis on the building up of the Scottish collection as well as that of international art, the Gallery was in a much improved position at the beginning of the twentieth century.

It had also acquired a sister institution with the opening in 1889 of the Scottish National Portrait Gallery in Queen Street, Edinburgh (fig.4). Founded in 1882 and designed by Sir Robert Rowand Anderson (1834–1921) in the 'Venetian Gothic' style, it was largely paid for by John Ritchie Findlay, proprietor of *The Scotsman* newspaper. Its primary remit was to collect likenesses of notable Scots, fulfilling the great Scottish historian and philosopher Thomas Carlyle's (1795–1881) belief that 'Historical Portrait Galleries far transcend in worth all other kinds of National Collections of Pictures'. Given Carlyle's belief in the worth of 'Great Men' and 'Heroes' in determining the course of history, this point of view was hardly surprising. The

to his cousin, William Murray of Henderland. General Ramsay may have inherited some of his pictures from his father, but the majority he probably acquired himself. A significant group of them were of the French eighteenth-century school. They were noted in Lord Murray's house in Great Stuart Street, Edinburgh by the distinguished director of the Berlin Museum, Dr Gustav Waagen, when he visited Edinburgh in 1856. The fascinating Watteau, now known as the *Fêtes Vénitiennes* (cat.16), he described as 'A party in the open air … An excellent picture, of vigorous and warm colouring, and spiritedly treated', and he greatly admired, for their delicacy of feeling, the two most important Greuzes: *Girl with a Dead Bird* (cat.19) and *A Boy with a Lesson book*.

Portrait Gallery's holdings embrace many of the most famous figures from Scottish history including Mary, Queen of Scots, the reformer John Knox, the architects Robert Adam and Charles Rennie Mackintosh and the poet Robert Burns. Externally the building is clad on its north and west façades with sculptures of poets, monarchs and statesmen (a sculptural programme completed in 1902), while the entrance hall is graced with William Hole's (1846–1917) remarkable painted processional frieze depicting over 150 figures or 'heroes' from Scotland's past. Early acquisitions included images of Robert Burns and of the novelist Sir Walter Scott. Today the Gallery has a much wider collecting brief embracing many different aspects of Scottish society. It also houses a world-class collection of photography, the origins of which date back to the calotypes taken by David Octavius Hill and Robert Adamson in the 1840s.

Returning to the Scottish National Gallery, the compiler of its first catalogue (1859) had presciently observed that 'the maintenance and extension of this National Collection must always, in great measure, depend on the public spirit and liberality of individuals'. This has proved true throughout its history. One of the most extraordinary early arrivals was Frederic Edwin Church's great *Niagara Falls, from the American Side* (fig. 1 and cat.35), presented in 1887 by John Stewart Kennedy, a Lanarkshire-born entrepreneur and philanthropist who had made his fortune in the United States. Kennedy died in 1909 and among the beneficiaries of his will were Columbia University, the New York Public Library and the Metropolitan Museum of Art. Rembrandt's *A Woman in Bed* (cat.14), which possibly depicts Geertje Dircx, who lived with Rembrandt from about 1642 to 1649, was bought in 1892 with funds provided by the Edinburgh-based brewer William McEwan. Rembrandt's great contemporary Frans Hals's memorable portrait of the Mennonite preacher *Verdonck* (cat.9) was presented in

1916 by John J. Moubray of Naemoor. In 1919 James Cowan Smith, the son of a ship-owner from Banffshire, who had settled in Yorkshire, bequeathed £55,000 to the Gallery, the interest on which was to be used for the purchase of works of art. The somewhat curious terms of this bequest were that the Gallery had to accept and display in perpetuity a portrait of Cowan Smith's favourite Dandie Dinmont terrier *Callum*, 1895, painted by the relatively obscure John Emms. The Trustees also had to provide for the care of Cowan Smith's dog Fury, who was put in the charge of Mr Wing, a coachman.

A number of major purchases have been made over the years with the Cowan Smith Fund. John Singer Sargent's *Lady Agnew of Lochnaw* (cat.40) established the artist's reputation as a society portraitist when it was exhibited at the Royal Academy in 1893, where it enjoyed enormous critical success. It was acquired by the Gallery in 1925,

though it could have been on its way to the United States, for in 1922 it had been offered to Helen Clay Frick, who declined to purchase it. John Constable's magnificent *Vale of Dedham* (cat.30) was acquired in 1944. It was his last major painting of the Stour valley and was widely praised when exhibited in 1828 at the Royal Academy. Constable was finally elected a full member of the Academy the following year.

In the same year that the Constable was purchased, another call was made on the Cowan Smith Fund when the Gallery acquired the Scottish landscape painter Peter Graham's *Wandering Shadows* (fig.5). Graham was one of the brilliant generation of painters who had trained under Robert Scott Lauder at the Trustees Academy in Edinburgh in the 1850s. His work was much admired in London as well as Edinburgh and his technically accomplished scenes helped established a market for views of the Scottish

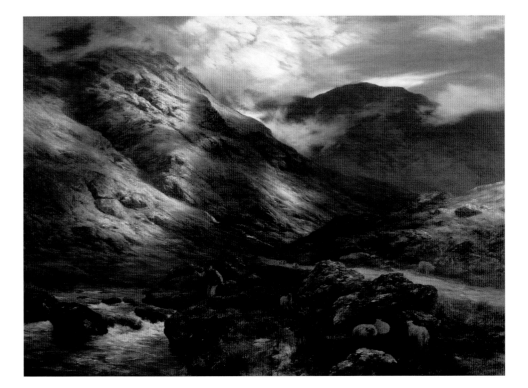

Fig.5 | Peter Graham, *Wandering Shadows*, 1878
Scottish National Gallery, Edinburgh [NG 1986]

13

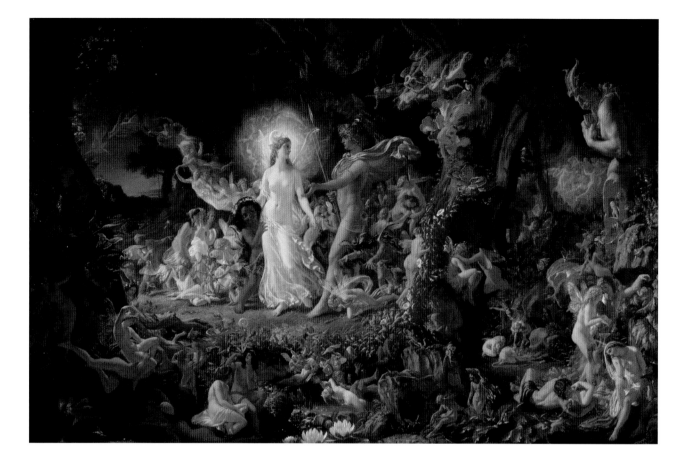

Highlands portrayed as the 'land of the Mountain and the Flood' (Sir Walter Scott). A major impetus to the representation of the Scottish school in the Gallery's collection had been provided in the nineteenth century by the activities of the Royal Association for the Promotion of the Fine Arts in Scotland. Founded in 1834, its stated aim was 'to elevate the character of national art'. Members paid an annual subscription and the funds were used to purchase modern Scottish art, almost entirely at the annual exhibitions of the Scottish Academy. The majority of these works were distributed by lottery among the members, but up to ten per cent of the funds were used over the years to buy a total of twelve paintings which were placed on loan to the Gallery and eventually presented in 1897. These included Sir Joseph Noel Paton's *The Quarrel of Oberon and Titania* (fig.6), the subject of which was taken from Shakespeare's *A Midsummer Night's Dream*. Paton was particularly known for his fairy paintings. The minute detail of *The Quarrel* caused much curiosity among visitors, whose pointing fingers caused it to be among the first paintings in the Gallery to be glazed in order to avoid accidental damage.

A further important group of Scottish paintings entered the Gallery's collection via transfer from the Royal Scottish Academy in 1910; these included William Dyce's *Francesca da Rimini* (cat.31), in which the subject of the ill-fated lovers Paolo and Francesca is taken from Dante's *Inferno*, and David Roberts's spectacular *Rome: Sunset from the Convent of Sant'Onofrio on the Janiculum*, 1856. In the years following the establishment of a purchase grant the Gallery did not neglect the Scottish collection. Indeed Trustees such as the artist and President of the Royal Scottish Academy Sir James Guthrie, and the Gallery's first Director (1907–30), Sir James Caw (he was knighted in 1931), saw to it that such a policy of acquiring Scottish art was actively pursued. Caw's monograph *Scottish Painting 1620–1908* was published in 1908 and his wife, Annie, was the daughter of the Scottish landscape painter William McTaggart. In 1917 the Gallery acquired the romantic 'Highland' full-length portrait of *Colonel Alastair Ranaldson Macdonell of Glengarry* (cat.27) painted by the great portraitist of the Scottish Enlightenment, Sir Henry Raeburn, and shown at the Royal Academy in London in 1812. Probably painted

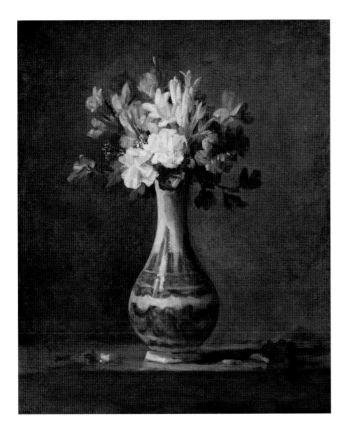

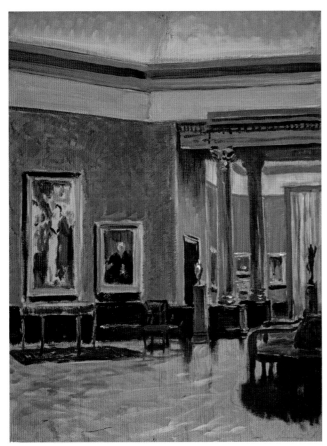

in Raeburn's studio in York Place, Edinburgh, it vividly captures the overblown importance which the sitter undoubtedly attached to his role as clan chieftain, richly clad in tartan (the proscription on the wearing of Highland dress following the Jacobite Rising of 1745 had been lifted in 1782). Macdonell of Glengarry and his friend the writer Sir Walter Scott would have viewed the tartan as a symbol of Scottish national identity, albeit within the context of the Union with England. Scottishness of a different type, a panoramic celebration of the rural society of Fife, was achieved by the precociously talented nineteen-year-old David Wilkie in his *Pitlessie Fair* (cat.25). This major work, teeming with incident and detail, was acquired in 1921.

Sir James Caw, and his successor as director (1930–48), the Orcadian painter and curator Stanley Cursiter, also made a number of brilliant foreign-school purchases in the interwar years. The British were, on the whole, slow to catch on to the achievements of the French Impressionists and Post-Impressionists. Nevertheless, in 1925 the Gallery succeeded in acquiring both Gauguin's seminal *Vision of the Sermon*, 1888 and Monet's *Poplars on the Epte* (cat.39). Degas's *Portrait of Diego Martelli* (cat.37) would follow in 1932, and in 1937 a great French masterpiece of the eighteenth century was acquired: Chardin's only surviving flower-piece *A Vase of Flowers* (fig.7). Given the relatively limited means at the Gallery's disposal, this was purchasing of a high order. During his directorship, Cursiter also made a fundamental change to the interior of the National Gallery building by inserting Corinthian columned room dividers between each of the rooms on the main floor (fig.8). This obscured Playfair's less intrusive round arches and was doubtless devised in order to create distinct spaces within the Gallery so the collection could be hung on more art-historical lines. This arrangement, put in place in the late 1930s, was retained until the late 1980s when Playfair's original scheme was reinstated.

During the Second World War the Gallery's collection

was stored for safekeeping in a number of houses in the Scottish Borders. By coincidence, the bulk of the finest private collection of old master paintings then in London, at Bridgewater House, was also moved to the Borders, to Mertoun House. This collection contained some of the greatest French and Italian pictures from the Orléans Collection which had been formed in Paris in the early eighteenth century. The vicissitudes of the French Revolution brought about its dispersal on the London art market, and a significant part of it was acquired by the Duke of Bridgewater (of Bridgewater Canal fame) and his nephew Earl Gower. The Duke died in 1803. The collection, which contained incomparable masterpieces by Raphael, Titian and Poussin among others, was placed on display in Cleveland, later Bridgewater, House in the heart of London. Limited public admission was possible on certain days. In 1945 the owner of the collection, the then Earl of Ellesmere, approached the Scottish National Gallery to ascertain if it might be possible to place on temporary loan to the Gallery a selection of the greatest pictures from the collection. Bridgewater House had been damaged by German bombing in 1941, and Mertoun was deemed unsuitable now that the war was over. Unsurprisingly, Cursiter and his Trustees readily agreed to this proposal, and so it came about that the Gallery received on loan a group of thirty paintings which comprised, among others, two of the Titian *poesie* (poetic narratives) painted for Philip II of Spain – *Diana and Actaeon* (fig.9) and *Diana and Callisto*, 1556–9 – together with the Venetian master's *Three Ages of Man* and his *Venus Rising from the Sea* (cat.2), Raphael's *Holy Family with a Palm Tree* and his *Bridgewater Madonna*, Poussin's complete second set of the *Seven Sacraments* painted in the 1640s for Paul Fréart de Chantelou, and a Rembrandt *Self-Portrait* from the later 1650s. At a stroke the quality and range of the display in the Gallery was immeasurably improved. This loan has continued to the present day, and over the years the

Gallery has been fortunate enough to purchase seven of its greatest masterpieces: in 1984 a group of four works by Lotto, Tintoretto, Dou (cat.11) and Steen; in 2003 Titian's *Venus Rising from the Sea*. Most recently, in partnership with the National Gallery in London, the two *poesie* by Titian were acquired in 2009 (*Diana and Actaeon*) and 2012 (*Diana and Callisto*) respectively.

The post-war period was a time of rebuilding across Europe. The Edinburgh International Festival was founded in 1947 as part of the process of cultural healing. Though primarily musical and theatrical in origin – the first Festival was marked by Bruno Walter conducting the Vienna Philharmonic – the Festival soon encouraged a lively programme of exhibitions. A close association between the Festival Society, the Royal Scottish Academy and the newly created Arts Council of Great Britain led to a spectacular series of summer shows in the Academy building beginning, in 1952, with Degas. Among the successes which followed were shows on Cézanne, Gauguin, Braque and Monet.

In the Gallery a steady programme of acquisitions was pursued. Sir Joshua Reynolds's *The Ladies Waldegrave* (cat.22), a charming conversation piece of the great-nieces of the antiquarian and connoisseur Horace Walpole, was acquired in 1952 and formed a perfect complement to Gainsborough's *The Honourable Mrs Graham*. Three years later, with the aid of a special Treasury Grant, the Gallery made its most expensive purchase to date, that of Velázquez's remarkable *An Old Woman Cooking Eggs* (cat.7), painted in his native Seville when he was just eighteen or nineteen. At the beginning of the next decade it succeeded in capturing Claude Lorrain's largest surviving painting, his *Landscape with Apollo and the Muses*, 1652, originally painted for Camillo Astalli, Cardinal-Nephew to Pope Innocent X.

That same year, 1960, also saw the opening of the Scottish National Gallery of Modern Art in the charming,

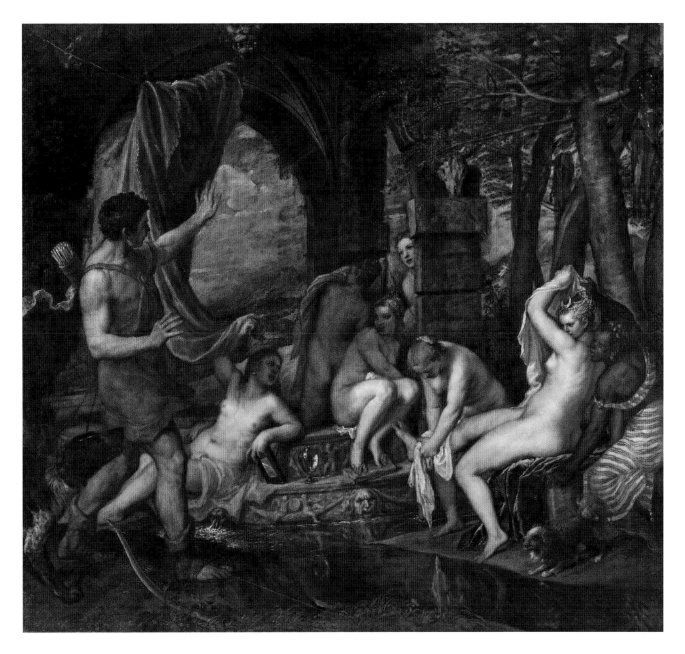

if hardly spacious, Inverleith House, a former laird's house of the late eighteenth century set in the Royal Botanic Garden in Edinburgh. An approximate demarcation line of 1900 was set between the National Gallery and the new Gallery of Modern Art, and works in the permanent collection were transferred accordingly. The modest scale of the rooms in Inverleith House determined that early purchases for the Gallery of Modern Art were of relatively small dimensions, notable among which were Expressionist works by Kirchner (cat.46), Nolde and Jawlensky (cat.47), and the first masterpiece of modern French art to enter the Gallery, Léger's *Woman and Still Life*

(cat.53). For various reasons, large-scale works by leading American artists, for example, were simply out of the question. Although considerable Gallery funds were devoted to the building up of the collection, it was not until 1976 that a Cubist painting was acquired, Braque's *The Candlestick* (cat.48). Inverleith House was always viewed as a temporary solution, and in 1984 the Gallery of Modern Art moved to larger, and permanent premises in the former John Watson's School in Belford Road (fig.10), a building originally designed by William Burn (1789–1870).

Almost comparable in impact to the Bridgewater Loan were the 1958 and 1960 gifts and 1965 bequest of

works of art from the collection of Sir Alexander and Lady Maitland. Many of these were French paintings of the later nineteenth century, including major pictures by the Impressionists and Post-Impressionists, among them two Gauguins (cat.41), two dance scenes by Degas, a *Haystacks*, 1891 by Monet and a Cézanne of the *Montagne Sainte-Victoire*, 1890–5. They had been collected over several decades by Sir Alexander and his wife Rosalind and hung in their house in Heriot Row, Edinburgh, where they maintained a musical salon. Rosalind had studied music at the Berlin Hochschule and had also helped to organise war-time concerts in the Scottish National Gallery.

A further strengthening of the Gallery's holdings of Impressionist works came about with the addition of the Richmond-Traill collection bequeathed by Mrs Isabel M. Traill in 1979. These French and Scottish pictures had been acquired by Mrs Traill's uncle, Sir John Richmond, who was a senior figure in the Glasgow business community.

Richmond's interest in French painting of the late nineteenth and early twentieth centuries had been stimulated by Alex Reid, the leading art dealer in Glasgow and, in the late 1880s, a friend and colleague of Van Gogh. It was from Reid that Richmond bought Monet's *Church at Vétheuil*, 1878 and Pissarro's *Kitchen Gardens at L'Hermitage, Pontoise*, 1874, two of the major pictures in the Traill Bequest.

An extraordinarily successful period of increasing the size and quality of the Galleries' collections began in the early 1980s and has continued to the present day, despite diminishing purchase funds. Taking maximum advantage of grants available from funding bodies and the government scheme whereby works of art could be accepted by the State in lieu of tax, the National Gallery acquired an impressive series of masterpieces by Bernini, Botticelli (cat.1), Canova (in partnership with the Victoria and Albert Museum, London), El Greco (cat.4), Guercino, Leonardo da Vinci, Raphael and Benjamin West, among

many others. The Gallery of Modern Art's holdings of
Dada and Surrealism achieved world-class standing with
the acquisition of many masterpieces from the Penrose
collection and the gift, in 1995, of the Keiller collection. Sir
Roland Penrose (1900–1984) owned probably the greatest
private collection of twentieth-century art ever assembled
in Britain. He acquired most of his works in the 1930s,
when he established friendships with many of the French
Surrealists and with Picasso, whose biography he wrote.
Prominent among the works purchased from Penrose
by the Gallery of Modern Art was Picasso's *Guitar, Gas-Jet
and Bottle* (cat.49). Penrose's highly important library and
archive were acquired in 1994. The Gallery of Modern Art
also enlarged its estate with the addition of the former
Dean Orphanage, originally designed by Playfair's great
rival Thomas Hamilton (1784–1858) and completed in 1833.
The interior of the building was successfully restyled by
the distinguished contemporary architect Sir Terry Farrell

and reopened as the Dean Gallery in 1999. The Portrait
Gallery, too, saw major acquisitions during this period,
among which should be noted Van Dyck's intimate and
direct study of Charles I's two youngest children *Princess
Elizabeth (1635–1650) and Princess Anne (1637–1640)* (cat.12).
This was bought in 1996 with the aid of generous grants
from the Heritage Lottery Fund, the Scottish Office and
the Art Fund.

Meanwhile at the National Gallery, as the collections
grew, so did the need for more space become increasingly
apparent. A construction programme had been undertaken
in 1975–8 whereby a semi-underground addition was
created running down the east side of the building which
provided new picture galleries, a suite of offices, a library
and a print room. The galleries were to be devoted to the
Scottish school, a part of the collection which it was felt
had not received due recognition. However, this area
had a dual brief, and would also be used for temporary

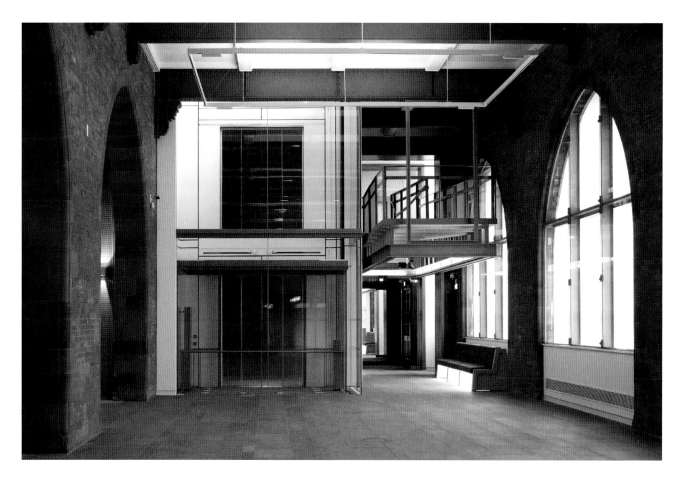

exhibitions. These were usually staged in the summer
and coincided with the annual Edinburgh International
Festival held in August and early September. Whenever
an exhibition was installed in this space, the Scottish
Collection had to be put into store. This was clearly
unsatisfactory and the obvious answer was for the Gallery
to make greater use of the Academy building for its major
exhibitions. However, by the 1990s that structure was in
poor shape. Much of its wooden foundations had rotted
away, and it was prone to subsidence. The roof leaked,
lighting was inadequate and the building lacked a modern
air-conditioning system, an essential prerequisite for
a venue for exhibitions of international stature. It was,

therefore, decided to mount an ambitious scheme, known
as the Playfair Project after the architect of both the
Academy and Gallery buildings, whereby an underground
link would be created between the two buildings and the
Academy building would have its foundations repaired
and be upgraded to meet the exhibition requirements
of the twenty-first century. Into the link space were to
be inserted an education suite and lecture theatre, a
restaurant and a gallery shop. Designed by John Miller
and Partners, the Playfair Project was begun in 1999 and
completed in 2004 at a cost of just over £30 million (fig.11).
As a result, the Gallery and Academy buildings functioned
as one connected complex and annual attendances more

than doubled from 450,000 to just under a million. A highly successful and ongoing programme of major exhibitions was inaugurated in 2003 with *Monet: The Seine and the Sea*. Many of the inherent problems of the Gallery/Academy site, which can be traced back to its creation in the mid-nineteenth century, appeared to have been resolved with the completion of the Playfair Project.

There have been a number of other significant developments across the National Galleries of Scotland in recent years. In 2008 there was the joint acquisition, with Tate, London, of the ARTIST ROOMS collection of contemporary art formed by the distinguished dealer and collector Anthony d'Offay. Comprising over 700 works by leading modern and contemporary artists such as Andy Warhol, Robert Mapplethorpe and Damien Hirst, selections made up of a room of a particular artist's work are toured regularly throughout the United Kingdom. In 2011 there was the successful completion of the renovation and internal expansion of the Scottish National Portrait Gallery to designs by the Glasgow-based architects Page and Park. With more exhibiting space available, the refurbished Portrait Gallery now boasts splendid new galleries, a bold insertion of a mezzanine floor and a striking glass lift (fig.12).

Public institutions cannot rest on their laurels, however, and the next challenge to be addressed will be the creation of a space at the National Gallery where our rich holdings of Scottish paintings can be displayed in a manner which does full justice to our national school. Similar ambitions have motivated the recent upgrading of the American wings of some of the great art museums of the United States such as the Museum of Fine Arts in Boston and the Metropolitan Museum of Art in New York and, nearer to home, there has been the recent comprehensive redisplay of the British school at Tate Britain, London. It has become increasingly apparent that the 1975–8 extension at the Scottish National Gallery, which was intended to address this problem, falls short of the required standard, both in overall capacity and from an aesthetic point of view (fig.13). Accordingly, it has been decided to redevelop this part of the Gallery, thereby tripling the exhibition space devoted to the Scottish school and improving visitor circulation throughout the complex. A completion date for the project has been set for 2018. It is anticipated that visitor figures in the remodelled Gallery will rise to a total approaching 1.5 million per year, a far cry from when the Gallery first opened in 1859 and the public was only admitted on three days per week!

MICHAEL CLARKE
Director, Scottish National Gallery

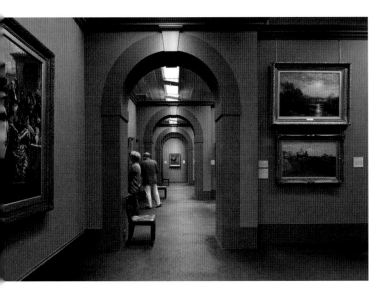

Fig.13 | Works by Scottish artists are shown in the 1975–8 extension at the Scottish National Gallery, which will be redeveloped to triple the exhibition space.

Botticelli to Braque

Catalogue

1 Sandro Botticelli 1444/5–1510
The Virgin Adoring the Sleeping Christ Child ('The Wemyss Madonna'), about 1485

Botticelli was one of the outstanding Florentine painters of the second half of the fifteenth century, the creator of such celebrated works as the *Primavera* and the *Birth of Venus* (both in the Galleria degli Uffizi, Florence). He trained initially as a goldsmith and then learned painting under Filippo Lippi. He was an independent master by 1470, joined the painters' guild in 1472, and soon received important commissions from members of the powerful Medici family. His secular pictures are imbued with the sophisticated humanist culture of the court of Lorenzo ('il Magnifico') de' Medici. In the early 1480s he was summoned to Rome by Pope Sixtus IV to execute frescoes in the Sistine Chapel. In the 1490s he came under the sway of the influential Dominican preacher, Fra Girolamo Savonarola, whose ideas are reflected in some of his later paintings. Although Botticelli enjoyed considerable success during his lifetime and ran a busy studio, his mature style was ultimately too personal and idiosyncratic to exert a lasting influence on Italian painting.

The Virgin is here shown kneeling in silent adoration of her sleeping child surrounded by motifs replete with symbolism. The luxuriant meadow bounded by a hedge of papery pink roses forms an 'enclosed garden', a symbol of the Virgin's immaculate conception derived from imagery in the Old Testament (Song of Solomon 4:12). That the roses are thornless alludes to the Virgin's freedom from the taint of original sin. The 'star of the sea' emblazoned in gold on the shoulder of her mantle is another symbol of the Virgin's purity cited in liturgical hymns. The plants – a cranesbill, a violet and a strawberry – arranged across the foreground like liturgical objects on an altar carry symbolic meanings too, alluding to the purity and humility of the Virgin and to the Incarnation of Christ. As if to stress the absence of thorns, the rose bush is extended to form a sort of floral mattress beneath the Virgin's cloak on which the baby Jesus lies. He is shown asleep, presumably as a premonition of his future Passion. But in the underdrawing his eyes are wide open, so this was a late change on Botticelli's part and is unlikely to be crucial to the picture's meaning. The barren, stratified blocks of the rocky outcrop behind the Virgin contrast with the abundant fertility of the meadow. It seems unlikely that this feature was intended to allude to Christ's Entombment, as has been suggested, since there is no hint of a cave or a recess.

The patron of *The Virgin Adoring the Sleeping Christ Child* is unknown, but on stylistic grounds it can be dated to about 1485. Technically the picture is rather unusual for Botticelli in that it is a devotional work painted on canvas rather than panel. However, there is evidence that it was originally nailed to a wooden support, as was the case with *The Birth of Venus*, so the choice of canvas was apparently an aesthetic rather than a financial one. Combined with the contemplative, slightly melancholy mood of the painting, this may suggest that it was intended for a domestic setting in a palace or convent, rather than a more public location.

At the time of its purchase by Viscount Elcho, later 10th Earl of Wemyss, in 1859, this beautiful painting was held in high regard, but towards the end of that century it was judged by the influential critic Bernard Berenson to be a product of Botticelli's workshop. Such was its subsequent neglect that, until its acquisition by the Scottish National Gallery, it had been overlooked by all modern Botticelli scholars. Full conservation of the painting and the discovery by infra-red reflectography of a free under-drawing with numerous changes have dispelled any doubts that it is entirely from Botticelli's hand. AWL

Tempera, oil and gold on canvas, 122 × 80.5 cm (48 × 31¾ in)
Scottish National Gallery, Edinburgh
Purchased by private treaty with the aid of the Heritage Lottery Fund, the Art Fund, the Scottish Executive, the Bank of Scotland, the Royal Bank of Scotland, Sir Tom Farmer, the Dunard Fund, Mr and Mrs Kenneth Woodcock (through the American Friends of the National Galleries of Scotland), and anonymous private donations, 1999 (NG 2709)

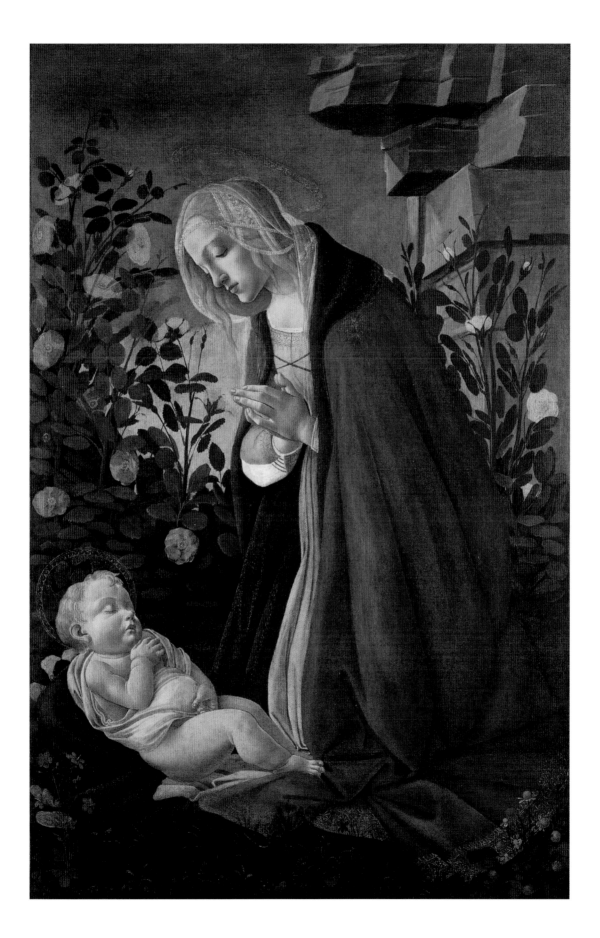

2 Titian (Tiziano Vecellio) about 1485/90–1576
Venus Rising from the Sea (Venus Anadyomene), about 1520–5

Titian was the most celebrated painter in Europe during his lifetime and his reputation has remained undiminished ever since. He was born in Pieve di Cadore, in the Dolomite Mountains, but trained in Venice, probably in the Bellini workshop, and then collaborated with Giorgione. Titian's first documented works are his frescoes of 1511 in the Scuola del Santo, Padua. His ground-breaking *Assumption of the Virgin* of 1518 in the church of the Frari sealed his status as the leading painter in Venice, where he remained based for his entire career.

Titian excelled as a painter of both religious and secular works, and his unrivalled talents as a portraitist were in huge demand. He received prestigious commissions for Venetian churches and from the Venetian government, but as his career advanced he came increasingly to work for patrons outside his adoptive city, notably the Dukes of Ferrara, Mantua and Urbino, and Pope Paul III Farnese, who prompted his only visit to Rome, in 1545–6. His long relationship with the Habsburg family began in 1530, first with the Holy Roman Emperor Charles V, who knighted him in 1533, and later with his son Philip II of Spain, the recipient of most of his best pictures from the early 1550s onwards. Over his immensely long career Titian produced work of an astonishing range and complexity. With their sumptuous colours and lively brushwork, his paintings are prized for their technical brilliance, and for the narrative skill, psychological insight and sheer inventiveness he brought to often familiar themes.

The goddess of love and beauty in Greek mythology, Venus (or Aphrodite) was born fully grown from the foam created when the genitals of the castrated Uranus were cast into the sea. She was blown ashore on a scallop shell, landing at Paphos on Cyprus, which became the main centre of her worship. Titian shows her as a beautiful young woman wading through the shallows wringing her hair, the diminutive scallop functioning like an identifying attribute. With his luminous palette, feathery brushstrokes and slightly blurred contours, Titian brilliantly evokes the soft, palpable flesh of his model. The subtle harmony of pastel blues and pinks is set off against the vibrant auburn of Venus' hair.

Titian would have been well aware of Pliny the Elder's description of a famous painting of this subject by Apelles, the greatest painter of antiquity, and in choosing to depict it he was deliberately inviting comparison with his ancient rival. He no doubt coveted – and later achieved – the exalted status and celebrity Apelles had enjoyed thanks to his privi-leged relationship with his patron, Alexander the Great. The gently twisting, *contrapposto* pose of Titian's figure recalls, without replicating, some classical statues of Venus, but it may have been a work of contemporary sculpture – a high relief by Antonio Lombardo (Victoria and Albert Museum, London), possibly carved for Titian's patron Alfonso d'Este, Duke of Ferrara – that inspired him to tackle this subject.

Venus Rising from the Sea is generally dated on stylistic grounds to about 1520–5, but its original recipient is unknown. Several scholars have argued in favour of Duke Alfonso of Ferrara, but the evidence for this is not compelling. An intriguing alternative that has not been fully explored is that it may have been painted, perhaps as a gift, for Titian's important Venetian patron Jacopo Pesaro, who had commissioned a votive painting from the artist around 1512, and a major altarpiece for the family chapel in the church of the Frari in 1519 (completed in 1526). Jacopo Pesaro was titular Bishop of Paphos, the city of the ancient cult of Venus, from 1495 until his death in 1547, so the subject – notwithstanding the nudity – could not have been more fitting for him. AWL

Oil on canvas, 74 × 56.2 cm (29⅛ × 22⅛ in)
Scottish National Gallery, Edinburgh
Accepted by HM Government in lieu of inheritance tax (hybrid arrange-ment) and allocated to the National Galleries of Scotland, with additional funding from the Heritage Lottery Fund, the Scottish Executive, and the Art Fund (including a contribution from the Wolfson Foundation), 2003 (NG 2751)

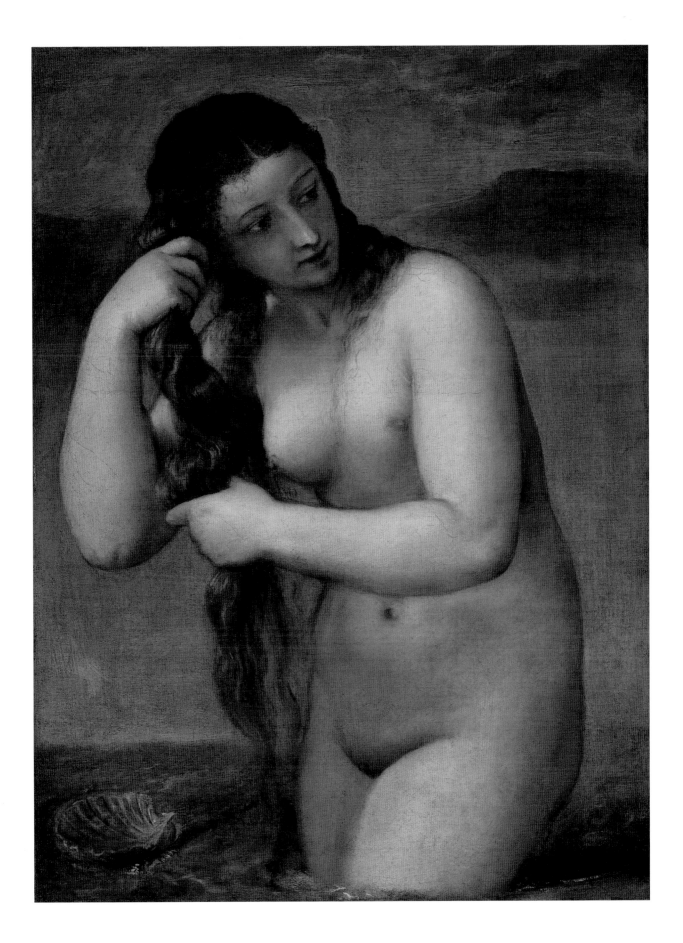

3 Paolo Veronese 1528–1588
Venus, Cupid and Mars, 1580s

Veronese was one of the most brilliant and successful Venetian artists of the sixteenth century. Born Paolo Caliari, he trained and established his reputation in his native Verona in the 1540s. By the early 1550s he was receiving major commissions from Venice, and in 1553 he moved there definitively, becoming known as 'Veronese' after his birthplace. Assisted by his brother and later by his sons, his highly productive workshop became the principal rival in Venice to that of Tintoretto. He won major decorative commissions for the church of San Sebastiano and the Doge's Palace, and gained the support of a network of wealthy Venetian patricians. A series of vast banquet scenes for monastic refectories, one of which elicited the censure of the Inquisition and led to a fascinating court hearing, are among his most famous works. Veronese also worked in fresco, notably at the Villa Barbaro at Maser on the Venetian mainland. The last decade of his career was especially productive and included, for the first time, important orders from abroad. A superb colourist, Veronese's paintings are typically filled with exotic figures, sumptuous fabrics, grandiose architecture and much incidental detail.

In this late work dating from the 1580s, Venus gently comforts her son Cupid, who has been frightened by a lively little spaniel. This seemingly whimsical intrusion of an everyday incident into a mythological subject adds a note of humour and may have triggered other associations. As a traditional symbol of marital fidelity, the appearance of a lap dog in a painting of the adulterous relationship between Venus (who was married to Vulcan) and Mars (who has begun to undress her) could hardly be less appropriate. The dog, which appears almost to ravish the startled Cupid, might also symbolise carnal passions. The goddess of love is perched somewhat awkwardly on Mars' knee. He is poorly integrated into the composition, and since he does not feature in Veronese's otherwise closely related sheet of preparatory sketches in the British

Museum, he may have been inserted at a relatively late stage, possibly by an assistant. The drawing shows that Veronese was considering showing Venus with one of her standard attributes, a mirror, as well as (or instead of) her fan. The execution of Venus, Cupid and the spaniel is on a par with Veronese's best late works, and refutes the recent suggestion that the painting is entirely the work of his son Carletto Caliari. The tonal imbalance of the painting (more pronounced now than it was originally) is due to a technical peculiarity, the figures of Venus and Cupid alone having been prepared with a thick, white ground layer, which guaranteed the luminosity of their flesh. The very sketchy treatment of Cupid's wings supports the idea that the painting may have been left unfinished at Veronese's death, and brought to a saleable state of completion by one of his heirs.

It has recently been established that this painting was presented as a diplomatic gift by the Spanish Crown to Charles I when Prince of Wales, during his ill-judged trip to Spain in 1623 to win the hand in marriage of the Spanish Infanta. Amusingly, in a document recording this gift, the picture is described reductively as 'a painting by Paolo Veronese of a boy fleeing from a dog', but a later inventory reference clarifies that it was indeed the Edinburgh picture that was given to Prince Charles. It had previously been in the collection of the Duke of Lerma, the favourite of King Philip III, at his estate of La Ribera near Valladolid. AWL

Oil on canvas, 165.2 × 126.5 cm (65 × 49¾ in)
Scottish National Gallery, Edinburgh
Purchased by the Royal Institution, 1859; transferred, 1868 (NG 339)

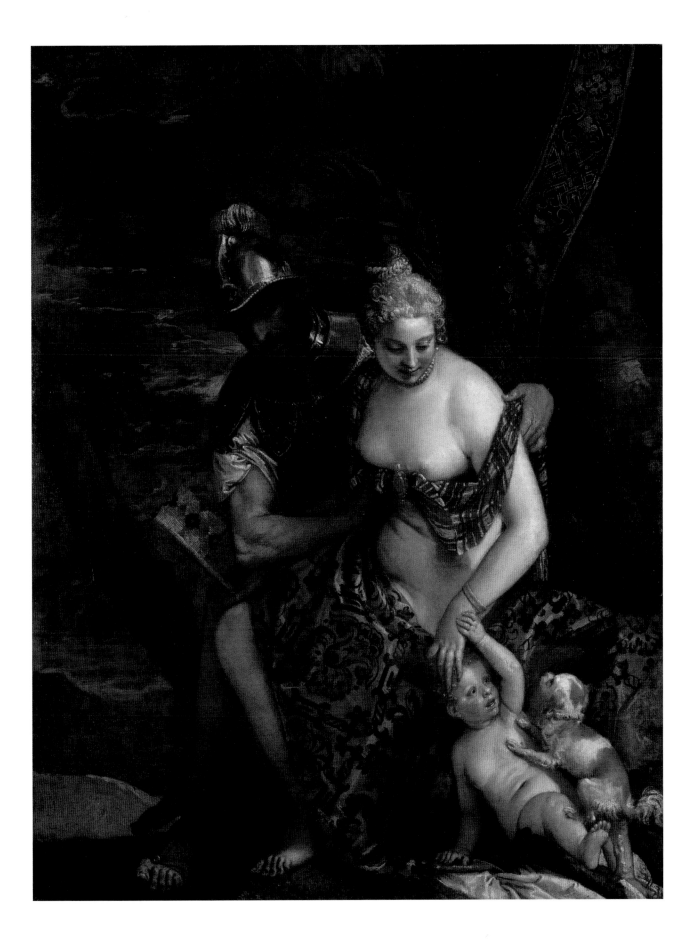

4 El Greco (Domenikos Theotokopoulos) 1541–1614
An Allegory (*Fábula*), about 1585–95

Greek by birth but Spanish by adoption, El Greco was one of the most original and distinctive artists of the sixteenth century. Born in 1541 in Crete, he trained in the local Byzantine tradition and is first recorded as an icon painter in 1566. He had arrived in Venice by the summer of 1568, where he is said to have been a pupil of Titian, and his Venetian experience transformed his style. In 1570–2 he was working for the Farnese family in Rome, and seems to have remained there until his departure for Spain in 1577. He established himself in Toledo, where he resided for the rest of his life, soon perfecting the highly idiosyncratic style which changed little over the remainder of his career. The output of his workshop was prodigious, with many compositions surviving in multiple versions, and it is often difficult to distinguish fully autograph works from those produced with studio assistance.

This enigmatic picture is usually described simply as an allegory or fable (*fábula*), and despite a great deal of scholarly research and much informed speculation, quite what is going on is still uncertain. A youth is shown blowing on an ember to kindle a flame to light a candle. As the ember ignites, brilliant light illuminates parts of the boy and his companions, but fails to penetrate the surrounding darkness. Concentrating intently on his task, the youth seems oblivious to the presence of his odd companions – a monkey gazing fixedly at the glowing ember, and a figure in a red hat and yellow cloak grinning inanely, who may represent a fool or a simpleton.

This haunting image has often been thought to illustrate a Spanish fable or proverb, but no convincing literary source has been found. The kindling of flames has long been equated with the arousal of the passions, and monkeys were often associated with sexual appetite, so it has been argued that it was intended as an allegory of lust. A different reading stems from the short-lived nature of flames and interprets it primarily as a *vanitas*, a reminder of the transience of human life. Youth will all too soon give way to old age and death, so we should not squander it by indulging in sensual pleasures and frivolity, represented by the ape and the grinning man.

An attractive alternative theory is that the picture should be understood as a gloss on the nature of art. This takes its cue from an earlier painting by El Greco in Naples showing a single youth blowing on an ember, which was painted in Rome for his learned patron Cardinal Alessandro Farnese. That picture is a re-creation of a painting by the artist Antiphilus of Alexandria, described by the first-century AD writer Pliny the Elder. In the expanded, three-figure composition, the boy blowing on an ember would demonstrate the sophistication of an art capable of re-creating with great naturalism a lost picture described in words; the monkey would allude to the classical dictum *ars simia naturae*, art as the ape of nature; and the laughing man might signify the ultimate folly of the painter's aim of reproducing a convincing illusion of the visible world on a flat surface.

The Edinburgh canvas was probably painted around 1585–95, long after the artist had moved to Spain. Two other versions of the composition are known, at Harewood House in Yorkshire and in the Museo del Prado in Madrid, both of which probably predate the Edinburgh picture. The fact that early owners of these pictures came from Spain's cultivated elite, among them two archbishops and the Count of Monterrey, makes it all the more likely that they embody some sophisticated conceit. AWL

Oil on canvas, 67.3 × 88.6 cm (26½ × 34⅞ in)
Scottish National Gallery, Edinburgh
Accepted by HM Government in lieu of inheritance tax (hybrid arrangement), with additional funding from the National Heritage Memorial Fund, the Art Fund, and Gallery funds, 1989 (NG 2491)

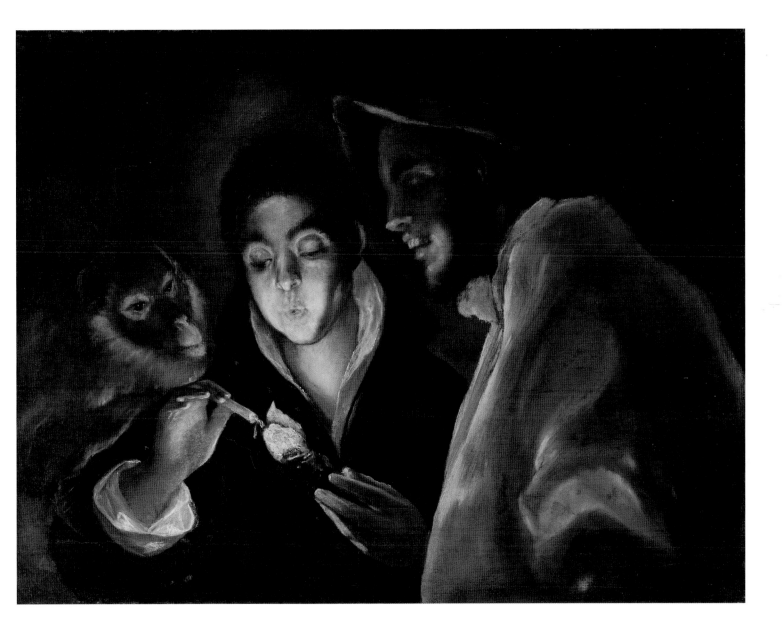

5 Adam Elsheimer 1578–1610
The Stoning of Saint Stephen, about 1603–4

Adam Elsheimer remains less well known than might be expected for an artist who was a friend of Rubens and whose paintings had a lasting impact on Rembrandt and Claude Lorrain. This may partly be due to the small number of paintings that survive, most of which are of miniature format, some smaller than a playing card. Elsheimer was born the son of a tailor in Frankfurt, Germany, where he trained with Philipp Uffenbach. He then moved south and, via Munich, reached Venice in about 1599, eventually settling in Rome in 1600 where he would work for the rest of his brief career. In Rome he met Rubens and other painters from north of the Alps. According to contemporaries, he worked slowly and the total number of his paintings may not have been significantly higher than the forty or so pictures that survive. His time-consuming technique as well as illnesses drove him into financial hardship and he died impoverished, aged thirty-two.

The Stoning of Saint Stephen exemplifies why Elsheimer's contemporaries called him 'the devil in the detail' and praised his meticulous, jewel-like paintings. Painted in brilliant colours on a copper plate prepared with a tin-alloy coating, its incredible detail and pristine enamel-like surface are equally captivating. The composition exudes a monumentality that belies the small scale of the painting. Stephen was among the first deacons and one of the earliest martyrs of Christendom. He aroused the wrath of the high priests in Jerusalem, was cast out of the city and stoned to death (The Acts of the Apostles 6–7). His vision of Christ sitting at God's right hand is depicted in the upper left corner. In the absence of dated paintings, the precise chronology of Elsheimer's work remains difficult to ascertain. *The Stoning of Saint Stephen* was most probably executed around 1603–4, and its dynamic composition marks Elsheimer's debut as a baroque painter. Rubens probably saw it in Rome. An etching by the Flemish printmaker Pieter Soutman shows a figure group derived from it. The print is based on a drawing in the British Museum, London that has been attributed to either Rubens or Soutman.

The Stoning of Saint Stephen was owned by Elsheimer's friend, the painter Paul Bril, before 1626. Intriguingly, he also had another painting of the same subject and size, described as 'similar' to *The Stoning of Saint Stephen*. In 1659 both paintings featured in the inventory of Bril's daughter, Faustina, the 'similar' painting now described as a 'copy' of Elsheimer's *The Stoning of Saint Stephen*. It seems likely that this second version is the one in a private collection, on long-term loan to the Wallraf-Richartz-Museum & Fondation Corboud in Cologne. Also painted on copper and of almost identical size, it shows the same composition but with some significant differences such as the absence of the prominent stone-throwing figure on the right and the angel in the upper left. It has been suggested that the picture in Cologne was painted by Elsheimer while still in Venice, the Edinburgh work being a mature Roman version. The provenance of the two paintings is often difficult to disentangle. It seems that the Gallery's painting, contrary to what has been assumed in the past, was in Britain as early as the late seventeenth century. A *Stoning of Saint Stephen* by Elsheimer was in the collection of Francis Newport, 1st Earl of Bradford, who also owned the *True Cross Altarpiece* (Städel Museum, Frankfurt) and two other Elsheimer paintings now in the Fitzwilliam Museum, Cambridge. The Earl of Bradford's painting was probably sold between 1737 and 1762 by his son, and was later in the collection of the Reverend George David Boyle in Salisbury, from whose descendants the Gallery acquired it in 1965. The Gallery is fortunate to own another of Elsheimer's rare paintings, *Il Contento* of about 1606–10.
CTS

Oil on tinned copper, 34.5 × 28.5 cm (13⅝ × 11¼ in)
Scottish National Gallery, Edinburgh
Purchased 1965 (NG 2281)

6 Domenichino (Domenico Zampieri) 1581–1641
The Adoration of the Shepherds, about 1606–8

Domenichino was born in Bologna and trained there under the Fleming Denys Calvaert and then, from the mid-1590s, in the more progressive Carracci Academy. In 1602 he moved to Rome and became a favoured assistant to Annibale Carracci. He was the leading exponent of the more restrained, classical tendency in Italian painting of the earlier seventeenth century, characterised by ordered, easily legible compositions and clearly articulated gestures and expressions. He was an important influence on painters of the next generation such as Nicolas Poussin and Pietro Testa. Domenichino also made a vital contribution to the development of ideal landscape painting. He enjoyed considerable success in Rome and Bologna before accepting a prestigious commission in Naples in 1631. The animosity of local artists marred his later years and his death was rumoured to have been due to poisoning. Domenichino's working method was exceptionally thorough and meticulous, with every stage of the evolution of a composition worked out carefully in preparatory drawings.

The nocturnal setting of this *Adoration*, with the scene bathed in brilliant divine light emanating from the infant Jesus is derived ultimately from the celebrated altarpiece by Correggio known as *La Notte* (Gemäldegalerie, Dresden), then in the church of San Prospero in Reggio Emilia. A close-knit group of angels and gesticulating shepherds look on in wonder, while the shepherd at the left sounds what must have been a startlingly loud celebratory blast on his bagpipes.

Dating from about 1606–8, the earliest provenance of this painting is unknown and its precise status is problematic. Doubt has even been cast recently on its authorship, with a few scholars preferring an attribution to Annibale Carracci instead. This confusion stems in part from the account given by Giovan Pietro Bellori in his biography of Annibale Carracci (1672), who describes in detail a composition corresponding to this one, the

whereabouts of which were unknown to him, adding that a copy of it by Domenichino had been taken to France. This is an entirely plausible scenario, for Domenichino made copies and variants of several other works by Carracci while working as his assistant.

However, the evidence indicates that on this occasion Bellori was mistaken, and that the design of the Edinburgh painting is essentially Domenichino's own, albeit heavily indebted to several different Nativity compositions by Carracci. Not only are the figure types more characteristic of Domenichino than Annibale, but there exists a preparatory drawing by Domenichino himself for the figure of Joseph carrying a bundle of hay, which would clearly have been unnecessary were he replicating an existing composition. A similar painting of the *Adoration of the Shepherds* by Carracci (Musée des Beaux-Arts, Orléans), which was one of Domenichino's main sources for his composition, passed from the Ludovisi collection in Rome to that of Everard Jabach in Paris around 1650, and this may be the cause of Bellori's confusion. Domenichino also drew on Annibale's etching of the *Adoration* of 1606, and on a group of Carracci drawings on this theme (Morgan Library, New York; Musée du Louvre, Paris; J. Paul Getty Museum, Los Angeles). A life study by Annibale for the kneeling boy holding a dove (Royal Library, Windsor Castle) seems to have been made explicitly to assist his pupil, a practice of which there are other examples. Finally, an etching by Stephan Colbenschlag, published in Rome around 1650, reproduces the Edinburgh painting in reverse and credits its design to Domenichino.

Domenichino's *Adoration of the Shepherds* was part of the founding bequest of Dulwich College Picture Gallery in London in 1813. It was controversially sold from there at auction in 1971, when it was acquired by the Gallery. AWL

Oil on canvas, 143 × 115 cm (56¼ × 45¼ in)
Scottish National Gallery, Edinburgh
Purchased 1971 (NG 2313)

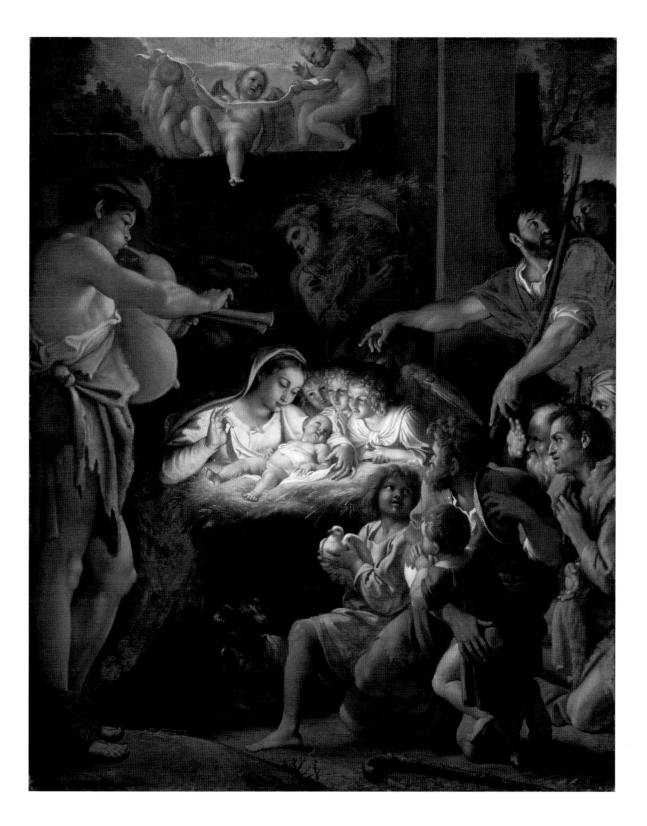

7 Diego Velázquez 1599–1660
An Old Woman Cooking Eggs, 1618

Velázquez is one of the most widely admired of all old master painters, and his technical wizardry in the application of paint has made him the 'painter's painter' par excellence. He was born in Seville and trained there under Francisco Pacheco. He enjoyed some success in his native city, but the lure of Madrid and the royal court was strong. He moved there permanently in 1623 and was soon appointed painter to the young King Philip IV. He was to remain in Philip's service for the rest of his career, enjoying increasing influence and intimacy both in his professional role as a painter and as a trusted member of the royal household. After protracted petitioning, involving special dispensations from both the king and the pope, in 1659 he was made a knight of the Order of Santiago.

Portraiture was the mainstay of a court artist, and the series Velázquez painted of Philip IV and his family over thirty-five years is unprecedented, culminating in his most celebrated work, *Las Meninas* (Museo del Prado, Madrid). But he also made a decisive contribution to many other branches of painting, including mythology, contemporary history, and even landscape. Two lengthy trips to Italy in 1629–31 and 1649–51 were crucial for Velázquez's professional development and stimulated some of his most original work.

Painted in 1618 when Velázquez was just eighteen or nineteen, the *Old Woman Cooking Eggs* is a tour de force of naturalistic painting, displaying a technical sophistication vastly superior to any of his Sevillian contemporaries. It belongs to a group of kitchen and tavern scenes with prominent still-life elements, known in Spain as *bodegones*, which the young Velázquez made his own. There were ancient precedents for painting low-life scenes of this kind, as well as examples in recent Italian and Flemish art, but the *Old Woman Cooking Eggs* has a distinctively Spanish character, and is remarkable for its detachment from pictorial models from elsewhere.

A plainly dressed old woman holding a wooden spoon is shown frying eggs in a glazed terracotta dish over a charcoal brazier. She gazes towards a boy who holds a melon and a flask of clear, reddish liquid, presumably wine, and looks out of the painting. Masterfully depicted on the table at the lower right is a still life of kitchen vessels and simple foodstuffs. Hanging on the wall behind are a basket and cloth, and a pair of ladle-like steel oil lamps. The protagonists are clearly of humble stock, but unlike most earlier scenes of everyday life, they are presented with dignity, without mockery or censure. The palette is dominated by a range of earth colours and creamy white. Even the subtlest differences of texture and reflectivity – the duller sheen of the pestle and mortar compared to the gleaming, burnished surface of the pan – are brilliantly nuanced. Most extraordinary of all is the rendering of the semi-solidified whites of the cooking eggs.

The old woman and the boy represented in this painting were real people – family members or neighbours of Velázquez, perhaps – and both reappear in other early paintings by the artist, as do some of the kitchen utensils. All of the elements in the composition were no doubt painted directly from life. Domestic scenes comparable to this appear in Spanish picaresque novels of this period, notably Mateo Alemán's popular *Guzmán de Alfarache*, published in 1599. This actually includes an episode in which an old hag cooks a dish of eggs for a young *pícaro* (street urchin) in a humble inn, but both the details and the censorious tone are quite different.

This painting is first recorded in 1690 in the distinguished collection of Nicolás Omazur, a wealthy Sevillian silk merchant of Flemish extraction, who was a major patron of the painter Murillo. AWL

Oil on canvas, 100.5 × 119.5 cm (39½ × 47 in)
Scottish National Gallery, Edinburgh
Purchased with the aid of the Art Fund and a special Treasury Grant, 1955
(NG 2180)

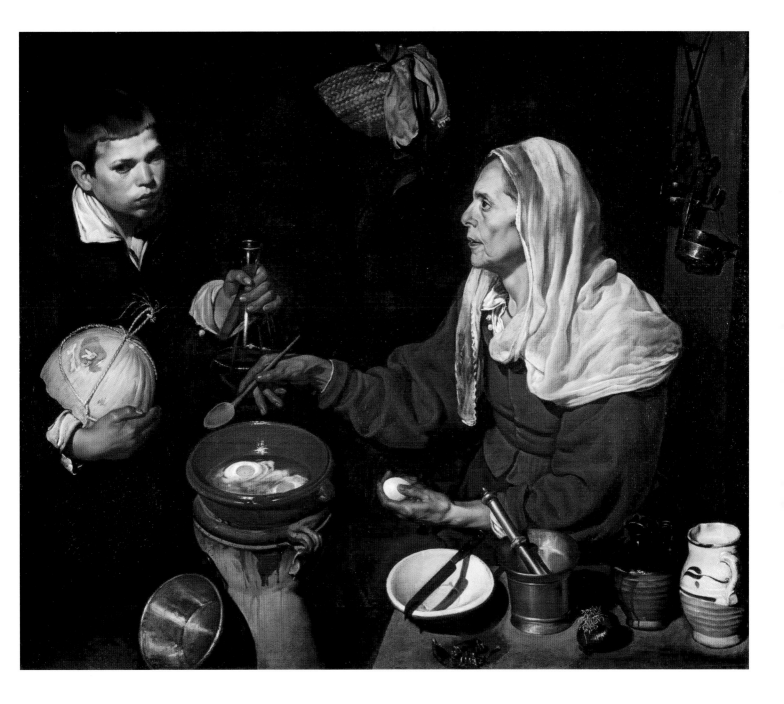

8 Sir Anthony van Dyck 1599–1641
Saint Sebastian Bound for Martyrdom, about 1620–1

Van Dyck is regarded as one of the greatest masters of the Flemish Baroque. He is best known for his elegant portraits which had a lasting impact on British art in particular. However, throughout his career, Van Dyck also painted a large number of sacred and mythological subjects. Born the son of a silk merchant in Antwerp, he enrolled as a pupil of Hendrik van Balen at the age of ten. Van Dyck registered as a master painter in 1618. By this time he had probably been working in Rubens's studio for several years, although no formal apprenticeship is documented. He collaborated with Rubens as his assistant in 1620. After a few months in England and a brief return to Antwerp, Van Dyck left for Italy in 1621, where he spent six years, mostly in Genoa. After another five years in Antwerp, he left for England in 1632 to become Charles I's 'principal painter'. Apart from a brief return to Flanders in 1634–5, he spent the rest of his highly successful career in London.

Saint Sebastian, an early saint and martyr, was a Roman officer who converted secretly to Christianity. When his faith was discovered, he was tied to a tree and shot with arrows. Usually shown at the moment of his martyrdom, with arrows piercing his body, Van Dyck here depicts him prior to his execution, following Wenzel Coberger's *Saint Sebastian* of about 1598–9, formerly in the Antwerp Cathedral (now Musée des Beaux-Arts, Nancy). The young Van Dyck created several versions of this subject. X-radiographs show that underneath the painting is a first composition that closely resembles his earlier *Saint Sebastian* of about 1617–18 (Musée du Louvre, Paris). It seems that Van Dyck intended to paint an enlarged version of this smaller picture, as he did on at least one other occasion around the same time. However, at a fairly advanced stage and for reasons unknown, Van Dyck decided to overpaint this composition with the one we see today. To complicate matters, a third version exists in the Alte Pinakothek, Munich. This one is extremely close to the Edinburgh picture; in fact, they are identical in scale, proportion and the positions of the figures, except for a few details. The most significant difference is the gap between the saint and the soldier on horseback which is wider in the Gallery's version. This part of the painting has been reworked by Van Dyck and originally was even closer to the Munich picture. This seems to imply that the Edinburgh picture is the later of the two, whilst the underlying older composition which resembles the Louvre painting would suggest the opposite sequence. Could it be that Van Dyck painted the Edinburgh version first, then modelled the one in Munich on it, before finally improving the former, perhaps only after the Munich version had left the studio?

In the past, the Gallery's painting has often been assigned to the early years of Van Dyck's Italian period. However, a drawing after it from Rubens's workshop indicates its presence in Rubens's house in the 1620s, when Van Dyck was already in Italy. Accordingly, a date of 1620–1 for the *Saint Sebastian Bound for Martyrdom* is most likely. Rubens perhaps sold or gave the picture to Don Diego Felípez de Guzmán, 1st Marquess of Leganés, a major Spanish collector, before the latter left Flanders in 1634. It was in the Marquess's collection in 1637 but had departed by 1711. First documented in Costantino Balbi's collection in Genoa in 1724, it was acquired from his descendants by the Scottish painter and agent Andrew Wilson in 1830, on behalf of the Royal Institution for the Encouragement of the Fine Arts in Scotland. The picture was transferred to the Scottish National Gallery in 1859, the year it opened to the public. CTS

Oil on canvas, 230 × 163.3 cm (90½ × 64¼ in)
Scottish National Gallery, Edinburgh
Purchased by the Royal Institution, 1830; transferred, 1859 (NG 121)

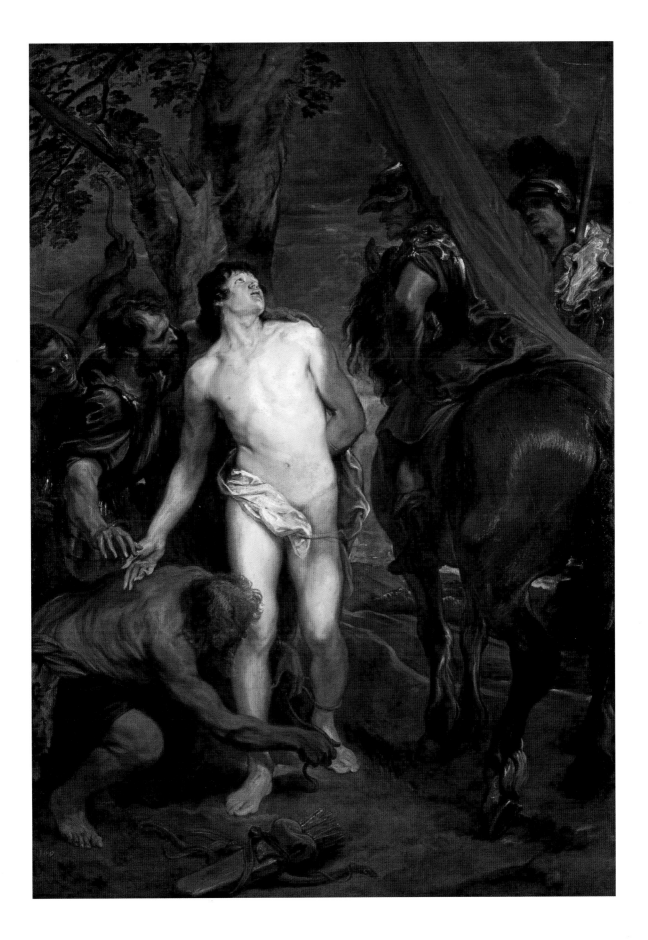

9 Frans Hals 1582/83–1666
Portrait of Pieter(?) Verdonck, about 1627

Frans Hals is regarded as one of the greatest artists of the Dutch Golden Age. His loose and seemingly spontaneous brushwork, combined with an exceptional ability to capture a sitter's likeness and expression, inspired later artists ranging from Fragonard to Whistler. Hals was born in Antwerp, the son of a cloth maker. Following the capture of the city by Spanish troops in 1585, the family fled to Haarlem in Holland. Hals trained with Karel van Mander, the painter and author of the *Schilder-boeck* (*Painter's Book*), and enrolled as a master in the local St Luke's Guild in 1610. He briefly lived in Antwerp in 1616 and took a commission in Amsterdam in 1633–4, but essentially spent his whole career in Haarlem. Hals was chiefly a painter of individual and large official group portraits, but occasionally also made genre pieces, particularly in the 1620s. Despite his success, he got into financial difficulties in the 1650s but was granted a generous pension by the city council towards the end of his life. He was buried in St Bavo, the 'Groote Kerk' in Haarlem.

When this painting was given to the Gallery, it was titled *The Toper*. In 1927 the Dutch conservator A. Martin de Wild took X-radiographs of the picture and discovered that it had been prettified in the late nineteenth century. The jawbone had been replaced by a drinking glass and a beret had been added, presumably to make it more saleable. These alterations were removed in 1928. A similar case is Hals's *Saint Mark* (Pushkin State Museum of Fine Arts, Moscow), which had been transformed into the portrait of an elderly man with a lace ruff.

The Gallery's portrait was engraved by Jan van de Velde the Younger and the inscription of this print reveals the identity of the sitter: 'This is Verdonck, that outspoken fellow,/ whose jawbone attacks everyone,/ He cares for nobody, great or small,/ That's what brought him to the workhouse.' Most likely, the sitter is Pieter Verdonck, a Haarlem Mennonite, who had been sanctioned by the Haarlem burgomaster for harassment in 1623. A copy of Hals's portrait in the Cincinnati Art Museum is dated 1627 and it seems likely that Hals's painting as well as Van de Velde's print were executed the same year or a little earlier.

The *Portrait of Pieter(?) Verdonck*, a crossover between portrait and genre piece, shows Hals's inventive powers when it came to a sitter's pose and attributes. The jawbone is the same weapon used by the biblical hero Samson to kill the Philistines (Judges 15: 14–15). Hals merged the likeness of Verdonck with the iconography of Samson, with the jawbone aptly referring to the sitter's ability to wound with his cutting words.

The picture was given to the Gallery by John James Moubray, a Justice of the Peace and lieutenant for the Scottish county of Kinross, living at Naemoor near Alloa in Clackmannanshire. He donated the painting in memory 'of wet afternoons spent happily there [in the Gallery] in his youth'. A portrait by John Constable of Laura Moubray, a relative of the donor, was added to the Gallery's collection in 2013. The Gallery also boasts a superb pair of portraits by Hals, of Frans Wouters, a Haarlem councillor, alderman and mayor, and, presumably, his second wife, Susanna Baillij, of about 1645. CTS

Oil on panel, 46.6 × 35.7 cm (18⅜ × 14 in)
Scottish National Gallery, Edinburgh
Presented by John J. Moubray of Naemoor, 1916 (NG 1200)

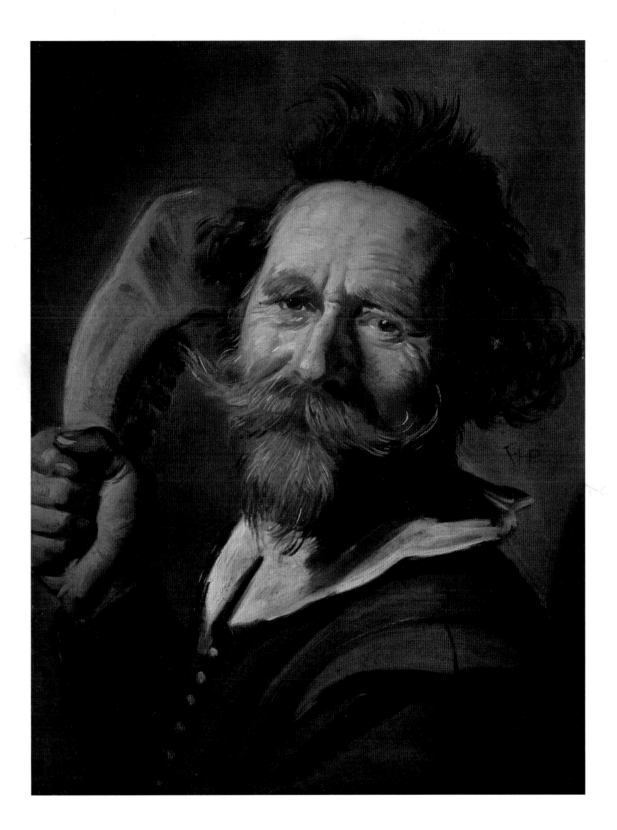

10 Jan Lievens 1607–1674
Young Man in Yellow, about 1630–1

Jan Lievens enjoyed a considerable artistic reputation in his own day but has since been outshone by Rembrandt. Like him, Lievens was born in Leiden, where he trained for two years with Joris van Schooten, subsequently serving as Pieter Lastman's apprentice in Amsterdam in about 1618–20. On his return to Leiden at the age of about twelve, Lievens set up his own studio in the family's house. The Leiden burgomaster Jan Orlers praised the 'consummate skill' of the precocious child and Constantijn Huygens, secretary to the Stadholder, predicted that Lievens would surpass even Rubens. When Rembrandt returned from his training with Lastman in 1625, he and Lievens worked independently in Leiden, though the two engaged in artistic exchange and competition. Lievens went to London (1632–5) and was active in Antwerp from 1635 to 1644 before settling in Amsterdam, where he was based for most of his remaining career. Prestigious commissions included large paintings for the decoration of the Stadholder's summer palace Huis ten Bosch (1648–50), for the court of Friedrich Wilhelm, Elector of Brandenburg, in Berlin (1653–4), and for the Amsterdam Town Hall (now the Royal Palace, 1655 and 1660). During the last decade of his career, Lievens increasingly faced domestic and financial difficulties, and he died in poverty.

This intriguing, dramatically lit depiction of a young man, posing as a commander in a yellow robe, with gorget and baton and carrying his (invisible) sword on an embroidered baldric, has a chequered history of attributions and identifications. John Raphael Smith reproduced the painting in mezzotint in 1772, as by Gerrit Dou, representing 'Wallenstine', Count Albrecht von Wallenstein, the supreme commander of the Habsburg armies during the Thirty Years War. The painting was sold with this fanciful but improbable identification as late as 1921. The attribution has also been much discussed. Apart from Dou, Rembrandt (certainly because of the spurious signature), Ferdinand Bol, Salomon Koninck and Paulus Bor were suggested. The London dealer H.M. Clark was the first to propose the now universally accepted attribution to Jan Lievens, in 1921.

Most probably, this painting is what was known in Dutch as a *tronie* (literally: 'face'), a type of expression or costume study. Both Lievens and Rembrandt experimented with *tronies* early in their careers, often featuring members of their families or their own likenesses. Indeed, Lievens's painting has been described as a self-portrait. Due to the uneven lighting of the face it is difficult to compare it to (self-)portraits of Lievens. However, it is likely that he modelled this *tronie* on his own features and combined it with exotic costume, like Rembrandt did in his *Self-Portrait* (Isabella Stewart Gardner Museum, Boston) or *The Artist in Oriental Costume* (Petit Palais, Paris). Lievens's painting was probably executed around the same time, 1630–1. It is unusually large for a *tronie*, although another one by Lievens, *Man in Oriental Costume* (Bildergalerie, Potsdam), is of similar size. The commanding pose and rich costume would fit well with Huygens's observation made in 1631, of the young Lievens suffering from 'an excess of self-confidence'. Lievens's character seems to have been unchanged when Sir Robert Kerr, 1st Earl of Ancram, an exiled Scottish royalist, sat to him in Amsterdam in 1654. Kerr described Lievens in a letter to his son as having 'so high a conceit of himself that he thinks there is none to be compared with him in all Germany, Holland, nor the rest of the seventeen provinces'. Kerr's portrait, which had remained in the family ever since, was acquired for the Scottish National Portrait Gallery in 2010. CTS

Oil on canvas, 112 × 99 cm (44⅛ × 39 in)
Scottish National Gallery, Edinburgh
Purchased with the aid of the Cowan Smith Bequest Fund, 1922 (NG 1564)

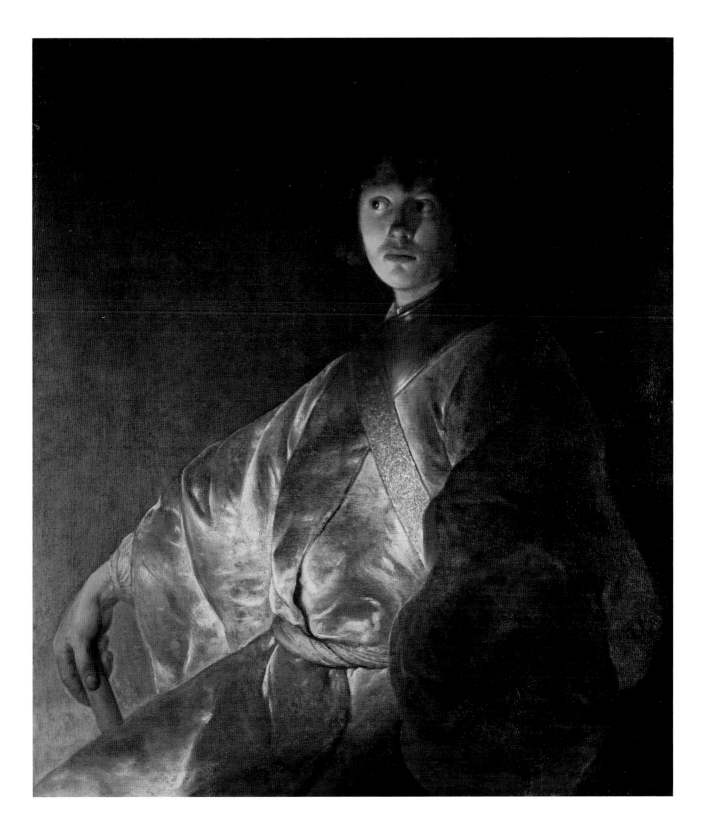

11 Gerrit Dou 1613–1675
An Interior with a Young Viola Player, 1637

Gerrit Dou was one of the most highly esteemed painters of the Dutch Golden Age. He was the father of the so-called school of *fijnschilders* (fine painters) in his home town of Leiden, celebrated for their detailed illusionism and refined technique. The son of a glassmaker, Dou trained with the engraver Bartholomeus Dolendo and the glass painter Pieter Kouwenhorn. In 1628, he became Rembrandt's first pupil, remaining for three years. Dou spent his whole career in Leiden but soon became famous far beyond. He was among the best-paid painters of his day and his pictures were owned by aristocrats and princes across Europe. In 1660, he advised the States of Holland and Westfriesland on the 'Dutch Gift', the States' highly prestigious present to Charles II. Dou himself contributed three commissioned paintings. He died a very wealthy bachelor, aged sixty-one.

This is Dou's earliest surviving dated work. The English dealer and art writer John Smith wrote in 1829 that 'this little bijou is perhaps, as a whole, the most perfect work that the master ever produced'. The young man has just stopped playing the viola and turned his head, his gaze meeting the viewer. In the past, the figure has been identified as a student, probably because of the scattered books, or, highly unlikely, as a self-portrait. The prominent viola – the stringed instrument is too large to be a violin – and tranquil scene, combined with the inward-looking expression of the young man, create a sensitive, almost melancholic atmosphere. In the seventeenth century music-making was a favourite pastime of young gentlemen but also strongly associated with love and courtship.

Technical examination has revealed that Dou changed the composition in several places. Most notably, the open book on the table was initially a large folio, as often features in Dou's work. At some stage, Dou replaced it with a much smaller, oblong book. It is painted so precisely that it has been possible to identify it as *De Friesche Lust-Hof*

(*The Frisian Pleasure Garden*), a popular Dutch song book by the Frisian poet Jan Starter, first published in 1621. The text page on the right corresponds to the opening page of Starter's *Melis Tijssen*, a burlesque about the joys and sorrows of love which forms part of the *Friesche Lust-Hof*. However, the print on the left of Dou's book is different from the accompanying illustration in all the four editions of Starter's book predating Dou's painting. It is difficult to read Dou's image, but it depicts two lovers under a tree in a landscape. Apparently, he developed this subject from his own imagination, finding it more appropriate than the 'Merry Company' illustrated in Starter's book, which reflects the opening lines of *Melis Tijssen*. For the informed viewer who was able to identify the book, probably with a magnifying glass, this added an unexpected burlesque layer to the tranquil, melancholic image of the young musician.

The painting was probably bought from the artist by Pieter Spiering, the Swedish king's representative in The Hague, who paid Dou a substantial sum of 500 guilders a year, for the right of first refusal on his production. Spiering offered the picture to Queen Christina of Sweden in 1651 but she returned it the following year. In 1747 the painting was sold from the collection of James Brydges, 1st Duke of Chandos, and the composer Handel's great patron. The 2nd Marquess of Stafford owned it by 1808 and, possibly, had acquired it at Robert Ladbroke's sale in 1800. By descent it came to the 6th Duke of Sutherland who placed it on long-term loan to the Scottish National Gallery in 1945. It was purchased in 1984. Since 2006 the Gallery has also owned *A Woman Playing a Lute* (NG 2795) by Frans van Mieris, Dou's most famous pupil. CTS

Oil on oak panel, 31.1 × 23.7 cm (12¼ × 9⅜ in) (arched top)
Scottish National Gallery, Edinburgh
Purchased with the aid of the National Heritage Memorial Fund, 1984
(NG 2420)

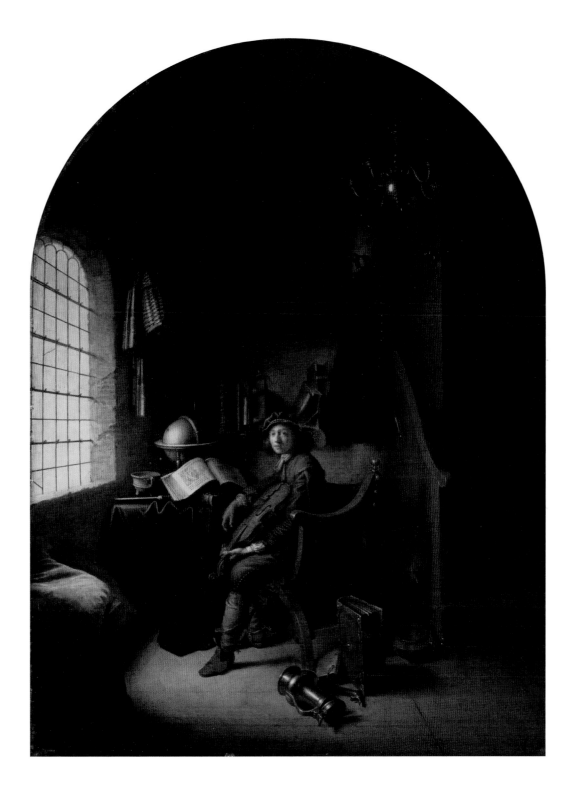

12 Sir Anthony Van Dyck 1599–1641
Princess Elizabeth (1635–1650) and Princess Anne (1637–1640), Daughters of Charles I, 1637

After a second period in the Netherlands, Van Dyck returned to London in 1632 where he was knighted and appointed 'Principal Painter in Ordinary to their Majesties' by Charles I. A series of majestic formal portraits of the royal family followed and were hung in the royal palaces, presented as gifts to loyal subjects and sent abroad to European courts. The splendour and power of the Stuart court was exemplified by Van Dyck's confident and painterly style, and as a result patronage from elite families abounded. Van Dyck was only able to meet the demand for his work with the support of his assistants who worked alongside the master in a methodical fashion in his studio in Blackfriars, London.

This charming oil sketch of Charles I and Henrietta Maria's second and third daughters, Princesses Elizabeth and Anne, is a unique surviving study by Van Dyck for the larger group portrait, *The Five Eldest Children of Charles I* (Royal Collection, Windsor Castle). Commissioned by the king in 1637, the painting originally hung above his breakfast table at the Palace of Whitehall.

The sketch is the only known preparatory work painted from life during Van Dyck's period in Britain and demonstrates the artist's flair for capturing his subjects in fluid and expressive brushstrokes. Bold, deep-brown outlines define the heads, while individual features are exquisitely modelled with a combination of creamy highlights and subtle shading to create a fresh and animated portrait. Given the young age of the sitters – Elizabeth aged two, seen on the left cradles her baby sister Anne who is only a few months old – Van Dyck may have chosen to make a quick sketch of the sisters in this affectionate pose to work up later onto a larger canvas. In the finished painting Elizabeth appears slightly older and is depicted wearing a pearl earring and with fine hair under her cap.

In contrast to Van Dyck's vast statement portraits, the study of the two princesses is strikingly intimate.

The artist has acknowledged the innocence of his royal subjects and has departed from the earlier tradition of presenting children as miniature adults. The chubby cheeks of the children and their wide-eyed optimism are all the more poignant when we realise that neither girl survived to adulthood. During the Civil War, Elizabeth and her brother Henry, Duke of Gloucester, were taken into the custody of the Parliamentarians and virtually imprisoned in St James's Palace, London. Elizabeth died in 1650 aged fifteen, apparently from pneumonia, although her mother claimed that she had never recovered from her father's death and had died of a broken heart. Anne died aged three from tuberculosis and her short life may account for the mistake in the later inscription which identifies the infant as Henry, Duke of Gloucester.

During the nineteenth century the painting entered the collection of Charles Compton Cavendish, 1st Baron Chesham and descended through the Cavendish family until the 1970s when it was sold by John Cavendish, 5th Baron Chesham to the British Rail Pension Fund. Purchased from the fund in 1996, the double portrait was a high profile acquisition for the Scottish National Portrait Gallery and today it is considered one of the highlights of the collection. KA

Oil on canvas, 29.8 × 41.8 cm (11¾ × 16½ in)
Scottish National Portrait Gallery, Edinburgh
Purchased with the aid of the Heritage Lottery Fund, the Scottish Office and the Art Fund, 1996 (PG 3010)

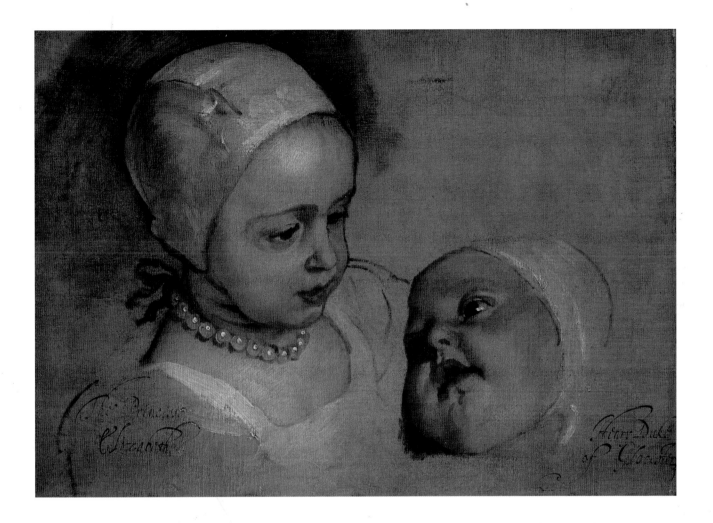

13 William Dobson 1611–1646
Charles II (1630–1685) when Prince of Wales, with a Page, about 1642

The English painter William Dobson rose to prominence during the Civil War when he painted a number of illustrious Royalist sitters including the courtier *Endymion Porter*, 1642–5 (Tate, London) and the nobleman and soldier *James Graham, Marquess of Montrose*, 1643–4 (private collection).

Dobson was born in London in 1611 and was later apprenticed to the dealer and print-seller William Peake. There is evidence that during this period Dobson restored paintings and copied old master works, before he moved on to develop his own compositions. The outbreak of the Civil War in 1642 presented Dobson with a lucrative business opportunity; along with Charles I, the royal court relocated to Oxford, and Dobson quickly followed to set up a studio in the city to paint portraits of the fashionable visitors. The sitters in these portraits are highly individualised and the compositions and colouring demonstrate the influence of the Venetian masters on Dobson, particularly Titian.

This portrait of the young Prince of Wales is considered to be Dobson's masterpiece and was probably his first royal commission. The painting commemorates Charles II's earliest experience of military action at the battle of Edgehill in 1642, when he was just twelve years old. A pertinent example of Stuart propaganda, the prince is depicted defending the Royalist cause.

In the dramatic composition, Charles stands majestically at the forefront of the painting and holds a commander's baton in his right hand while resting his left hand on the helmet presented by his page. Traditionally the page has been identified as 'Mr Windham', perhaps the son of Charles's nurse; alternatively, he may be Charles's younger brother James, future Duke of York and James II, who was also in Oxford at this date. Both the helmet and breastplate or cuirass that Charles wears are from a distinctive suit of armour made for the prince, which survives today in the collection of the Royal Armouries,

London. A second portrait by Dobson – *Charles II* (Royal Collection, London), painted two years later – shows the prince in three-quarter length wearing the full suit.

In the distance, to the left of Charles, the battle rages; and, to emphasise further the horrors of war, in the lower left corner we see the head of the snake-haired Gorgon Medusa among discarded axes and banners, a motif perhaps derived from the *Head of Medusa* by Sir Peter Paul Rubens, 1617–18 (Kunsthistorisches Museum, Vienna), which at the time was in the collection of the Duke of Buckingham. The vivid colouring and fine attention to detail, in the costume and armour, are combined with a baroque sense of drama to create a compelling work.

While the portrait was composed to show the boy prince as a military hero, his attendance at Edgehill proved uninspiring and he had to be rescued after accidentally encountering the Parliamentarian cavalry. Charles remained in Oxford until March 1645 and then headed west, ending up in refuge in Jersey, before making his way to the Continent where he lived in exile at the French court and at The Hague. KA

Oil on canvas, 153.6 × 129.8 cm (60½ × 51⅛ in)
Scottish National Portrait Gallery, Edinburgh
Purchased 1935 (PG 1244)

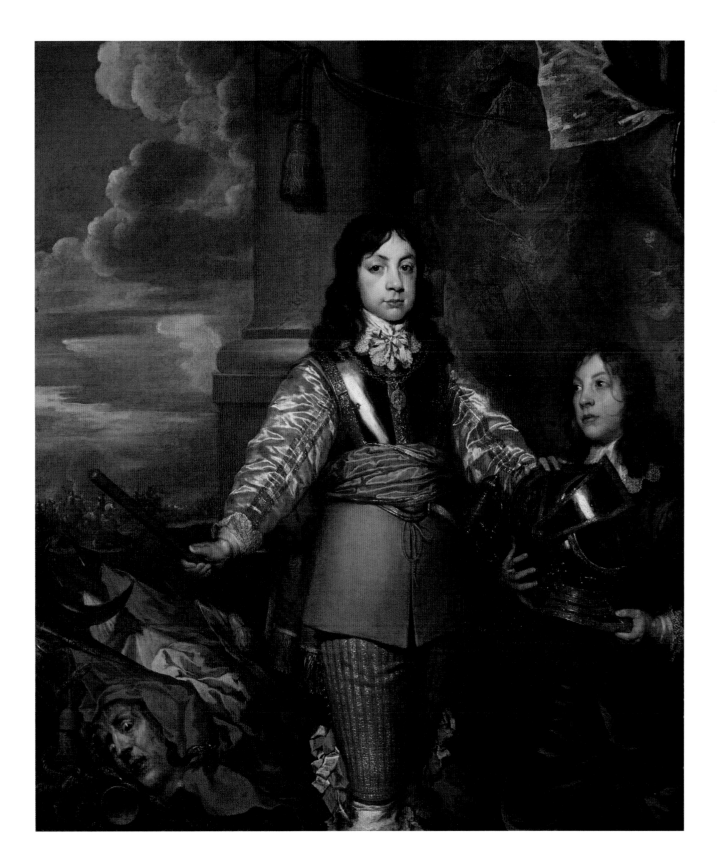

14 Rembrandt van Rijn 1606-1669
A Woman in Bed, 164[7?]

Rembrandt was the greatest artist of the Dutch Golden Age and one of the most famous artists of all time. Equally prolific as a painter, draughtsman and etcher, his art had an enormous impact throughout the centuries – matched only by Raphael's and Dürer's – and many of his works have become iconic images. He was born in Leiden, the son of a miller. After a brief period at Leiden University, Rembrandt trained with Jacob van Swanenburg and then for six months with Pieter Lastman in Amsterdam. On his return in 1625 he set up a studio in Leiden, entering into an artistic exchange and competition with Jan Lievens and training his first pupil, Gerrit Dou. Rembrandt worked as a portraitist for Hendrick Uylenburgh in Amsterdam from 1631, eventually settling in the city in 1633, and married Hendrick's niece Saskia the year after. He soon established his own busy workshop, taking a large number of apprentices over the years. Despite his success, Rembrandt faced financial difficulties in his later career, being declared bankrupt in 1656. He continued to work until his death in 1669.

This painting has at various times been thought to represent all three women in Rembrandt's life: his wife Saskia, his son's nursemaid Geertje Dircx, and the servant girl Hendrickje Stoffels. The Dutch conservator A. Martin de Wild treated the painting in 1929 and read the last digit of the date, now completely lost, as '7', that is 1647. Saskia had died in 1642 and Hendrickje Stoffels is first recorded in Rembrandt's house in 1649. The most likely model therefore would seem to be Geertje Dircx who lived with him from about 1642 to 1649. However, no firmly identifiable portrait of her is known. The subject matter of this painting has remained equally elusive. It is certainly not a portrait, as the intimate setting, in bed, would be inappropriate for any respectable female sitter. Perhaps the model posed as Sarah, who is watching from her marriage bed whilst her bridegroom Tobias chases away the Devil that slew each of her previous seven husbands on their

wedding night (Tobit 8, 1–3). The rich linen and curtain, as well as the fanciful gold headdress, would be appropriate for the bride. Equally, her gaze seems to be concentrated, watching an invisible Tobias with concern, between hope and despair. Rembrandt's teacher Lastman had painted this same story (Museum of Fine Arts, Boston). Rembrandt's depiction, however, is an 'isolated subject', as it only focuses on Sarah. The informed viewer would have to recognise and 'read' the story from this single figure.

To complicate matters even further, the picture has a peculiar structure. It was painted on canvas stuck onto panel. The panel support was removed in 1932 by De Wild, on the assumption that it was a later addition. Recent technical examination has revealed that, most probably, Rembrandt himself had chosen this unusual structure. His painting may have been inserted at some point into a piece of furniture. This would also explain why Rembrandt opted for such a strong illusionistic effect in the painting.

A Woman in Bed may be identical to a painting that Rembrandt bartered for boat supplies in 1647. Jean-Étienne Liotard's pastel portrait (Cleveland Museum of Art) of the famous Geneva-based collector François Tronchin shows Rembrandt's painting unframed on an easel in 1757. The wealthy Scottish brewer William McEwan, who had given the Scottish National Gallery a superb pair of Frans Hals portraits in 1885, presented the Gallery with this painting, its first Rembrandt, in 1892. Since 1945 it has been accompanied by Rembrandt's *Self-portrait aged 51* from the Bridgewater Loan. CTS

Oil on canvas (formerly laid down on panel), 81.4 × 67.9 cm (32 × 26¾ in)
Scottish National Gallery, Edinburgh
Presented by William McEwan, 1892 (NG 827)

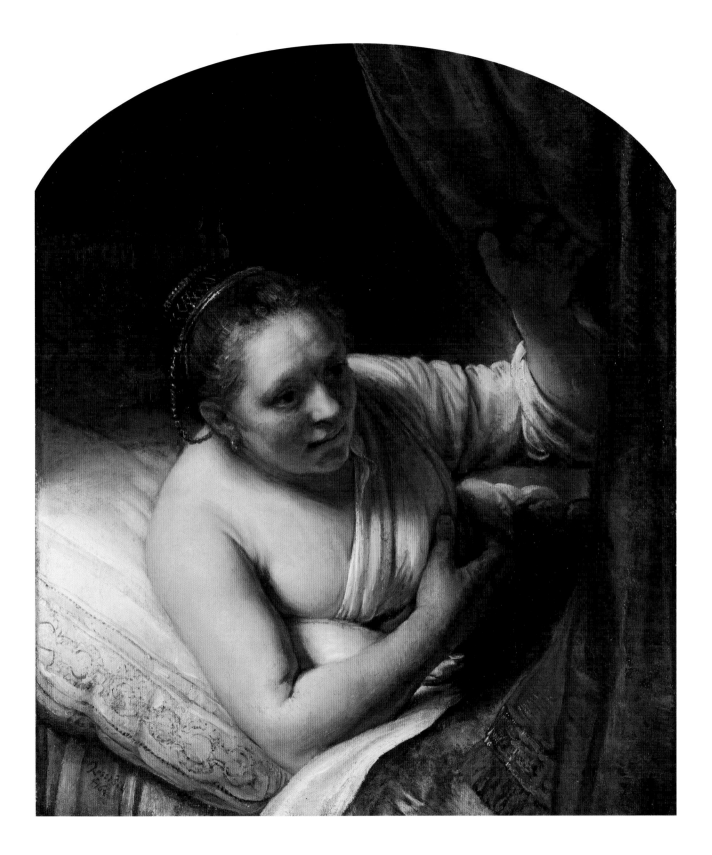

15 Johannes Vermeer 1632–1675
Christ in the House of Martha and Mary, about 1654–5

Today Vermeer is among the best-known artists in the world, although only thirty-six of his paintings survive. His popularity is all the more remarkable as he had been forgotten soon after his death and was rescued from obscurity as late as the mid-nineteenth century. Vermeer was born in Delft where he spent his entire career as a master painter. Nothing is known about his teachers: he may have received some or all of his training elsewhere, or have been largely self-taught. Vermeer is most famous for his genre pieces, quiet interiors showing figures in everyday activities.

Christ in the House of Martha and Mary is Vermeer's largest painting and the only one with a biblical subject. It was probably painted around 1654–5, soon after he had become a member of the St Luke's Guild in Delft, in December 1653. The balanced composition shows three figures closely linked by their gestures and gazes. This interaction portrays the essence of the story (Luke 10: 38–42), in which Martha objected to her sister Mary listening to Jesus while she herself was busy serving. Christ, however, praised Mary's eagerness to contemplate and pleaded that Martha place the spiritual above the material. It is this moment of Christ addressing Martha and pointing towards her sister that Vermeer depicted. In this picture Vermeer demonstrates his mastery in rendering light and shade, while the broad brushstrokes show him experimenting with various techniques, possibly inspired by artists such as Rubens and Van Dyck. The strong contrast of Mary's profile against the tablecloth and the reflecting light illuminating her shaded face are similar to works by the Utrecht Caravaggists, such as Dirck van Baburen and Hendrick ter Brugghen. Although this painting looks very different from his later works, there are some elements that Vermeer elaborated upon at the end of his career: in particular, his fascination with light and its effects, the problem of space, as visible in the corridor on the left, and the overall sense of tranquility and serenity.

Christ in the House of Martha and Mary belongs to a group of only three paintings that mark Vermeer's early career. The other two are *Diana and her Nymphs*, about 1653–4 (Mauritshuis, The Hague) and *The Procuress*, 1656 (Gemäldegalerie Alte Meister, Dresden). Clearly, Vermeer initially wanted to make a career as a history painter, depicting mythological and biblical subjects. However, after *The Procuress* he never returned to history painting and almost exclusively painted genre scenes for the rest of his career.

Given the unusual size, it is likely that this painting was a specific commission, possibly intended for a Catholic church or – more likely – for an individual patron. Vermeer married in 1653. His wife came from a wealthy Catholic family and the artist had probably converted to Catholicism shortly before the marriage. The young couple moved in with Vermeer's mother-in-law Maria Thins and it has been suggested that *Christ in the House of Martha and Mary* was painted for her, to whose first name the subject may have alluded. The picture is known to have been in Britain by the late nineteenth century. However, it was only in 1901 that Vermeer's monogram was discovered and the painting identified as a masterpiece of the young artist. It was bought the same year by William Allan Coats, a Scottish textile manufacturer, and was given to the Gallery by his sons, in memory of their father, in 1927. CTS

Oil on canvas, 160 × 142 cm (63 × 55⅞ in)
Scottish National Gallery, Edinburgh
Presented by the sons of W.A. Coats in memory of their father, 1927
(NG 1670)

16 Jean-Antoine Watteau 1684–1721
Fêtes Vénitiennes, 1718–19

Watteau was one of the foremost exponents of the Rococo style in French painting. His work is characterised by its delicacy of execution and feeling, which is particularly evident in the category of painting for which he is best known, the *fête galante*: a scene with a social gathering of elegantly costumed people in a parkland setting. He was born in Valenciennes and moved to Paris around 1702, where he trained with Claude Gillot and Claude Audran. He was admitted to the Académie in 1712 and finally submitted his reception piece in 1717, *Pilgrimage to the Isle of Cythera* (Musée du Louvre, Paris). In 1720, suffering from poor health, he went to live with the dealer Gersaint, for whom he painted in 1721 the celebrated shop sign *L'Enseigne de Gersaint* (Schloss Charlottenburg, Berlin).

Fêtes Vénitiennes is generally agreed to be one of Watteau's most important paintings and is the only one of his *fêtes galantes* in which the essential action relates to real people. The title by which it is now usually known first appeared in Laurent Cars's engraving, in reverse, of the picture which was announced in the *Mercure de France* in July 1732 and was included in the *Recueil Jullienne*, published in 1734. It was most probably derived by Jullienne or Cars from the opéra-ballet, *Les Festes Vénitiennes*, the music for which was by André Campra and the choreography by Antoine Danchet, which had recently been revived in 1731.

Although he was not responsible for its later title, the picture must have had a very personal meaning for Watteau. The dominant male figure on the left can be identified as Watteau's friend and fellow artist, the Franco-Flemish painter Nicolas Vleughels, with whom he shared a house in 1718–19, the period to which the picture is usually dated. The sickly-looking musette player on the right is now generally thought to be a self-portrait of Watteau. The object of the two men's affections is the female dancer in the centre foreground, who would appear to be the same woman, possibly an actress, who posed for

Love in the French Theatre of about 1716 (Gemäldegalerie, Berlin). The picture may illustrate some private risqué joke between Watteau and Vleughels, alluded to by the sexual shape of the musette, the voluptuous female statue, and the lascivious ram on the vase. The introduction of specific personalities only occurred at a later stage in the picture's execution: the heads of Vleughels and Watteau were painted over earlier, anonymous ones.

Watteau was a prolific draughtsman, and a total of twelve drawings can be associated with this composition, of which two are now lost but are known through engravings. As was his custom, he reused and adapted poses from earlier drawings.

The picture was known to be in the collection of the leading amateur and collector Jean de Jullienne, who had been Watteau's great patron and dealer, by about 1756. It was then owned by Paul Randon de Boisset, who had visited the Low Countries with Boucher, and who numbered Greuze and Hubert Robert among his artistic advisers. It later formed part of the collection of General John Ramsay the youngest son of the painter Allan Ramsay, and came to the Gallery as part of the 1861 bequest of Lady Murray of Henderland, in whose will it was engagingly described as a 'Burgomaster and Lady dancing by Watteau'. Today it forms part of the Gallery's distinguished holding of French eighteenth-century paintings, which includes important examples by Pater, Lancret, Chardin, Boucher and Greuze. MC

Oil on canvas, 55.9 × 45.7 cm (22 × 18 in)
Scottish National Gallery, Edinburgh
Bequest of Lady Murray of Henderland, 1861 (NG 439)

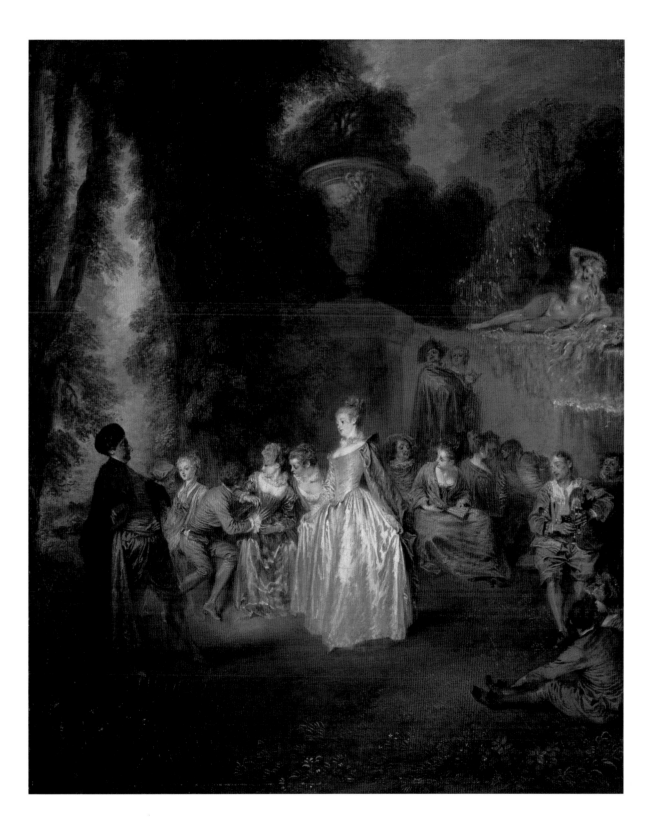

17 Thomas Gainsborough 1727–1788
River Landscape with a View of a Distant Village, about 1748–50

Admired for his delicate brushwork and rich sense of colour, Gainsborough was lauded by his rival Sir Joshua Reynolds as 'among the very finest of that rising name [the nascent English school of painters]'. While best known for his portraits, he also painted fine landscapes throughout his long career, deriving particular enjoyment from this work. A native of Sudbury, a provincial market town in Suffolk, south-east England, Gainsborough was the youngest of the nine children of John Gainsborough, a cloth merchant, and his wife, Mary, daughter of the Reverend Henry Burrough. Having already demonstrated a strong talent for drawing, at the tender age of thirteen he went to study in London with Hubert-François Gravelot and Francis Hayman and thus became associated with the circle of artists around the St Martin's Lane Academy (a precursor of the Royal Academy). On completion of this training, Gainsborough set up on his own, specialising in small landscapes in the style of Dutch seventeenth-century painters such as Jan Wijnants and Jacob van Ruisdael. In 1748, as a young man of twenty-one, he contributed one of eight roundels for the court room of London's new Foundling Hospital, alongside well-established painters such as William Hogarth.

Gainsborough is thought to have painted *River Landscape with a View of a Distant Village* soon after returning from London to Sudbury in 1748/9. Rich in incident and carefully composed, it reveals Gainsborough's first-hand knowledge of seventeenth-century Dutch landscapes combined with an appreciation of the fresh colouring and playful atmosphere of French Rococo art. The untypical format of Gainsborough's picture, being unusually wide and low, suggests that it may have fulfilled a decorative purpose within a domestic interior, probably serving as a 'chimney piece' above a fireplace. Gainsborough makes sophisticated use of this unusual format: roughly equal sections of the canvas, divided horizontally, are devoted to the depiction of land and sky; the bulky wooded outcrop on the left is offset by the panoramic landscape, with its flat, low horizon. An engaging series of motifs occupies the immediate foreground, from the blasted tree on the extreme left, to the dog on the landing stage, barking at two low-flying birds above the river on the right.

Gainsborough's debt to Dutch Golden Age landscape painting in *River Landscape with a View of a Distant Village* is evident, both in his use of features, such as the winding track, low horizon and dramatic clouds, and in the picture's overall effect. During the 1740s, London witnessed a dramatic influx of such paintings, by artists such as Wijnants, Meindert Hobbema and Ruisdael. In addition to an appreciation of Dutch art, Gainsborough's *River Landscape* reveals his strong feeling for his native Suffolk countryside; it was a landscape he had drawn repeatedly from an early age.

River Landscape with a View of a Distant Village has been in America before; it belonged to William H. Fuller of New York and also to James W. Ellsworth of Chicago during the 1890s and early 1900s. It was bought by the Scottish National Gallery in 1953, during a period when a number of important paintings entered the collection; they included the famous triple portrait by Gainsborough's contemporary Sir Joshua Reynolds, *The Ladies Waldegrave* (cat.22). When the Scottish National Gallery bought the picture, it was thought to be a view of Cornard Village in Suffolk; however, this identification is no longer accepted: the picture is not primarily topographical in nature but a 'work of fancy' or the imagination. The Scottish National Gallery also has a late landscape by Gainsborough, *Rocky Landscape*, of about 1783. In addition, it is home to *The Honourable Mrs Graham (1757–1792)* of 1775–7 (NG 332), a masterpiece of the sort of 'swagger' portraiture for which Gainsborough is best known. PA

Oil on canvas, 76 × 151 cm (29⅞ × 59½ in)
Scottish National Gallery, Edinburgh
Purchased 1953 (NG 2174)

18 Allan Ramsay 1713–1784
Margaret Lindsay of Evelick, Mrs Allan Ramsay (about 1726–1782), about 1758–9

Internationally acclaimed as Ramsay's consummate achievement as an incomparable painter of women, this ravishing likeness of his second wife epitomises the distinctive grace, refinement and naturalism of his mature style in female portraiture following his second visit to Italy in 1754. The eldest son of the poet Allan Ramsay, author of *The Gentle Shepherd* (1725), he had enrolled as a founder member of the Academy of St Luke in his native Edinburgh, aged sixteen. From 1736 successive study visits to Italy accelerated his transformation into a portraitist of European stature. In 1738, with no serious rivals in Britain, Ramsay established himself in London while also maintaining a studio and clientele in Edinburgh. The following year he married Anne Bayne, daughter of an Edinburgh law professor. But in 1743 she died in childbirth at the Ramsays' London residence.

The circumstances of Ramsay's second marriage, nine years after this bereavement, were to add immeasurably to the mystique surrounding his definitive portrait of his new young wife. During a return visit to Edinburgh in 1752 he eloped with the elder daughter of the Perthshire baronet Sir Alexander Lindsay of Evelick, a niece of the Lord Chief Justice Lord Mansfield. The marriage took place without the consent of the Lindsays who immediately severed all relations, deploring their daughter's conduct and the social inequality of this alliance.

The couple's sojourn in Italy from 1754 to 1757, accompanied by Margaret Lindsay's younger sister Katherine, marked a period of self-reinvention for Ramsay through renewed exposure to the work of Andrea del Sarto and Raphael and especially Domenichino, the supreme exponent of the gracefulness to which Ramsay himself aspired. The exquisite draughtsmanship honed in Italy reached its apogee in the present portrait of Margaret, completed about 1758 on returning to Britain. Far from posing formally, she has ostensibly been surprised in the everyday task of arranging flowers, a conceit reflecting the artist's evolving ideal of the 'natural portrait'. Complemented by the harmonious balance of the composition and the extreme delicacy of its execution, the predominantly pastel hues reveal Ramsay's emulation of the portraiture of Maurice-Quentin de La Tour and Jean-Étienne Liotard as well as Jean-Marc Nattier, another likely French model being Louis Tocqué. Margaret herself is expensively dressed in the height of French-style fashion – as appropriate to her husband's status by this time and his imminent engagement as court artist to George III.

Paradoxically, despite its current fame, this picture is a quintessentially private image. Probably painted for the artist's own pleasure and never publicly exhibited in his lifetime, it originally hung in his London house in Soho Square. Margaret's portrait eventually passed to her sister Katherine's husband Alexander Murray, Lord Henderland, and then to his younger son Lord Murray, Lord Advocate of Scotland. In 1832 Murray was appointed to the Board of Manufactures, the governing body of the Scottish National Gallery when founded in 1850. A year after the formal opening of the Gallery in 1859, his widow made a memorial gift of drawings as the foundation nucleus of the Scottish national graphic collections. This comprised both old master Italian drawings, mainly by Francesco Allegrini, and a superb cache of Ramsay drawings which is still the principal holding of his graphic oeuvre worldwide. Lady Murray's first benefaction was followed in 1861 by a sizeable bequest of her late husband's French and British paintings. Among them was a Reynolds of Margaret Ramsay's brother Sir David Lindsay of Evelick (NG 427). But the jewel of this bequest was, without question, Ramsay's peerless portrait of his beloved second wife. HS

Oil on canvas, 74.3 × 61.9 cm (29¼ × 24⅜ in)
Scottish National Gallery, Edinburgh
Bequest of Lady Murray of Henderland, 1861 (NG 430)

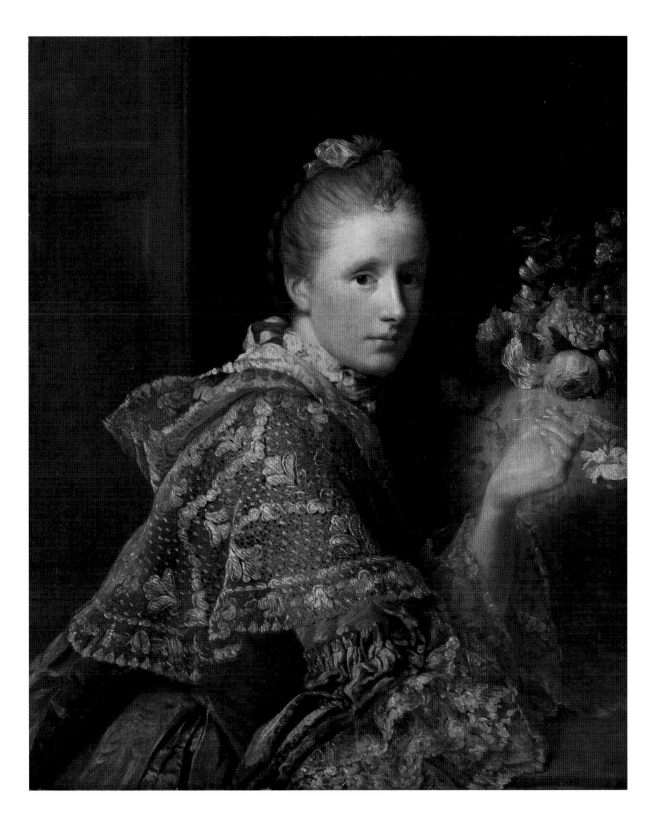

19 Jean-Baptiste Greuze 1725–1805
Girl with a Dead Bird, 1765

Greuze enjoyed a successful career as a painter of sentimental and melodramatic genre scenes. His ability to combine the delicacy of the Rococo with the morality of neoclassicism was admired by the critics, most notably Denis Diderot. Greuze trained in Lyon, and under Charles Natoire in Paris, before travelling extensively in Italy, where he absorbed the work of Correggio and Parmigianino. The ten years following his return from Italy were particularly successful and produced many masterpieces, including *A Marriage Contract* (Musée du Louvre, Paris) which caused a sensation at the 1761 Salon and demonstrated Greuze's ability to imbue a moralising subject with epic qualities. However, when he finally presented his reception piece to the Académie in 1769 he suffered the humiliation of not being accepted, as he had wished, as a history painter, but as a genre painter. Greuze exhibited at the Salon that year but thereafter effectively severed all links with the Académie until 1800.

This is the finest version of this subject by Greuze. It was exhibited at the Paris Salon in 1765, when Greuze was at the height of his career and represented that year by no fewer than thirteen works. The subject of a young girl weeping over the death of a bird would have greatly appealed to French eighteenth-century audiences, with their predilection for scenes that provoked an emotional response. Indeed, the picture was greatly admired by, among others, Diderot, who claimed a symbolic reference to the loss of virginity. He constructed an imaginary dialogue with the heartbroken girl: according to his fanciful interpretation, the girl had been visited by her lover (in her mother's absence) and had consequently neglected the little bird, which had died of starvation. Grief-stricken, she weeps over the bird's death and also at the possibility of abandonment by her lover.

More recently scholars have suggested that the picture illustrates a poem by the Roman poet Catullus, *De Passere mortuo Lesbiae*, which Greuze could have known from a

seventeenth-century translation. In the poem, the girl laments the demise of a sparrow, her dearest companion, and is thus confronted, for the first time, with the mystery of death. The poem evokes the young girl's loss of innocence, but the sexual undertone suggested by Diderot is absent.

The subject proved extremely popular and there are numerous copies in existence, many of them doubtless based on the reproductive print by Jean-Jacques Flipart, an impression of which was exhibited at the 1767 Salon. The painting or print may also have inspired other famous works of art as diverse as Sir Joshua Reynolds's various versions of *Girl with a Dead Bird*, and Jacques-Louis David's portrait of *Madame François Buron* (Art Institute of Chicago).

The painting's first owner was Alexis-Janvier de La Live de La Briche, sécretaire des commandements to Maria Leczinska, Queen Consort of France. La Live de La Briche was an important patron of modern French art and an early enthusiast of Greuze. The picture – like the Watteau (cat.16) – was subsequently in the collection of General John Ramsay and came to the Gallery as part of the 1861 bequest of Lady Murray of Henderland. F F

Oil on canvas (oval), 52 × 45.6 cm (20½ × 18 in)
Scottish National Gallery, Edinburgh
Bequest of Lady Murray of Henderland, 1861 (NG 435)

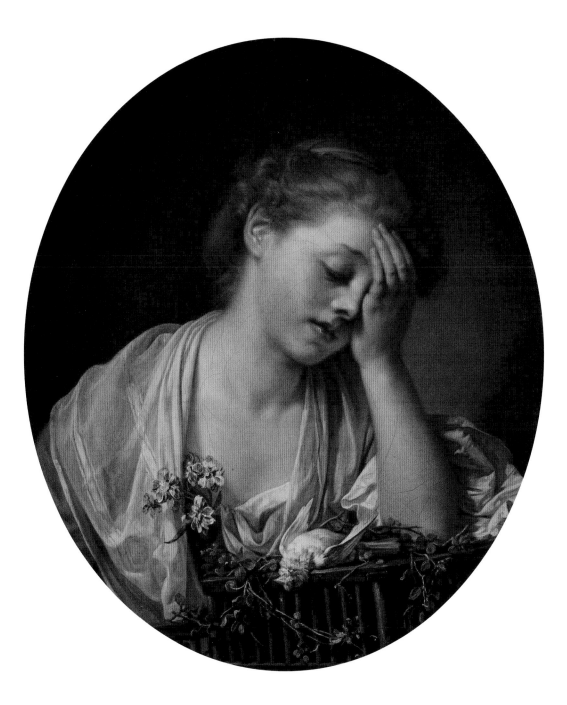

20 Thomas Gainsborough 1727–1788
John Campbell, 4th Duke of Argyll (about 1693–1770), 1767

Thomas Gainsborough was one of the greatest English portrait painters of the eighteenth century, and the only artist of his time who was able to emulate and even rival the success of Sir Joshua Reynolds. After an initial period of training in London, Gainsborough briefly returned to his native Suffolk to establish his career, before moving in 1759 to the fashionable spa town of Bath in search of wealthier and more prestigious patrons. It was the work of his Bath period that saw Gainsborough move beyond the charming but somewhat naïve artistic approach of his early portraiture and develop the highly distinctive painterly style upon which his artistic reputation rests.

Gainsborough's approach is epitomised in this portrait of the 4th Duke of Argyll, which is characterised by dense layers of feathery brushstrokes that, when viewed from a distance, combine to produce a brilliant evocation of the sitter and his lavish costume. The sumptuous ermine and velvet of Argyll's ducal robes, cloth-of-gold coat, weighty collar of the Order of the Thistle, and magnificent baton of his hereditary office of Master of the King's Household are all conveyed with equal brilliance. Gainsborough pursued these effects quite self-consciously, paying close attention to the distance at which such full-length portraits would be hung and subsequently viewed. Not only did he frequently combine two different viewpoints in a single work, setting his sitters at eye level whilst painting the background as if viewed from below, he is also known to have used brushes attached to sticks up to six feet in length and to have walked back and forth in front of his canvases to accurately gauge their effect from a distance.

Even more than the brilliance of the brushwork, however, it is Argyll's firm stance and resolute expression that make this portrait such a powerful image. They vividly convey the forceful personality of a man who, prior to inheriting his aristocratic titles in 1761, had pursued a successful military career. Unstintingly loyal to the Hanoverian dynasty, Argyll played an important role in suppressing attempts by the Jacobites to regain the British throne for the descendants of the deposed Stuart king, James II. In the aftermath of the 1745 Jacobite Rising, his determined efforts to capture Prince Charles Edward Stuart were unsuccessful, but led to the arrest of many Jacobite sympathisers.

The portrait almost certainly originated as a formal commission. Visits to a fashionable resort like Bath would have been de rigueur for a man like Argyll who, in spite of his soldierly mien, was known as a man of pleasure. Given his wealth and status, it would have been natural for Argyll to commission a portrait from Gainsborough, who had recently confirmed his status as Bath's leading portraitist by moving to new premises at the town's most fashionable address, the Circus. Argyll was evidently pleased by the result and retained the portrait in his own possession. The painting subsequently passed by descent to the 11th Duke of Argyll, at Inveraray Castle, before being purchased from the Argyll Estates by the Scottish National Portrait Gallery in 1953. LL

Oil on canvas, 235 × 154.3 cm (92½ × 60¾ in)
Scottish National Portrait Gallery, Edinburgh
Purchased 1953 (PG 1596)

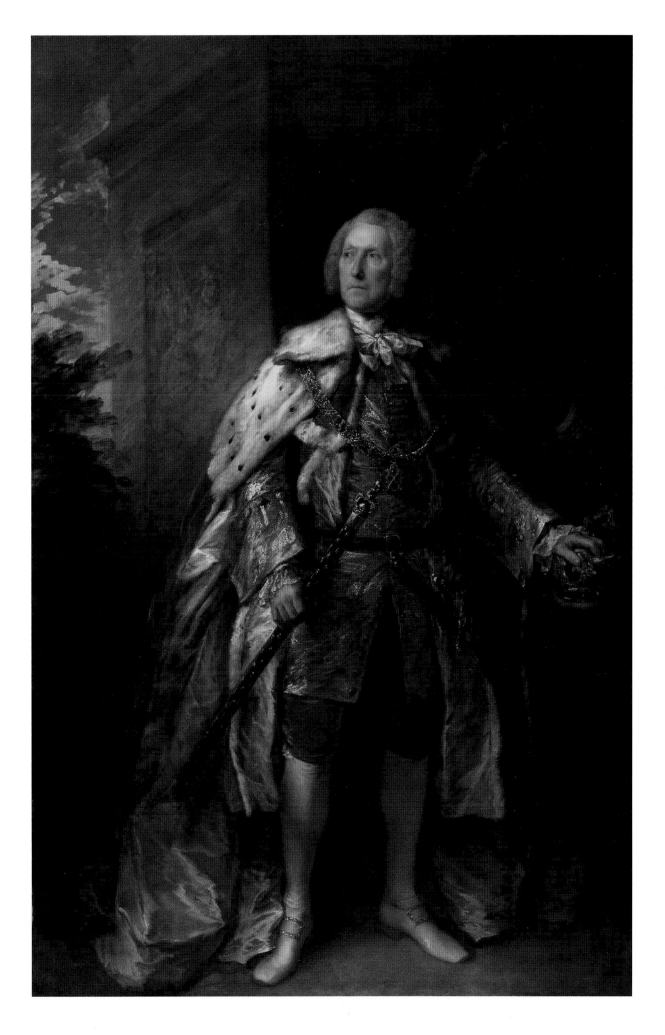

21 Francesco Guardi 1712–1793
The Piazza San Marco, Venice, about 1770–5

Guardi is the most famous Venetian view painter of the eighteenth century after Canaletto, by whom he was influenced. He appears to have turned his attention to topographical views (*vedute*) only in the 1750s, but there are few fixed points of reference to help establish his chronology. A canvas of *The Mardi Gras Festival in the Piazzetta*, in an Italian private collection, bears the date 1758 and is his only dated view painting. From its style it must be among the artist's earliest productions as a *vedutista*. Guardi had been active during the 1730s and 1740s as a figure painter, often in collaboration with his older brother Gian Antonio, who was probably his teacher. Francesco was certainly more talented as a landscapist than as a history painter, and the shift in his production enabled him to exploit the lucrative market for *vedute* established by Canaletto. Compared to the crystalline clarity and precision of the latter's mature works, Guardi's views of Venice are characterised by a more rapid and impressionistic touch, and a greater feeling for more transient effects of light and atmosphere. Like Canaletto, he certainly made use of a camera obscura for his topographical views, and he sometimes based his compositions on engravings after other artists, including Canaletto.

Guardi painted the Piazza San Marco, the hub of Venetian civic and religious life, repeatedly from various angles. The main market for these paintings lay with foreign tourists eager for a memento of this spectacular urban space. The Edinburgh painting, which probably dates from about 1770–5, shows the principal view of the square looking towards the façade of the Basilica of San Marco, its mosaics shimmering in the sunlight. Behind the *campanile* (bell-tower) is a glimpse of the Doge's Palace, while at the sides the view is framed by the receding arcades of the Procuratie Vecchie and Nuove, the former casting a strong shadow over much of the piazza. The scene is enlivened by traders, uniformed government officials and fashionably dressed tourists and promenaders,

all sketched in with a few deft strokes of the brush. Guardi depicts the *campanile* as slightly taller and slenderer than it is in reality, a peculiarity he seems to have adopted from Canaletto. A painting in the National Gallery, London, generally dated to about 1760, is probably the earliest of Guardi's numerous versions of this composition.

This is the largest and finest of the Gallery's five paintings by Guardi. It has recently been convincingly proposed that it originally formed part of a set of four classic views of Venice which were in the Caldwell collection at New Grange, County Meath, Ireland (or in the family's London house) from at least 1863 until their dispersal at auction in 1939. The other paintings in the series are *The Grand Canal with the Rialto Bridge from the South* in the San Diego Museum of Art, and two views now in a private collection in New York, the *Punta della Dogana with Santa Maria della Salute* and the *Isola di San Giorgio*. AWL

Oil on canvas, 55.2 × 85.4 cm (21¾ × 33⅜ in)
Scottish National Gallery, Edinburgh
Accepted by HM Government in lieu of inheritance tax and allocated to the Scottish National Gallery, 1978 (NG 2370)

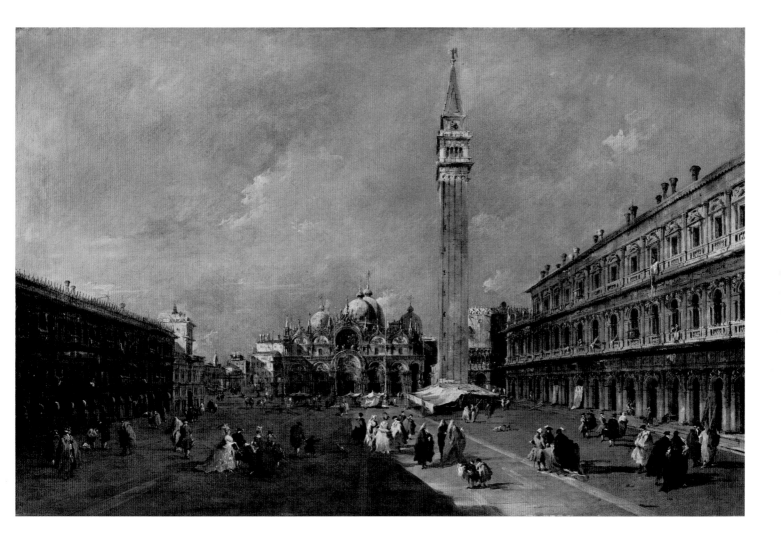

22 Sir Joshua Reynolds 1723–1792
The Ladies Waldegrave, 1780–1

Sir Joshua Reynolds was a major English portrait painter of the eighteenth century and first president of the Royal Academy. His aim was to raise the status of portraiture in Britain by painting in the 'grand manner' normally reserved for history paintings. By 1780, when he began this famous triple portrait, Reynolds could boast a highly successful career stretching back more than thirty years. He was born in 1723 in Plympton in the south-west of England. Settling in London from 1753, after an intensive period studying old master paintings in Italy and Paris, he spent the rest of his life in the English capital and was buried, with great ceremony, in St Paul's Cathedral.

The Ladies Waldegrave is one of Reynolds's best-known pictures, inspiring later artists such as Sir John Everett Millais with his painting *Hearts are Trumps*, 1872 (Tate, London). The work encapsulates Reynolds's aspirations for portraiture: although his sitters are dressed in fashionable white muslin and have elaborately dressed and powdered hair, the painting has a timeless quality. Reynolds achieved this by referencing the old master paintings and sculptures he revered. The colouring of the great swathe of silk drapery behind the eldest two sisters and of the upholstered chairs, together with the bright patch of sky in the upper right corner, owes much to Titian and Rubens. Together with Van Dyck, these artists also used imposing structural motifs such as stone columns and balustrades as a background for their figures. This approach is similarly deployed by Reynolds. The subtle allusion in *The Ladies Waldegrave* to the lithe interlocking figures of *The Three Graces*, one of the most celebrated works of ancient art, would not have gone unrecognised by classically educated viewers of the late eighteenth century.

The three young women – from left to right Lady Charlotte Maria, Lady Elizabeth Laura and Lady Anna Horatia Waldegrave – are shown collectively engaged in a refined handicraft: fine silk work. The eldest, who was aged twenty in 1780 and known simply as Laura, sits in the centre demurely winding silk thread. She is aided in this dainty pursuit by Maria (aged nineteen) on her right, while Horatia, at eighteen, the youngest of the three sisters, is working on a length of delicate silk lace stretched across a tambour frame. The combined effect is one of chaste and elegant feminine activity. While Laura and Horatia appear completely involved in their tasks, Maria has an alert expression on her face, suggesting her awareness of something happening outside the picture frame.

Reynolds's triple portrait was commissioned by the sitters' great-uncle, the celebrated antiquarian, connoisseur and critic, Horace Walpole. In 1782 Walpole is recorded as paying 300 guineas for the picture. It hung in the refectory at Strawberry Hill, Walpole's influential Gothic Revival villa located on the river Thames, at Twickenham, west of London. The three Waldegrave sisters were frequent visitors to Strawberry Hill. The clandestine second marriage of their mother Maria, a renowned society beauty, to the king's brother, the Duke of Gloucester, in 1766, resulted in her lengthy absence abroad. During this period, Walpole took an active interest in his great-nieces' welfare. They initially lived at Windsor after their mother's departure, near their aunt Mrs Keppel, but subsequently moved to Hampton Court Park within easy access of Strawberry Hill.

When *The Ladies Waldegrave* was exhibited at the Royal Academy in 1781, Walpole expressed his pleasure with Reynolds's finished painting. However, his opinion of the portrait changed as he spent more time with it. After Walpole's death the picture was bequeathed to his cousin's daughter, the sculptor Mrs Anne Seymour Damer. It was bought by the Scottish National Gallery in 1952, with the help of the Art Fund. PA

Oil on canvas, 143 × 168.3 cm (56¼ × 66¼ in)
Scottish National Gallery, Edinburgh
Purchased with funds from the Cowan Smith Bequest and with the aid of the Art Fund, 1952 (NG 2171)

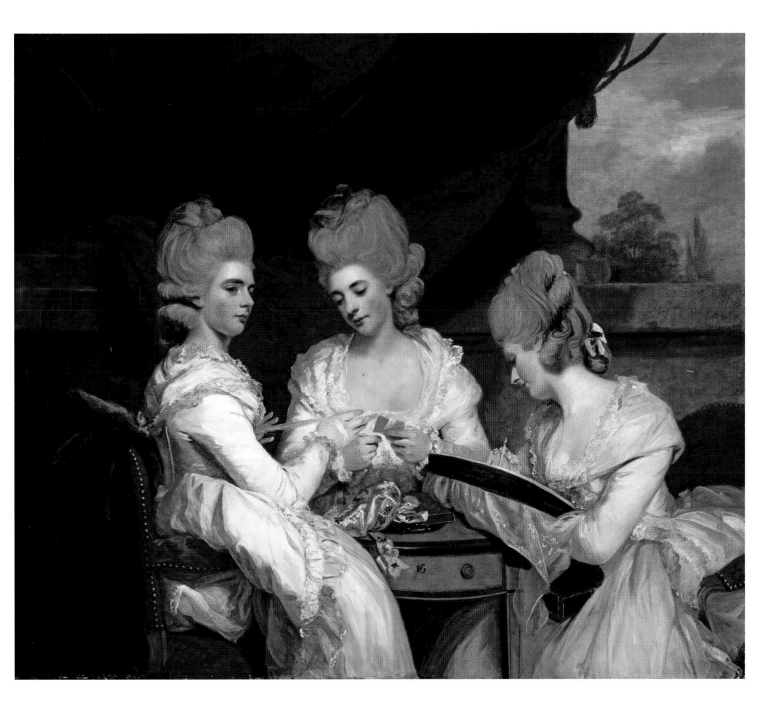

23 Sir Henry Raeburn 1756–1823
Reverend Robert Walker (1755–1808) Skating on Duddingston Loch, about 1795

This striking portrait of Robert Walker, minister of Edinburgh's Canongate Church and a leading member of the city's highly selective skating society, has come to be regarded as one of Sir Henry Raeburn's greatest works. Raeburn, the leading Scottish portrait painter of his time, was born in the village of Stockbridge, just outside Edinburgh, in 1756. Unlike most of his artistic peers, he received no formal artistic education, instead pursuing normal academic study before being apprenticed to a local goldsmith, James Gilliland, at the age of sixteen. Although the precise circumstances of his choice of career remain unknown, it is likely that he was introduced to the practice of painting portrait miniatures in Gilliland's workshop and, finding he possessed a natural talent for this work, then graduated to the full-scale oil portraiture for which he has become famous.

Raeburn's approach to painting reflected this unusual path into his profession. Avoiding the conventions and clichés of his contemporaries, his works were invariably based on close and accurate observation of the external world. He also eschewed the meticulous production of preparatory drawings and sketches characteristic of his academically trained peers, instead preferring to work straight onto the canvas with minimal formal planning. Whilst this approach invariably meant having to deal with compositional changes in the process of painting, it also enabled Raeburn to produce portraits that were unrivalled in their directness and spontaneity.

The modest scale of this image and the subject's dynamic pose are atypical of Raeburn's work, and for this reason its attribution has sometimes been doubted. Nevertheless, the painting includes many details that conform closely to the artist's working methods of the 1790s. Not only are there extensive pentimenti (compositional changes) visible around Walker's hat, but the sitter's face – in line with other full-size portraits from this period – has been reduced to a number of almost crystalline, abstract planes.

The picture's background, too, is characterised by the same economy, with the distant hills suggested by little more than a few deft brushstrokes. Such inventive spontaneity extends to the painting's foreground, where we find a dense network of hatched lines, scored freely into the paint surface to represent the grooves made by skaters on the ice.

It is, however, the painting's characteristically bold composition that is primarily responsible for its strong visual impact. Walker is shown in the midst of gliding across the icy surface of one of the small lochs near Edinburgh, his arms folded nonchalantly across his chest and his right leg lifted balletically behind him. The pose, overtly recalling the Renaissance sculptor Giambologna's famed statue of Mercury in flight, vividly evokes Walker's mastery of what had become an increasingly popular sporting activity among the city's social elite. The resulting image is at once the epitome of late-eighteenth-century elegance and a startling prefiguration of the modernistic concern with depicting movement.

Raeburn was a close friend of the Walker family, having been named as one of the nine trustees charged with looking after the minister's property upon his death in 1808. Walker's descendants cherished the tradition that Raeburn gave the picture to the sitter's widow, Jean Walker. Having passed first to her daughter, Margaret Scougall, it was eventually inherited by her great-granddaughter, Beatrix Scott. After being sold privately in 1926, it was offered for sale at auction in 1947, when it was bought by the National Galleries of Scotland at the instigation of its recently appointed director, Sir Ellis Waterhouse, the great scholar and connoisseur of eighteenth-century British painting. LL

Oil on canvas, 76.2 × 63.5 cm (30 × 25 in)
Scottish National Gallery, Edinburgh
Purchased 1949 (NG 2112)

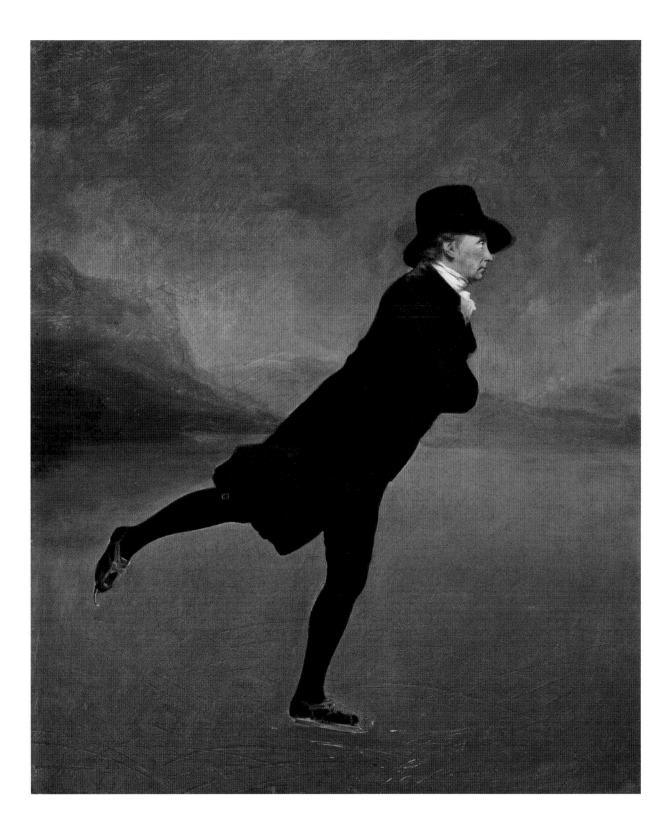

24 Sir Henry Raeburn 1756–1823
Sir John Sinclair of Ulbster, 1st Baronet (1754–1835), mid– to later 1790s

A devotee of elite portraitists, who also sat to Sir Thomas Lawrence and to Benjamin West, the internationally renowned American-born President of the Royal Academy in London, Sinclair began patronising Raeburn in the later 1790s when his reputation in Scotland was in the ascendant. In 1797 the death of Raeburn's former professional mentor David Martin consolidated the younger portraitist's dominance in his native Edinburgh and, by extension, the whole of Scotland. By 1799 his expanding business justified relocation to more capacious premises at 16 (now 32) York Place on the eastern margins of the Georgian New Town. This grand terraced house has retained in the first-floor studio the great north-facing windows installed by Raeburn and an intricate series of shutters designed to control the flow of light into the room during sittings. Of the six known Sinclair commissions, including a childhood portrait of Sir John's son and heir George (English Heritage, Iveagh Bequest, Kenwood) and a three-quarter-length portrait of Sir John himself of about 1810 (National Portrait Gallery, London), the later ones were probably all undertaken in this custom-built York Place studio.

Created a baronet in 1786, Sinclair was the prodigiously energetic head of an old Caithness landowning family, a cadet branch of the Sinclairs of Mey. From 1780 to 1811 he pursued a parliamentary career, and in 1793 he founded the British Board of Agriculture under the government of William Pitt the Younger – a venture which channelled Sinclair's commitment to agricultural improvement and innovation including the introduction of Cheviot sheep on his Caithness estates. Meantime, in 1790, he had instigated the compilation of the magisterial *First Statistical Account of Scotland* (1791–9), a twenty-one-volume parish-based socio-economic survey first mooted by the Society of Antiquaries of Scotland. In 1794, as hostilities with Revolutionary France escalated, he raised the Rothesay and Caithness Fencibles for home defence against possible invasion. Here, depicted as the regimental colonel, Sinclair is resplendent in a uniform of his own devising. The adoption of the trews, in government tartan, reflected his conviction that this was the most ancient and correct form of Highland dress in contradistinction to the kilt. In the same guise he posed for Benjamin West in 1798 for a full-length portrait now displayed in Wick Town Hall. This is thought to have influenced or been influenced by the conception of Raeburn's undated but nearly contemporary and iconic portrait.

Curiously in view of its calibre, the Gallery's portrait does not seem to have been exhibited within the lifetime of sitter or artist. Its first recorded public appearance was in 1863 in the Royal Scottish Academy's inaugural survey of historical and contemporary Scottish art, also featuring Nasmyth's *Princes Street with the Commencement of the Building of the Royal Institution* (cat.29) and held on the new Scottish National Gallery premises. In 1903 Sir John's portrait emerged on the London art market where the dealers Colnaghi ran up the bidding to 14,000 guineas, the second highest price hitherto achieved for a Raeburn. Auctioned again in 1909, it was restored to Sinclair family ownership by 1st Viscount Thurso and lent to the National Galleries of Scotland from 1910, initially for display at the Portrait Gallery. When a sale became inevitable, such was the concern about the risk of export – essentially to North America – that the Treasury was canvassed about a special grant to guarantee the Scottish National Gallery purchase in 1967. Since then the Galleries have been the proud custodians of the only two Raeburn full-length Highland dress portraits in public ownership in Britain. H S

Oil on canvas, 238.5 × 152.5 cm (93⅞ × 60 in)
Scottish National Gallery, Edinburgh
Purchased with the aid of a Treasury Grant, 1967 (N G 2301)

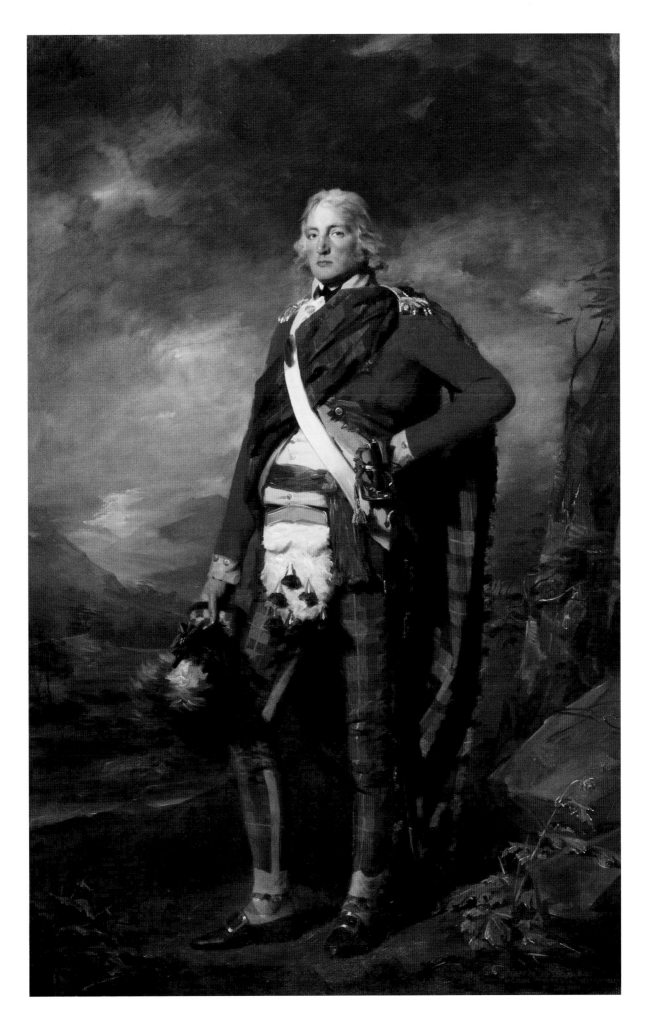

25 Sir David Wilkie 1785–1841
Pitlessie Fair, 1804

Of all the Scottish artists of the first half of the nineteenth century, Wilkie was unique in attaining genuine celebrity within his own lifetime – not merely in Britain itself but in Europe, largely courtesy of royal patronage and the wide circulation of reproductive engravings after his most sought-after pictures. In 1799 the precociously gifted son of the parish minister of Cults in Fife had entered the Trustees Academy in Edinburgh, founded in 1760 as an elementary drawing school. Following the introduction of oil painting into the curriculum in 1802, Wilkie embarked on his first major subject picture, a complex vernacular narrative 'portrait' of the annual May fair at Pitlessie village near his native Cults. On completing his formative studies, he returned home to Fife where he earned his living with portraits of the local gentry including the family of William Chalmers of Pitmeddan (in the Gallery's collection, NG 2433). And it was Fifeshire patronage, that of Thomas Kinnear of Kinloch, a landowning neighbour of Chalmers, which resulted in the crucial commission for *Pitlessie Fair* and the eventual reorientation of Wilkie's entire career. In 1805 he moved permanently to London, taking the picture with him as his artistic manifesto.

For immediate inspiration he had been able to draw upon the growing literary cult of the indigenous, folkloric and traditional aspects of Scottish life and the equivalent in painting in the work of David Allan, a former Master of the Trustees Academy, and Alexander Carse, one of whose watercolours of *Oldhamstocks Fair*, 1796 is in the Gallery's collection (D 4395). Wilkie's own composition displays an obvious affinity with village scenes by seventeenth-century Flemish and Dutch genre painters such as Teniers the Younger and Adriaen van Ostade, a pictorial tradition probably familiar to him through engraving and similarly adapted and customised by other Scottish near-contemporaries. Although lacking in integration, Wilkie's vivid human panorama represents a complete cross section of Fifeshire rural society, many individuals being actual parishioners whom the artist had secretly sketched in church. Lending itself to the multiplication of sub-plots and incidental detail, the essential subject also revealed the artist's aptitude for portraying psychological interaction between diverse groups – a distinguishing feature of his later work which was emulated, with very variable results, by the majority of his many followers.

However experimental, *Pitlessie Fair* marked a radical and ultimately extremely influential departure from the prescribed conventions of history painting in the grand manner. Once seen by the Earl of Mansfield, it generated a commission for *The Village Politicians* (Scone Palace, Perth). This drew prodigious crowds at the Royal Academy exhibition of 1806 and, in the estimation of Wilkie's fellow artist Benjamin Robert Haydon, revolutionised British genre painting. This phenomenal success encouraged him to mount a private promotional retrospective in Pall Mall in 1812, including *Pitlessie Fair*. And the precedent of his meteoric rise to fame lured other Scottish painters to London over at least two generations. Among them was Raeburn who, in 1810, was fêted by Wilkie in London when contemplating a permanent relocation.

In gratitude to Thomas Kinnear, who had paid over the artist's initial asking price, Wilkie presented him with two small oil studies for another early subject picture. *Pitlessie Fair* remained a Kinnear family heirloom until sold to the Gallery in 1921, after being lent at various times from 1874. It is one of a trio of highly important Wilkie oils in the Gallery's possession, the other two being *The Letter of Introduction*, 1813 (NG 1890) – one of the most frequently copied and imitated British paintings of the nineteenth century – and *Distraining for Rent*, 1815 (NG 2337). HS

Oil on canvas, 61.5 × 110.5 cm (24¼ × 43½ in)
Scottish National Gallery, Edinburgh
Purchased 1921 (NG 1527)

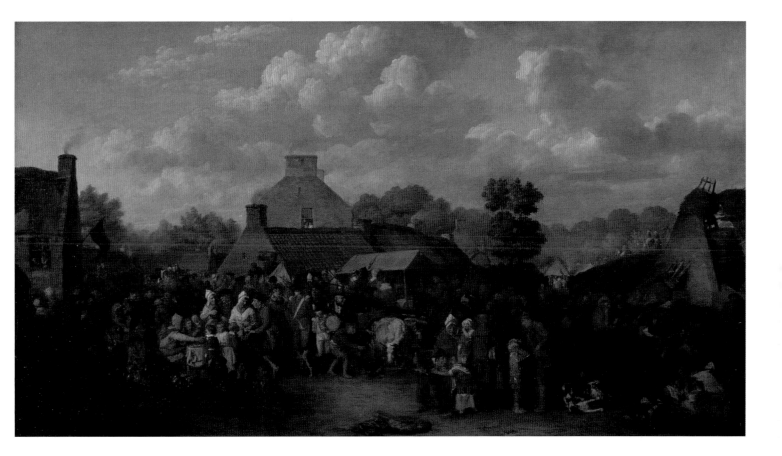

26 Sir David Wilkie 1785–1841
Self-Portrait, about 1804–5

This broodingly intense self-portrait is the earliest, and arguably the most important, of six surviving Wilkie self-portraits. The painting can be dated with some confidence on the basis of a pencil sketch of the hands, which features on the reverse side of a sheet containing several other preparatory drawings (Scottish National Gallery D 4893). As these appear to relate to Wilkie's first major genre scenes, *Pitlessie Fair* of 1804 and *The Village Politicians* of 1806, we can be fairly certain that the artist undertook this self-portrait at around the same time. This was the period when he decided to leave Scotland in order to seek the greater opportunities, in terms of both training and professional reputation, offered by London. He arrived in the city in May 1805, where he was first informally attached, and then formally enrolled, in the Royal Academy schools. Little more than a year later he had his first great critical and popular success when *The Village Politicians* was shown at the Royal Academy exhibition of 1806.

Wilkie's *Self-Portrait* is a strikingly self-revelatory image of the young and ambitious, but deeply serious, artist at this critically important transitional phase of his career. Still working with an approach to lighting and composition strongly influenced by Raeburn, Wilkie has skilfully deployed almost abstract brushwork to create vivid contrasts of light and shade. His fashionably tousled reddish hair and brown jacket emerge subtly from the similarly toned background, together creating a subdued setting against which the artist's intensely illuminated face and shirt front stand out sharply. There is little sense that he was inclined to flatter himself, with his strong features rendered with such vividness that the artist's presence seems almost tangible. Gazing straight out at the viewer, just as he would have seen himself reflected in the mirror, his face is strongly and realistically modelled. An impression of intense concentration is simply but effectively conveyed by the slight frown that fixes his forehead, marked by two touches of shadow over his left eyebrow. His hands, almost lost in the shadows, grip a portfolio and his pencil holder. Together, they make clear reference to his chosen vocation, and perhaps also to the practice of drawing, the central discipline of his academic training and, according to contemporary aesthetic theory, the foundation of all true artistic achievement. The resulting image more than holds its own against similar works by Raeburn's most important contemporaries, including Turner's slightly earlier self-portrait of about 1799 (Tate Britain), of which it is uncannily reminiscent.

Whilst the portrait's early history remains somewhat obscure, it is thought that it was given by Wilkie to the eminent physician and courtier, Sir William Knighton, who appears to have acquired it shortly before 6 July 1833. Upon Knighton's death in 1836, the portrait then passed to his son, Sir W. W. Knighton, who had been a pupil of Wilkie. It remained in his collection until its sale on 23 May 1885, when it was bought by the London dealer Agnew's. It was then sold to the private collector Robert Rankin, whose brother John Rankin finally gifted it to the Scottish National Portrait Gallery in 1898. LL

Oil on canvas, 76.5 × 63.5 cm (30⅛ × 25 in)
Scottish National Portrait Gallery, Edinburgh
Gifted by J. Rankin in 1989 (PG 573)

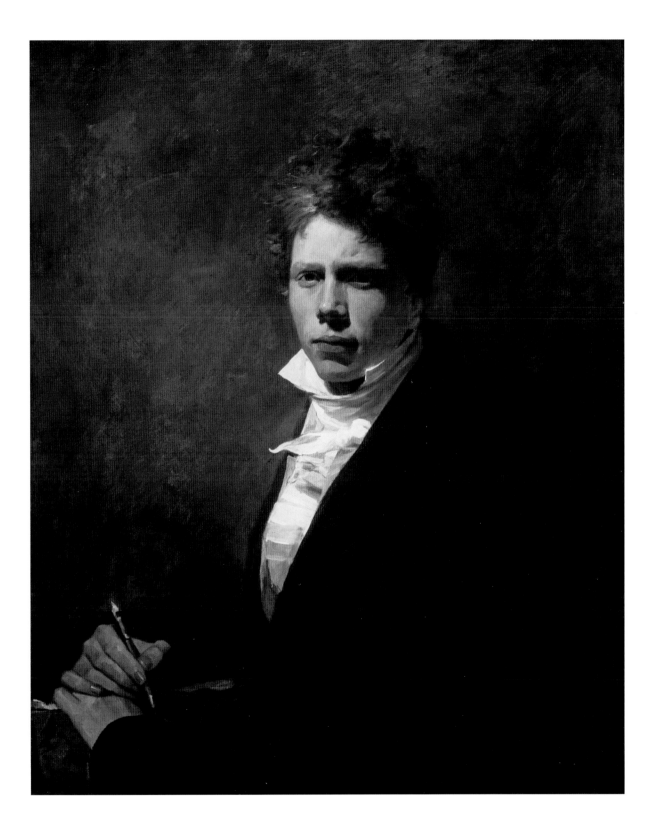

27 Sir Henry Raeburn 1756–1823
Colonel Alastair Ranaldson Macdonell, 15th Chief of Glengarry (1771–1828), about 1812

By 1810, when he reconnoitred in London with a view to taking over John Hoppner's former studio, Raeburn was the doyen of contemporary Scottish portraitists. Although he soon decided against a permanent relocation, he maintained a strong metropolitan profile, courting southern patronage by exhibiting annually at the Royal Academy, London, until his death in 1823. His loyalty to the Academy, where he had made his London debut in 1792, was rewarded with election as Associate in 1812 and Academician in 1815. Back in Scotland, he was lionised as 'the first Scottish portrait painter of eminence who settled in his native country'.

At the Academy's annual exhibition of 1812, Raeburn's principal contribution was this flamboyant full-length portrait of Macdonell of Glengarry, commissioned for the sitter's hereditary seat at Invergarry Castle in Inverness-shire. The epitome of anachronistic and atavistic Highland chieftainship, this is a statement picture – arguably as much about the artist's own status as that of his quixotic patron. But Raeburn's composition may well have been conceived as a pendant to Angelica Kauffman's equally monumental Highland dress portrait of Macdonell for which he had posed in Rome in 1800 while on the Grand Tour of Europe. Both portraits post-dated the repeal in 1782 of the Disarming Act (1746) outlawing the wearing of the tartan. With the sole exception of Highland regiments serving in the British army, this prohibition had been universally imposed after the failed Jacobite Rising of 1745.

Descended from the Lords of the Isles and a scion of Clan Donald, Macdonell inherited the Glengarry chieftainship in 1788. Like Sir John Sinclair of Ulbster, he raised a regiment (the Glengarry Fencibles) for the British Crown in 1794 at a time of national crisis occasioned by the French Revolutionary wars. Even in his maturity, however, the impulsive and autocratic Glengarry was paradoxical. A member of the Highland Society of London from 1797 and a passionate advocate of a vanishing Highland way of life and social structure, he retained a family bard and travelled with a 'tail' of clansmen. Yet he reneged on promises to resettle his disbanded Fencibles, forcing many into emigration to Canada, and evicted other tenants to clear his lands for sheep farming.

A British patriot despite his Jacobite ancestry, Glengarry was the probable inspiration for the character of the doomed Jacobite chieftain Fergus McIvor in the novel *Waverley* (1814) by Sir Walter Scott, a personal friend. Whether Macdonell posed at Invergarry or, more plausibly, under the controlled lighting of the artist's Edinburgh studio, his complex self-image is reflected in his melodramatic demeanour and telling accessories – from the powder horn, studded targe (shield) and basket-hilted sword of a bygone era to the hunting rifle of a modern sporting aristocrat devoted to deerstalking and the preservation of the Scottish deerhound.

Recognised within Raeburn's lifetime as one of his finest achievements and later as one of the defining historic British images of Highland chieftainship, this charismatic picture has fascinated artists and writers with its elusive combination of restraint and composure, panache and bravura, overlaid with almost palpable nostalgia. Raeburn's magnificent earlier Highland icon *Sir John Sinclair of Ulbster* (cat.24), dating from the turn of the eighteenth century, was on continuous loan to the National Galleries of Scotland from 1910, but did not become available for public purchase until 1967. This surely had a bearing on the Trustees' resolve to purchase the Macdonell portrait outright in 1917, the vendor being the sitter's great-grandson John Alister Erskine Cunninghame of Balgownie. H S

Oil on canvas, 241.9 × 151.1 cm (95¼ × 59½ in)
Scottish National Gallery, Edinburgh
Purchased 1917 (NG 420)

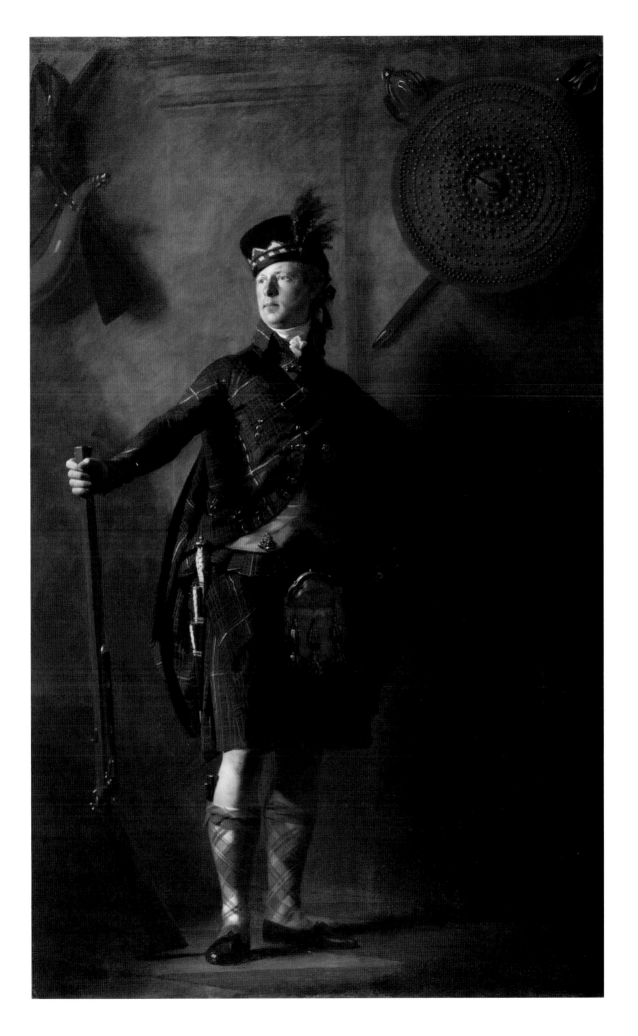

28 Camille Corot 1796–1875
Ville-d'Avray: Entrance to the Wood, about 1825, with later retouching

Corot is a key linking figure between the neoclassical landscapes of the early nineteenth century and the Impressionists. He received a conventional academic training under Jean-Victor Bertin and Achille-Etna Michallon and was particularly inspired by a period in Italy from 1825 to 1828, when he sketched in oil, painting subjects directly from nature. From the 1850s onwards, however, he developed a greyer, more diaphanous style where the emphasis is more on poetry than on naturalism. These later works were enormously popular with collectors in France and Britain, but it was the earlier oil sketches that had the greatest impact on the Impressionists.

This charming view was made at Ville-d'Avray, a small town to the west of Paris where Corot's parents had a modest country house with grounds. The picture features one of the roads that run down to the ponds at Ville-d'Avray. The semi-parkland scenery of that area recurs in Corot's oeuvre throughout his career and the painting resembles in handling other early works produced just before the trip to Italy, such as *Le Petit Chaville* (Ashmolean Museum, Oxford) and *Ville-d'Avray, The Cabassud Houses* (Musée du Louvre, Paris). The picture is remarkable for its fresh, airy atmosphere and keen observation of light and shade, giving the distinct impression that it was executed out of doors.

We know from infra-red examination, and from a painted copy of the picture that is now in the Göteborgs Konstmuseum, Gothenburg, Sweden, that there was originally a small thatched cottage in the mid-distance on the left side of the road and, on the right, a standing peasant woman with a cow. The picture was retouched around 1850, at least in part by Corot's artist friend Narcisse Diaz de la Peña, who chose the red cap of the seated woman as a bold complementary note to the range of greens. Corot's own retouches are also discernible in many areas of the foliage, particularly in the right and left foregrounds. In their delicate style and colouring these areas resemble works of around 1850 such as *Morning, Dance of the Nymphs* (Musée d'Orsay, Paris). They are carefully blended, however, with the original, freshly observed brushwork and colouring of the 1820s.

The picture's first owner was Alfred Sensier, a senior civil servant and friend of many of the major Barbizon painters. Sensier was a prolific author, publishing works on, among others, Georges Michel, Jean-François Millet and Théodore Rousseau. He became acquainted with Corot in the 1850s and it was presumably around this time that he acquired this picture. The first cataloguer of Corot's work, Alfred Robaut, records that Sensier was already the owner of the painting when the retouches were made:

M. Sensier, who owned the painting, was witness to the transformation. One day he was in Corot's studio at the same time as Diaz. The latter had criticised the execution of the cow (the painting was still as it appears in the copy) and Corot said to him, 'Well then, redo it yourself.' Diaz took the palette and replaced the animal with a second, seated, female figure. M. Sensier added that various details on the left of the picture had also been modified in his presence.

After Sensier's death in 1877 the picture was bought by the influential Paris dealer Georges Petit, an important patron of the Impressionists, who kept it in his private collection until his death. It was acquired by the Stettiner Gallery, Paris, from Petit's sale in 1921 and was subsequently owned by the London dealer Paul E. Cremetti, from whom it was acquired by the Gallery. F F

Oil on canvas, 46 × 35 cm (18⅛ × 13¾ in)
Scottish National Gallery, Edinburgh
Purchased with the aid of A.E. Anderson in memory of his brother Frank, 1927 (NG 1681)

29 Alexander Nasmyth 1758–1840
Princes Street with the Commencement of the Building of the Royal Institution, 1825

This fascinating city prospect is an outstanding example of the mature work of Nasmyth, whom Sir David Wilkie revered as 'the founder of the landscape painting school of Scotland'. The son of a local master builder who contributed to the construction of the Georgian New Town of Edinburgh, Nasmyth was highly unusual among his compatriot easel painters in pursuing a sideline in architecture, landscape and garden design and civil engineering. Throughout the 1790s he perfected the genteel conversation piece combining group portraiture with a naturalistic landscape or interior setting, a genre introduced to Scotland by David Allan during the previous decade. Nasmyth's most influential type of landscape painting evolved concurrently – large-scale panoramic views of Scottish mansions and castles in which topographical accuracy was qualified by a distinctive picturesque sensibility.

In 1815 he was invited to devise proposals for furthering the eastern extension of the New Town. In this spectacular panorama of Edinburgh's main thoroughfare, executed ten years later, Nasmyth celebrates the dynamic transformation of the city itself and its burgeoning cultural life at a dramatic and propitious stage of transition. From a vantage point at the junction of Hanover Street and Princes Street, the artist's outlook encompasses both the late medieval Old Town on the right and the neoclassical New Town on the left, with an extended vista towards Arthur's Seat and the Nelson Monument on Calton Hill. On the right, emerging from a building site on the artificial earthen Mound which linked the two sectors of the city, is the Doric temple to the arts opened in 1826. This was commissioned from one of the leading architects of the New Town, William Henry Playfair, who is probably the frock-coated figure addressing the masons in the right foreground of the picture.

Originally named the Royal Institution to commemorate George IV's visit to Edinburgh in 1822,

Playfair's multi-purpose temple first served as the venue for pioneering exhibitions of old master and contemporary Scottish painting staged by the Institution for the Encouragement of the Fine Arts in Scotland. In addition, the new building housed the Trustees Academy (the ancestor of Edinburgh College of Art) and eventually the Royal Scottish Academy formed in 1826. Playfair went on to design the adjacent Scottish National Gallery of which the foundation stone was laid in 1850 – a development fully vindicating the excited optimism which pervades this picture.

Completed in the year of Nasmyth's admission as an Associate Artist of the Institution, this magnificent picture was launched at the Royal Academy in London in 1826, accompanied by his similarly ambitious *View of Edinburgh from the Calton Hill* (Clydesdale Bank plc). *Princes Street* next reappeared in the public domain in the Royal Scottish Academy's inaugural survey exhibition of historical and modern Scottish art in 1863. This was mounted in the new Playfair-designed building on The Mound which the Academy then shared with the fledgling National Gallery, opened in 1859. Lent to the 1863 exhibition by Sir David Baird, 3rd Baronet, of Newbyth in Haddingtonshire, together with three other important Nasmyths, *Princes Street* remained in family possession until 1991. Following its loan to the Gallery in 1987, it was finally gifted outright in 1991 by the late Sir David Baird, 5th Baronet, in an act of exceptional generosity. The most significant Edinburgh cityscape in the National Galleries of Scotland, *Princes Street* is of unique importance for an understanding of the development of art and taste in early nineteenth-century Scotland. HS

Oil on canvas, 122.5 × 165.5 cm (48¼ × 65⅛ in)
Scottish National Gallery, Edinburgh
Presented by Sir David Baird, 5th Baronet, of Newbyth, 1991 (NG 2542)

30 John Constable 1776–1837
The Vale of Dedham, 1827–8

Constable created what now seem to be inevitable, archetypal depictions of the English countryside. He was, however, in the context of the early nineteenth century, a revolutionary artist who evolved a bracing devotion to the study of the natural world which excited his contemporaries but was slow to be fully appreciated. His father owned a mill at East Bergholt, a village in the Vale of Dedham, in Suffolk, about sixty miles north-east of London. Constable felt a profound affinity with the surrounding countryside, which he had explored since his boyhood, and it became a principal subject of his art and the focus of this mature masterpiece.

Constable acquired knowledge of the grand tradition of European landscape painting from key contacts made in the London art world early in his career. The collector Sir George Beaumont allowed him to study pictures he owned, including works by Claude Lorrain, the most revered of old master landscape painters; and the artist and antiquary John Thomas Smith provided some practical instruction. In March 1799, Constable entered the Royal Academy schools, where he enjoyed the confidence of Benjamin West, the Academy's American-born president. For the next eight years he tested various approaches to landscape painting, drawing on the art of Claude Lorrain and Thomas Gainsborough among others. It was not until about 1809 that he started to focus exclusively on the approach that would define his career and reputation – depicting with extraordinary freshness the English rural scenes he revered.

The Vale of Dedham was painted around 1827–8. Its composition is broadly indebted to that of Claude Lorrain's *Landscape with Hagar and the Angel* (National Gallery, London) which he had first studied in May of 1802 in the collection of Sir George Beaumont. A combination of two events probably prompted Constable to paint this work. Firstly, the death on 7 February 1827 of Beaumont; and so the creation of Constable's painting might reasonably be considered a memorial act. Additionally, in October of that year the artist spent a month's holiday at East Bergholt and was able to re-acquaint himself with the surrounding landscape which had become the key stimulus to his art.

The Vale of Dedham invites close exploration of its richness of detail and texture. It shows the river Stour, looking eastwards, from Gun Hill near Langham. In the middle distance is Stratford toll bridge. Beyond the bridge, the tower of Dedham Church forms a focus for the composition. On the edge of the estuary in the distance, the villages of Manningtree and Mistley are suggested with silvery light glinting on the water. Beyond the cornfield at the right the roof of a cottage with a smoking chimney is shown. In the foreground, nestled in the heart of this benign, animated landscape, a woman cradles a child by a fire, over which a cooking pot is suspended; a temporary shelter is placed to her left. The horizon lies just below a point halfway up the canvas, and so the majority of the composition is given over to a brilliantly evoked, blustery skyscape; the sheets of rain falling over the low hills at the left are especially masterly. Details such as this retain all the freshness of Constable's oil sketches executed before the motif, even though the whole work is a studio creation: it was painted in London. It is essentially a grand, carefully calibrated memory and celebration of a landscape the artist had known intimately since his childhood.

The Vale of Dedham was exhibited at the Royal Academy's Summer Exhibition. It was acquired by the Scottish National Gallery during the Second World War and must have seemed an especially appropriate purchase at a moment when the Romantic idyll it represents was so alarmingly threatened. C B

Oil on canvas, 145 × 122 cm (57¼ × 48 in)
Scottish National Gallery, Edinburgh
Purchased with funds from the Cowan Smith Bequest and with the aid of the Art Fund, 1944 (NG 2016)

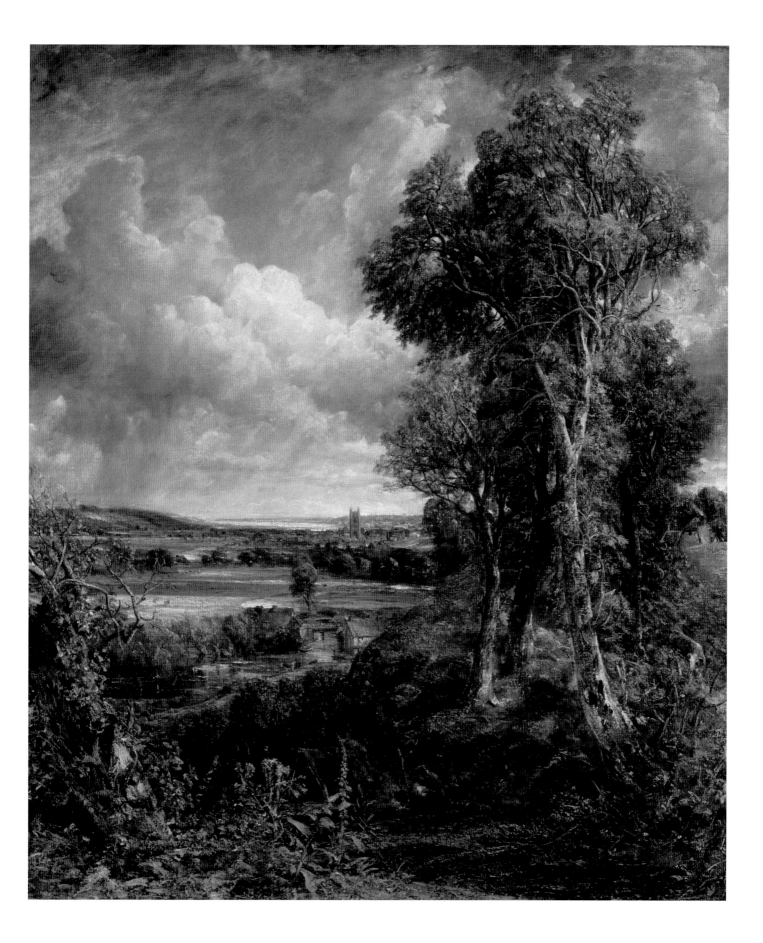

31 William Dyce 1806-1864
Francesca da Rimini, 1837

Born in Aberdeen, Dyce was one of the most artistically and intellectually gifted of the many nineteenth-century Scottish painters who migrated to London in quest of greater scope and international prestige. His polymathic range of interests encompassed medicine, musicology, geology and ecclesiology. By vocation a religious and subject painter and eventually the most competent British practitioner of fresco, he earned his living in the 1830s as a successful Edinburgh portraitist. In 1837, while teaching at the Trustees Academy, he published an influential letter/tract on the reform of Scottish art education. This immediately secured his appointment as superintendent of the new Government Schools of Design at Somerset House in London.

Dyce himself regarded *Francesca da Rimini* as the supreme achievement of his years in Edinburgh, as did many contemporaries. Completed in 1837, the picture illustrates an episode from *L'Inferno*, the first part of Dante's epic poem *La Divina Commedia*. Guido da Polenta has promised his beautiful daughter Francesca in marriage to the crippled Giovanni da Malatesta (known as Gianciotto or Giovanni the Lame), eldest son of his enemy the master of Rimini. But Francesca has rashly fallen in love with the younger son Paolo on his marrying her as proxy for his brother. The tragic couple are surprised by the jealous Gianciotto who was originally seen on the far left of the picture, creeping up with dagger in hand and murderous intent. In Dante's narrative the spirits of the adulterous lovers are trapped in an eternal whirlwind in the second circle of hell. A relatively unusual subject in British Romantic painting of the 1830s, it was more popular on the Continent where Jean-Dominique Ingres, Eugène Delacroix and the Austrian Joseph Anton Koch were among the leading artists to focus on the same moment of extreme emotional intensity. Being convinced that Dante's version of the story would be unfamiliar to some Royal Scottish Academy exhibition visitors in 1837, the erudite Dyce provided an explanatory text for the exhibition catalogue based on a commentary by Boccaccio.

The year 1834 witnessed the formation of the Royal Association for the Promotion of the Fine Arts in Scotland, the earliest of the British art unions. Funded by membership subscription, RAPFAS was one of the historical prototypes for the present-day Art Fund and played an equally transformative role in the development of the Gallery's collections. Purchased from the 1837 Royal Scottish Academy exhibition as one of RAPFAS's first important investments, the Dyce was awarded by membership prize lottery to an Edinburgh lawyer, later a sheriff-substitute in the artist's native Aberdeenshire. On Dyce's death in 1864, the Academy solicited a sale as a memorial tribute to one of its most distinguished honorary members – despite concerns about cracking paint layers on the left of the composition. In 1882, on the advice of Noel Paton (cat.32), the left edge of the canvas was trimmed. Of the malevolent figure of Gianciotto, nothing remained other than a disembodied hand which thus became, quite fortuitously, a powerfully suggestive dramatic device.

In 1910 this great picture was transferred to the Scottish national collections together with other significant art property acquired by the Academy. In exchange, the Academy was granted indefinite tenancy of the newly refurbished Royal Institution building on Princes Street whose construction in the 1820s had been so spectacularly commemorated by Alexander Nasmyth (cat.29). The Gallery now has the most comprehensive holdings of Dyce's work outside Aberdeen Art Gallery, and *Francesca da Rimini*, displayed at The Mound since 1864, is one of the National Galleries' most sought-after nineteenth-century British paintings. HS

Oil on canvas, 142 × 176 cm (55⅞ × 62¼ in)
Scottish National Gallery, Edinburgh
Purchased by the Royal Scottish Academy, 1864; transferred and presented, 1910 (NG 460)

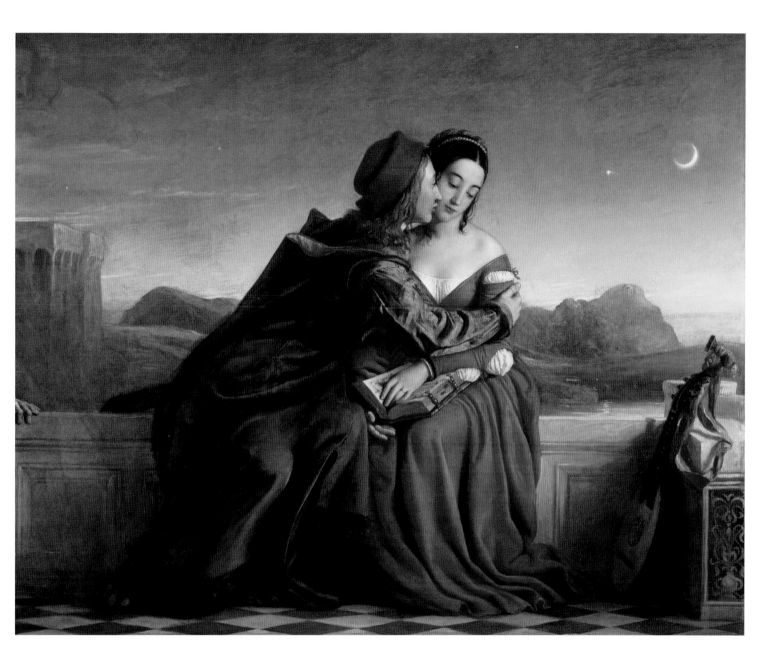

32 Sir Joseph Noel Paton 1821–1901
The Reconciliation of Oberon and Titania, 1847

Of the three distinguished artists born into the family of the Dunfermline damask designer Joseph Neil Paton, the figure painter Joseph Noel (known as Noel) was the most high profile, being appointed Queen's Limner for Scotland in 1866 and receiving a knighthood in 1867. His two surviving siblings were the monumental sculptor Amelia Robertson, second wife of the Royal Scottish Academy secretary and calotype photographer David Octavius Hill, and Waller Hugh, who became a prolific and sought-after landscape painter. A fellow student and friend of Millais's at the Royal Academy schools in London, Noel Paton's first major success came in 1845 as a prizewinner in the Westminster Hall national competitions for the decoration of the new Houses of Parliament which replaced the original buildings destroyed by fire in 1834. But it was Paton's participation in the 1847 competition which brought him to the attention of the Prince Consort as president of the Royal Commissioners overseeing the whole project – a connection which would ultimately attract the enduring favour and patronage of Queen Victoria herself.

Paton's tentative experiments with fairy motifs in the early 1840s were the prelude to what he evidently perceived as the career opportunity of a lifetime. One of the prescribed themes in 1847 being Shakespearian, the choice of *A Midsummer Night's Dream* provided the perfect opportunity to create a masterpiece of fantasy, *The Reconciliation of Oberon and Titania* being ostensibly presented as an allegory of harmonious government and a prosperous kingdom. The dispute between the fairy king and queen over the orphaned Indian changeling boy, raised by Titania but claimed by Oberon as his page, would become the subject of a pendant picture *The Quarrel of Oberon and Titania* (see fig.6), in 1849. Acclaimed as the picture of the season at the Royal Scottish Academy's 1850 exhibition, this was purchased by the Royal Association for the Promotion of the Fine Arts in Scotland for

eventual presentation to the Scottish National Gallery (NG 293) and has long been recognised as a consummate example of Victorian fairy painting. For *The Reconciliation*, which impressed the Commissioners with its skilled draughtsmanship and quasi-Pre-Raphaelite detail, Paton received a prize. But the hoped-for State commission and attendant prestige, which several other Scottish contemporaries also courted in successive Westminster competitions, eluded him on this occasion.

In Scotland *The Reconciliation* made its public debut at the annual exhibition of the Scottish Academy in 1847, Paton subsequently being elected an Associate member. The King of Belgium was pre-empted in his desire to own the picture by the Academy which had already secured it for its embryonic holdings of contemporary Scottish art, complementing the diploma works submitted as a condition of membership. From about 1829, when it began collecting, the Academy rapidly superseded the Royal Institution as the most vigorous and influential institutional champion of modern Scottish art. The nationally representative aims of the Academy's collecting were reflected in the inaugural displays of the Scottish National Gallery in 1859: in the Playfair-designed building then shared by both organisations, over half of the paintings were Academy property. Among them was Paton's *The Reconciliation* which, in 1910, would be transferred into the outright public ownership of the Gallery. Also on view was *The Quarrel* in which an enraptured Lewis Carroll, the author, counted 165 fairies. The phenomenal popularity of both pictures, which soon had to be glazed due to fingertip exploration by the visiting public, is now truly international and they are widely (if disputably) regarded as Paton's signature works. HS

Oil on canvas, 76.2 × 122.6 cm (30 × 48¼ in)
Scottish National Gallery, Edinburgh
Purchased by the Royal Scottish Academy, 1848; transferred and presented, 1910 (NG 294)

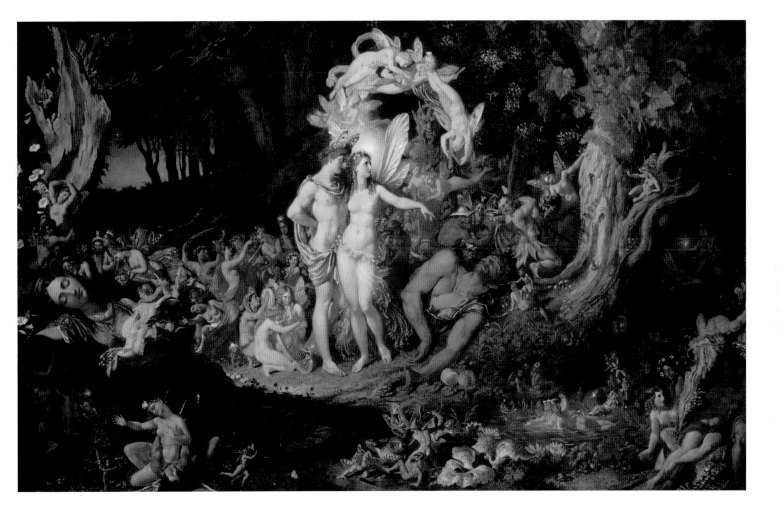

33 Richard Dadd 1817–1886
Sir Alexander Morison (1779–1866), 1852

The English painter Richard Dadd was admitted to the Royal Academy schools in 1837. He was considered an outstanding student and he became a member of the group of painters called 'The Clique' that included William Powell Frith and John Phillip. Dadd's good humour and 'exceeding gentleness' were remarked upon. However, it was during a trip to the Near East in 1842 that signs of mental illness began to manifest themselves. He suffered from delusions, announcing that he was receiving spirit messages from the Egyptian god, Osiris. At first, his companions thought that he was suffering from sunstroke; but his condition deteriorated until, in 1843, in the belief that he was acting on the instruction of ancient gods, he killed his own father. Dadd spent the rest of his life in psychiatric institutions. For twenty years, he was detained in Bethlem Hospital and, in 1864, he was transferred to the new state asylum of Broadmoor in Berkshire.

Dadd was encouraged by the doctors in these asylums to continue to paint. His prison case-notes show that his doctors and jailers acted as an audience for his work, and they even allowed him to have his own studio. A visitor in 1845 wrote of Dadd's drawings, that they 'exhibit all the power, fancy, and judgment for which his works were eminent previous to his insanity. They are absolutely wonderful in delicate finish.' His doctors were intrigued by the fact that Dadd's paintings were executed with great skill and expertise, pronouncing that they bore no signs of 'insanity'. However, the obsessive and microscopic detail of the paintings – particularly in the 'fairy' pictures for which he is best known – is slightly disturbing.

Specialising in mental and cerebral illness, Sir Alexander Morison was one of psychiatric medicine's pioneers. Born in Edinburgh, he was educated at the Royal High School and the University of Edinburgh, gaining his MD in 1799. Morison practised in Edinburgh for a time before taking up the position of Inspecting Physician of lunatic asylums in Surrey in 1810. In 1835, he was appointed physician to the Bethlem Hospital (Bedlam) in London. His publications included *The Physiognomy of Mental Diseases* (1840) in which he propounded his theory that facial expressions reveal the patient's underlying mental condition.

Dadd's portrait of his physician Sir Alexander Morison is particularly fascinating. The intense scrutiny on the painter's part meets the physician's close observation of his patient's facial expressions – and with equal professional detachment. The precision and exactitude of Dadd's treatment of his subject and the landscape could be described as forensic. The setting is Newhaven (a fishing village to the north of Edinburgh), and the house owned by Morison overlooking the Firth of Forth is in the background. It is based on a sketch provided by Morison's daughter. Two Newhaven fishwives are minutely rendered. It is thought that these were derived from images by the Scottish photographers David Octavius Hill and Robert Adamson. However, the accurate details of the brightly coloured striped costumes for which the fishwives were famous must have been based on additional information from another source or his memory of a visit to Edinburgh. The two diminutive figures are the size they are because this is how perspective works. This we know rationally. Distance is established in the painting: there are tiny boats in the background, and buildings and trees small in scale compared with the figure of Morison himself, set squarely at the front of the picture space. But there is no aerial perspective in the painting, and so – whatever our reason tells us – we somehow register the two women as miniature and thus the painting as slightly surreal. The power of reason is insecure when we look at Dadd's pictures. It is that disquieting effect that makes his work so distinctive and compelling. JL

Oil on canvas, 51.1 × 62.3 cm (20⅛ × 24½ in)
Scottish National Portrait Gallery, Edinburgh
Purchased with the aid of the National Heritage Memorial Fund, 1984
(PG 2623)

34 Camille Pissarro 1830–1903
The Marne at Chennevières, about 1864–5

Pissarro was slightly older than most of the other Impressionists and his early work reveals a strong debt to the preceding generation of landscape painters, such as Corot and Daubigny. In the later 1860s and 1870s he was in the mainstream of Impressionism and was the only artist to exhibit at all eight Impressionist exhibitions. He also encouraged younger artists such as Paul Gauguin and Georges Seurat to participate in the group shows. In the mid-1880s he became interested in the art theories of Seurat and the neo-Impressionists, and developed strong left-wing tendencies.

Pissarro painted this large riverscape while renting a house at La Varenne-Saint-Hilaire, a village to the southeast of Paris, situated on the river Marne. Some of the buildings of the village are visible on the left bank, while the church and houses of Chennevières can be seen in the distance at the top of the bank on the right. In the middle distance there is a small boat, possibly a ferry, carrying five people, one of whom holds a parasol. Modern life intrudes into this idealised riverscape in the form of the small factory buildings on the right. Pissarro chose the site carefully and must have been aware of the area's widespread popularity at the time. A pictorial guide to the river Marne, published in 1865, the year the painting was exhibited at the Paris Salon, extolled its attractions, describing 'a charming river dotted with islands whose vegetation rivals that of the tropics'.

In the early 1860s Pissarro was aware of the work of the so-called 'School of 1830'. The diagonal composition shows the influence of Daubigny, while the extensive use of the palette knife derives from Courbet. The landscape is carefully composed and it is possible there once was a preparatory sketch in oils among the large number of works destroyed when Pissarro's house was occupied by enemy troops during the Franco-Prussian War. Such a sketch (Fitzwilliam Museum, Cambridge) survives for the *Towpath* (Glasgow Art Gallery and Museum) exhibited

at the Salon of 1864. Another oil sketch known as *Ferry at La Varenne* of 1864 (Musée d'Orsay, Paris) depicts some of the topography in the Edinburgh painting, but was made slightly further upstream from the La Varenne side of the river looking across to Chennevières.

There are two surviving drawings that relate to the painting. A meticulously executed study in charcoal and white chalk, also in the Scottish National Gallery (D 5621), is related to the right foreground area. Given its high degree of finish and the Corot-like figure group in mid-distance, it is probably a fully autonomous composition rather than a preparatory study for the painting. There is also a more cursory drawing of the same view in the Ashmolean Museum, Oxford.

The picture's first recorded owner was the influential Paris dealer Ambroise Vollard, who acquired it by 1904. It remained with Vollard until January 1937, when it was bought by the London firm of Reid & Lefevre. Thereafter it was briefly in a private collection in Montreal before returning to Reid & Lefevre (via the New York gallery of Étienne Bignou). In 1939 it passed into the collection of Dr Tom Honeyman, director of Reid & Lefevre in Glasgow and London from 1929 until 1939, when he was appointed director of Glasgow Museum and Art Galleries. On leaving Reid & Lefevre, Honeyman received the painting as part payment of his original capital investment. He and his wife jokingly referred to the Pissarro as their 'Country Cottage' picture, in the hope that the picture would fund their retirement. It was purchased by the Gallery from Honeyman in 1947. F F

Oil on canvas, 91.5 × 145.5 cm (36 × 57¼ in)
Scottish National Gallery, Edinburgh
Purchased 1947 (NG 2098)

35 Frederic Edwin Church 1826–1900
Niagara Falls, from the American Side, 1867

Frederic Edwin Church was the highly successful American landscape painter who helped to establish an indigenous tradition of painting from nature in the nineteenth century. A native of Hartford, Connecticut, Church trained with Thomas Cole, founder of the Hudson River school of painting, from 1844 to 1846. After completing this period of instruction, Church spent much of his career in New York, where he settled in 1847. In 1877 he retired to Olana, a property he had built with stunning views over the Hudson River towards the Catskill Mountains, to which he had first been introduced by Cole.

Niagara Falls, from the American Side is a spectacular painting. It successfully conveys the breathtaking experience of encountering one of America's great natural landmarks for the first time. And it does this on a heroic scale. Church performs a difficult balancing act. Whereas his close attention to detail, in the rocks and blasted branches, reveals an almost scientific approach to nature, his bold handling of the thundering falling water and luminous mist and spray at the centre of the picture, invokes the sublime. Looking at the mass of swirling water, and the striking effects of light on the rocks, it is easy to understand why Church was compared to the great early nineteenth-century British landscape painter, Joseph Mallord William Turner.

By the mid-nineteenth century, Niagara Falls had become a national icon in America. Church first painted the Falls in 1857, following a series of three sketching visits in 1856. This painting (now in the Corcoran Art Gallery, Washington) established his reputation, making Church the most acclaimed American painter of his time. The artist undertook another extended sketching expedition to Niagara in 1858, but did not return before embarking on his second major painting of the site, *Niagara Falls, from the American Side*, in 1866–7. Instead, he based that work on a sepia photograph of Niagara Falls, which he had painted over earlier in oils. The view depicted was from Prospect Point, a popular destination for artists since 1821.

Church ignored the walkways and tracks that allowed an increasing number of tourists to visit the Falls during that era, replacing them with a small, rickety viewing platform bearing two tiny figures, on the extreme left.

Niagara Falls, from the American Side was commissioned by the New York art dealer Michael Knoedler and was intended to represent the newly constituted United States of America at the great Exposition Universelle in Paris in 1867. Although Church eventually sent his earlier, much-lauded view of Niagara Falls to the Exposition, winning a bronze medal, *Niagara Falls, from the American Side* was exhibited in both Paris and London in 1867–8. Chromolithographic prints of the painting were also distributed widely in Europe. On its return to America the painting was sold to Alexander Turney Stewart, an entrepreneur and pioneer of department stores, based in New York. It was subsequently bought, in 1887, by one of the richest men in America – John Stewart Kennedy, a financier of Scottish origin. Kennedy immediately offered the picture, as a faithful representation of his adopted country's iconic landmark and painted by America's most famous landscape artist, as a gift to the Scottish National Gallery.

Niagara Falls, from the American Side is one of the most significant American landscape paintings in Europe. Its donor presented the picture 'with the understanding that it will be placed on exhibition to the public at such times and under such conditions as [its Board] may see fit to describe'. Although the painting's arrival provoked considerable press coverage, the gift was not consistently appreciated by the Gallery's curators. Re-evaluated in the late 1970s, when nineteenth-century American landscape paintings began to achieve significant prices at auction, it is now one of the most popular works in the Scottish National Gallery. PA

Oil on canvas, 260 × 231 cm (102⅜ × 91 in)
Scottish National Gallery, Edinburgh
Presented by John Stewart Kennedy, 1887 (NG 799)

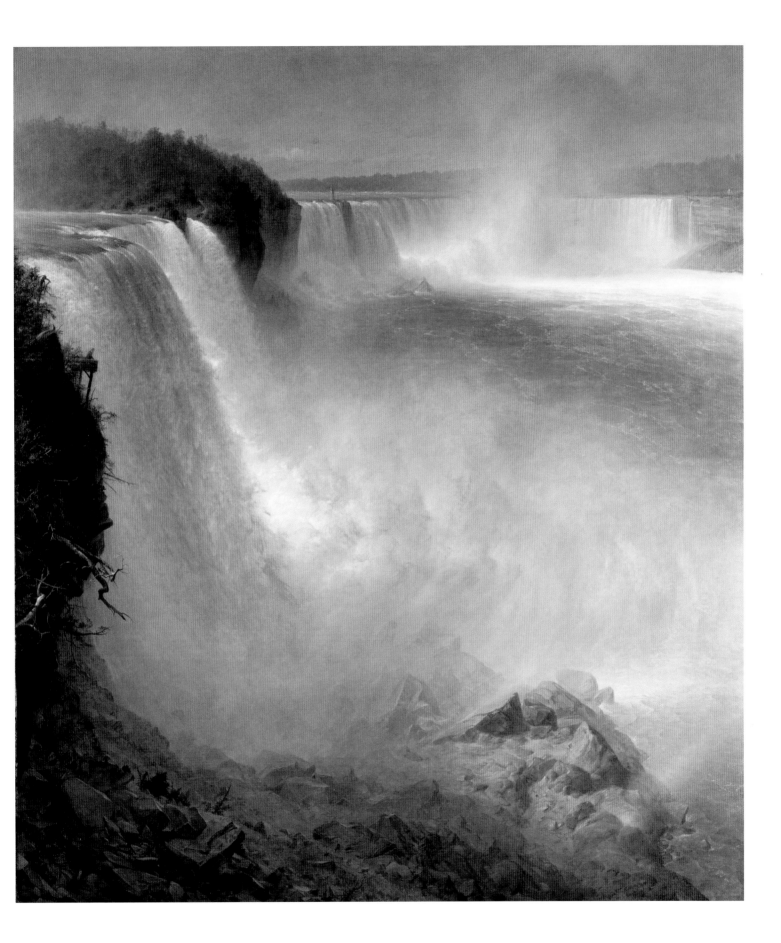

36 Sir Edwin Landseer 1802–1873
Rent-Day in the Wilderness, 1868

A Londoner by origin, Landseer first visited Scotland in 1824 in quest of Sir Walter Scott and in the company of the history painter and writer C.R. Leslie. Following a momentous encounter with Scott, Landseer contributed illustrations to Cadell's definitive edition of the Waverley Novels. The artist's fascination with Scotland, which he indulged during annual shooting and sketching trips from 1825, is now popularly identified with his single most spectacular Highland sporting picture *The Monarch of the Glen*, about 1851 (Diageo, on loan to National Museums Scotland, Edinburgh). But Landseer was also image-maker-in-ordinary to Queen Victoria in her Highland persona, receiving multiple royal commissions from 1837 and a knighthood in 1850.

Of Mackenzie descent through his mother and a Highlander by birth, Sir Roderick Impey Murchison settled in London in the 1820s. By 1855, when he approached Britain's leading *animalier* painter with an extraordinary proposal for a Scottish history painting, he was the pre-eminent British geologist of the day and president of the Royal Geographical Society. For Landseer's picture, based on Robert Chambers's graphic narrative of the heroic exploits of Colonel Donald Murchison in *Domestic Annals of Scotland* (1858–60), Sir Roderick assumed the starring role, modelling as his own great-grand uncle. Prominent in the foreground is the ivory snuff box containing the colonel's commission sent to Donald by the exiled Prince James Francis Edward Stuart, 'the Old Pretender'.

In 1715, shortly after the death of Queen Anne, the Earl of Seaforth (then head of Clan Mackenzie) and Donald Murchison (the Murchisons being a branch of this clan) had both joined the rebellion or Rising to reinstate the Stuart dynasty on the throne of Great Britain in the person of Prince James, son of the deposed James VII and II. Following the defeat of the Jacobite army at Sheriffmuir, Seaforth was attainted for high treason, forfeiting his

civil rights, earldom and legal ownership of his estates. From Paris the refugee Earl entrusted the management of his confiscated Ross-shire lands to Murchison, a lawyer turned guerrilla fighter. For ten years Murchison brazenly defied the government of Queen Anne's successor George I by illegally collecting rents from the Mackenzie tenantry to support Seaforth and to finance local armed resistance.

Here Landseer has conflated several distinct episodes including Murchison's notorious ambush of government-appointed factors, escorted by British redcoats, at Aa na Mullich (Ford of the Mull People) in 1721. The ambush was staged in a narrow pass by Loch Affric, south-west of Inverness. The magnificent mountain scenery of Glen Affric, the most beautiful and one of the wildest of all Scottish glens, had already provided Landseer with the backdrop of *The Monarch of the Glen*. But completion of Sir Roderick's picture was delayed for over a decade by more pressing commissions including a government order for four bronze lions to flank Nelson's Column in London's Trafalgar Square. *Rent-Day* was eventually delivered for the Royal Academy centenary exhibition in 1868 and then to mixed reviews, some critics commenting on Landseer's discomfiture in handling historical narrative and flaws in his compositional integration.

In 1871 Sir Roderick's will provided for the endowment of a chair of geology in the University of Edinburgh, a development building on the previous establishment of a Scottish division of the British Geological Survey under his directorship. Apart from his publications on Highland geology, his other most enduring legacy to Scotland was his bequest to the Gallery of his most important British picture. This is still the only, if exceptional, Landseer painting in the outright ownership of the National Galleries of Scotland. HS

Oil on canvas, 122 × 265 cm (48 × 104⅜ in)
Scottish National Gallery, Edinburgh
Bequest of Sir Roderick Impey Murchison, 1871 (NG 586)

37 Edgar Degas 1834–1917
Diego Martelli (1839–1896), 1879

Degas was a founder member of the Impressionist group and organised several of their exhibitions, even though he preferred to describe himself as an 'independent' artist. He was classically trained and remained, at heart, a studio painter, albeit highly experimental, with a passion for figurative art. His later work became increasingly personal in manner as he tirelessly re-examined his favourite themes of the female nude and ballet dancers.

Diego Martelli was a Florentine art critic, a close friend and supporter of Degas and an important champion of Impressionism. He was also the principal advocate of the Macchiaioli, a group of artists based in Tuscany and including Telemaco Signorini and Adriano Cecioni, as well as Giovanni Boldini, Giuseppe De Nittis and Federico Zandomeneghi, all of whom, like Martelli, were part of Degas's circle in Paris.

This portrait of the writer in his Paris apartment at 52 rue de Douai was painted during an extended, thirteen-month trip to Paris in 1878–9. The painting is closely comparable with a Degas pastel of the French critic Edmond Duranty (Burrell Collection, Glasgow) and, despite their different media, it is possible that they were designed as a pair, since they are of similar scale and composition. Both works follow Duranty's recommendations in *La Nouvelle Peinture* (1876) that the sitter should be shown in his working environment.

The high viewpoint in our painting flattens the composition, throwing the sitter's legs into sharp perspective. This compositional device, together with the picture's asymmetry suggest the influence of Japanese prints, as does the cropping of elements within the composition, such as the discarded slippers and the curved 'fan' picture behind the sofa. This can clearly be identified as a map of Paris: the river Seine is faintly visible, running through coloured 'segments' denoting the new southern arrondissements of Paris established by Baron Haussmann.

Degas painted two portraits of Martelli; the other is now in the Museo Nacional de Bellas Artes in Buenos Aires. There are three preparatory drawings which relate directly to the Edinburgh work. A hastily drawn compositional study (in Notebook 31, p.25) establishes the basic composition, including the map in the background. A full-length drawing of Martelli, squared for transfer (private collection, London), is inscribed 'chez Martelli/3 avril 79', thus establishing the location as Martelli's Paris apartment. Scholars have suggested that it was not this, but another, full-length composition in the Fogg Museum at Harvard University that was used as the final working drawing for the Edinburgh picture.

A portrait of Diego Martelli by Degas is listed in the catalogue of the fourth Impressionist exhibition which opened on 10 April 1879. However, given the date of 3 April 1879 inscribed on the London study, it seems unlikely that Degas would have completed either portrait in time for the opening, and there is no mention of the portrait in contemporary reviews. Martelli kept in touch with Degas via Zandomeneghi and tried in vain to obtain what he regarded as 'his' portrait from the artist. The picture remained with Degas until after his death and was included in the Atelier sale at Georges Petit's Paris gallery in May 1918 when it was acquired by Dr Georges Viau, a dental surgeon and an important early patron of the Impressionists. It then passed through Paul Rosenberg's gallery and was bought by the Glasgow dealer Alex Reid, who sold it to Elizabeth Workman, an early British collector of Impressionist art, in 1922. The picture remained with Mr and Mrs Workman until 1929 when R.A. Workman ran into financial difficulties and was obliged to sell the collection. The picture was bought by the Gallery from Reid & Lefevre in 1932. F F

Oil on canvas, 110.4 × 99.8 cm (43½ × 39¼ in)
Scottish National Gallery, Edinburgh
Purchased 1932 (NG 1785)

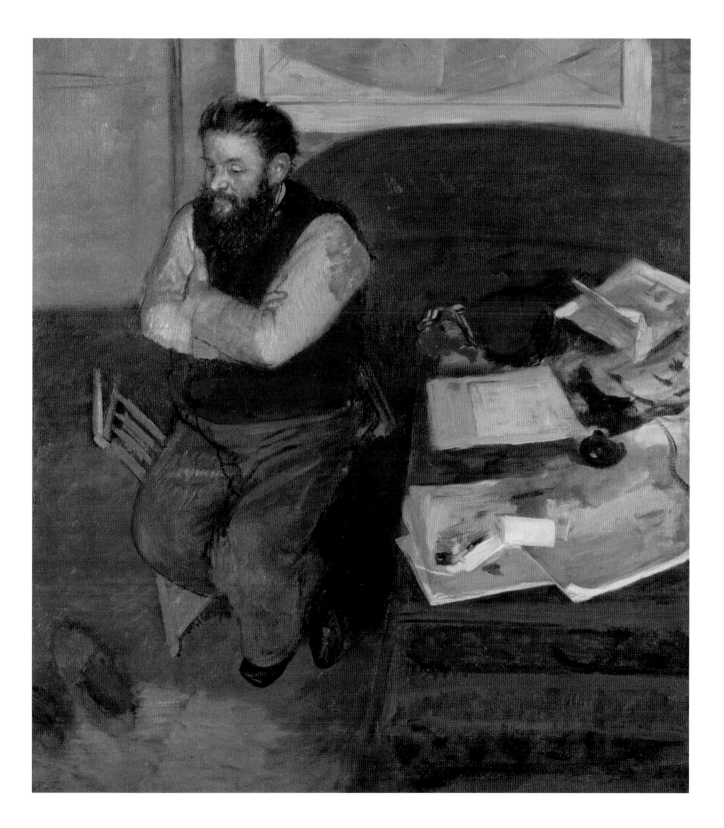

38 Georges Seurat 1859–1891
La Luzerne, Saint-Denis, 1884–5

The founder of Neo-Impressionism, Seurat was one of the most distinctive and influential artists to emerge in France towards the end of the nineteenth century. Born to comfortably-off parents, he was able to pursue his artistic interests relatively unfettered by financial worries. Seurat studied at the École des Beaux-Arts in Paris and then undertook military service. He developed a scientific approach to Impressionism, based on the colour theories of Michel-Eugène Chevreul and Ogden Rood. This involved applying small dots of unmixed colour laid side by side on the canvas, which produced an optical mixture of extraordinary vibrancy. The technique, known as 'Pointillism', was applied uniformly for the first time in his large-scale figure painting *Sunday Afternoon on the Island of La Grande Jatte* (Art Institute of Chicago), exhibited at the eighth and last of the Impressionists' group exhibitions in 1886.

La Luzerne represents a transitional stage in Seurat's development. The picture may have been begun in 1884 and finished the following year. The location is an area of agricultural land between Paris and Saint-Denis (now a northern suburb of the capital). Seurat is careful to omit from the scene any sign of industrial activity, even though, by this date, recently constructed factories and warehouses were beginning to encroach on the landscape. The blue lucerne, or alfalfa, seen here punctuated with red poppies, was used to feed the city's horses.

The painting is carefully proportioned, with the sky, distant buildings and low wall occupying approximately one quarter of the picture space, and with a figure walking along the path in front of the wall situated almost at the vanishing point. However, the composition, with its horizontal vast open foreground, lends the work an almost monotonous, anti-picturesque aspect. Seurat uses his criss-cross (*balayé*) brushstroke, earlier employed in studies for his first large figure painting *Bathers at Asnières* of 1883–4 (National Gallery, London). The brushstrokes

animate the canvas: larger in the foreground, they become smaller towards the horizon, creating an illusion of depth. In the right foreground a shadow, probably of a tree (balanced by the actual tree in the right background) adds a sombre contrast to the brilliant reds and oranges of the middle distance. The blue and lavender colours, and a similar use of shadow in the right foreground, appear in studies for the *Grande Jatte* painting and both pictures were exhibited at the second Salon des Indépendants, which opened in Paris on 21 August 1886.

The picture's importance is enhanced by its early provenance, since it was owned by the art critic Roger Fry, who introduced the British public to the work of the Post-Impressionists through his groundbreaking exhibitions of 1910 and 1912. Fry was initially ambivalent about Seurat's work and dismissed it as the product of a scientific approach. He reassessed his opinion of him in 1916, regretting the fact that he had previously overlooked Seurat's importance as an artist. He acquired this work between 1920 (when it was with the Paris dealer Bernheim-Jeune) and 1922, when he lent it to the Burlington Fine Arts Club exhibition. It was not, as had once been supposed, the first work by Seurat to enter a British collection, since in 1919 another member of the Bloomsbury circle, John Maynard Keynes, acquired *The Couple*, a study for the *Grande Jatte* (The Provost and Fellows of King's College, Cambridge [Keynes Collection], on loan to the Fitzwilliam Museum, Cambridge). Fry's most extensive analysis of Seurat, prompted by the National Gallery's purchase of *Bathers at Asnières*, was published in *The Dial* in November 1926. The picture remained in Fry's collection until his death in 1934. FF

Oil on canvas, 65.3 × 81.3 cm (25¾ × 32 in)
Scottish National Gallery, Edinburgh
Purchased with the aid of the Art Fund, a Treasury Grant and the family of Roger Fry, 1973 (NG 2324)

39 Claude Monet 1840–1926
Poplars on the Epte, 1891

Monet is, for many, the archetypal Impressionist painter. Born in Paris, he was brought up in Le Havre on the Normandy coast. There he met Eugène Boudin, who encouraged him to paint out of doors and to focus on the transient effects of light and atmosphere. He trained in Paris at the studio of Charles Gleyre, where he encountered Alfred Sisley, Frédéric Bazille and Auguste Renoir, all of whom joined the Impressionist group. In the 1870s he lived and painted at Argenteuil and Vétheuil before settling in the village of Giverny in Normandy. In the 1880s he painted on the Normandy coast, in the Creuse valley, and at Antibes in the south of France, gradually developing a more schematic and decorative approach to landscape. This led to his 'series' paintings of the 1890s, beginning with the *Haystacks* (or *Grainstacks*) in 1891 and culminating in his famous water lily paintings and his *décorations* for the Orangerie in Paris, which were installed after his death.

Following the success of his *Haystacks* series, Monet occupied himself during the late spring and autumn of 1891 painting twenty-three canvases of poplars. The poplars in question belonged to the village of Limetz, just over a mile from Giverny. Monet had already begun to paint them when the municipal authorities in Limetz decided (on 18 June 1891) to sell the trees at auction, since they had grown to their ideal height of about thirty feet and were ready to be felled. In partnership with a timber merchant, Monet was successful in saving the poplars at the subsequent sale on 2 August and was able to continue painting them.

The series was painted on the river Epte, close to where it joins the Seine. At this point the river bends back on itself before disappearing from view, providing an S-bend vista of trees, which appears in many paintings from the series. Nearly all these works were painted from Monet's studio boat, hence their low viewpoint.

Judging by the verdant growth and blue sky studded with cotton-wool clouds, the Edinburgh painting was executed in late spring. While the format of the majority of the *Poplars* paintings is vertical (i.e. portrait format), the Edinburgh painting is essentially square, emphasising the decorative aspects of the composition. The top half of the painting focuses on the gentle curve of the bank, the trees and their vertical, slender trunks. The same scene, reflected and strangely distorted in the water, occupies the bottom half of the canvas. Monet adopted this same format for only two other *Poplar* paintings: one in the Metropolitan Museum of Art, New York; the other, an autumn scene, in a private collection.

Fifteen of the *Poplars* were exhibited at Paul Durand-Ruel's Paris gallery in March 1892. This picture was not included in that show, but it was exhibited at the Durand-Ruel gallery at an unknown date. By 1924 it had been acquired by the Glasgow firm Alex Reid & Son, who sold it to the Scottish National Gallery the following year, making it the first Impressionist picture to enter the collection. Alex Reid was an important early dealer in Impressionist art, having trained for a period alongside Theo van Gogh at Boussod & Valadon in Paris. He was responsible for introducing Impressionism to a large number of British collectors, and several of the Impressionist pictures in the Scottish National Gallery's collection, including the Degas portrait of Diego Martelli (cat.37), passed through his hands. F F

Oil on canvas, 81.8 × 81.3 cm (32¼ × 32 in)
Scottish National Gallery, Edinburgh
Purchased 1925 (N G 1651)

40 John Singer Sargent 1856–1925
Lady Agnew of Lochnaw (1865–1932), 1892

John Singer Sargent was born in Florence to American parents and became the most fashionable and assured portraitist working on both sides of the Atlantic in the later nineteenth century. Sargent trained in Paris with Émile Carolus-Duran. He portrayed a number of French and American sitters in Paris, most famously Madame Pierre Gautreau (*Madame X*) whose portrait of 1884 (Metropolitan Museum of Art, New York) was denounced for its immodesty. Two years later he settled in London. In the 1890s he made a definitive move towards becoming a society portraitist, a development which was helped to a considerable degree by the success of this depiction of Lady Agnew.

The sheer glamour of this portrait, achieved through lush, fluid brushwork, delicate colour harmonies, and an overwhelming sense of opulence, has meant it has transcended its role as a depiction of an individual and almost become an icon for an era, embodying the grace and decadence associated with *fin-de-siècle* British high society. The sitter is Gertrude Vernon: her parents were the Hon. Gowran Charles Vernon and Caroline Fazakerly. In 1889, Gertrude married Sir Andrew Noel Agnew, 9th Baron of Lochnaw – a lawyer with political ambitions who came from an old Scottish family.

The connection with Sargent was probably forged through Gertrude's friends, the Dunhams, a New York family based in London; James and Harriet Dunham had six daughters, two of whom were painted by Sargent in the early 1890s. Gertrude and Noel dined with the Dunhams and Sargent on 11 July 1891. She sat to the artist in the following year, at the age of twenty-seven, during a period of nervous exhaustion (neurasthenia) and convalescence. Her pose is notably langorous, as she stares slightly upwards and very intently at the artist while he painted her. The precise cost of the commission is not recorded, however Sargent charged about £500 for a three-quarter-length portrait at the time.

The appeal and power of Sargent's work are largely reliant on the subtle and rich clothing and setting selected for his sitter. She wears a pearl-white satin and chiffon dress, called a tea gown. A bold mauve sash complements the trimmings on the sleeves. The pendant around her neck, which may have a large gem in the centre, appears to be surrounded by turquoises and seed pearls. Lady Agnew is seated on a Louis XVI bergère chair, which was a prop from Sargent's studio that he had brought from Paris to London in 1886. The Chinese turquoise and gold silk hanging which provides the backdrop for the portrait also formed part of the artist's collection of items he used to create luxurious settings for his subjects.

The picture – ostensibly so spontaneous, but actually so carefully judged – was to prove pivotal in the careers of the artist and sitter. It confirmed his reputation for elegant, slick portraiture and established her status as a beauty and hostess. The painting's appearance at the 1893 annual Royal Academy exhibition brought it to the attention of a wide public and prompted wildly enthusiastic critical notices.

Sir Noel and Lady Agnew's London life in the period leading up to the First World War was defined by parties, dinners, receptions and private views. The cost of being a society hostess was met by the sale of Lochnaw land and of Sargent's portrait. Intriguingly the picture was offered in 1922 to Helen Clay Frick, who was a passionate collector and distinguished philanthropist and the daughter of Henry Clay Frick, the founder of The Frick Collection. This offer was not taken up. Lady Agnew then approached the Trustees of the National Galleries of Scotland in 1924. They refused at the time to buy works by living artists. However, in the following year Sargent died and so this impediment fell away. C B

Oil on canvas, 125.7 × 100.3 cm (49½ × 39½ in)
Scottish National Gallery, Edinburgh
Purchased with the aid of the Cowan Smith Bequest Fund, 1925 (NG 1656)

41 Paul Gauguin 1848–1903
Three Tahitians, 1899

Gauguin is known today as one of the leading Post-Impressionist artists and an important figure in the Symbolist movement. He exhibited with the Impressionists in 1881 and 1882 but, working in Brittany, soon developed a synthetic style of painting, based on Japanese prints, stained glass and local popular prints. In search of a more 'primitive' mode of artistic expression, he travelled to Martinique in 1887 and made two trips to Tahiti (1891–3 and 1895–1901), eventually settling in the Marquesas Islands.

Typically in this painting Gauguin fuses traditional Western iconography with local, Tahitian references. The idea for the group of two women and one man may have come from a fashionable Tahitian song entitled *Oviri* ('The Savage'), but Gauguin also alludes to the classical theme of Hercules' choice between Vice and Virtue. According to the legend, Hercules opted for the path of virtue, but here Gauguin illustrates the opposite: the man gazes in the direction of the young woman who offers a mango – the Tahitian equivalent of Eve's apple – used here as a symbol of the temptations of the flesh; while on the right the 'virtuous' girl, who wears a wedding ring and carries a bouquet of flowers, fails to attract his attention.

The narrative recalls earlier images such as *Vahine no te Vi* (*Woman of the Mango*) of 1892 (Baltimore Museum of Art), which have been related in turn to an event recounted by Gauguin in a letter of 20 June 1887 to his wife Mette:

The day before yesterday a young negress of 16 years old, damnably pretty, offered me a split guava squeezed at the end. I was about to eat it as the young girl left, when a light-skinned lawyer standing by took the fruit out of my hand and threw it away. 'You are European, Monsieur, and don't know the customs of the country,' he said to me. 'You must not eat fruit without knowing where it comes from. This fruit has a spell;
the negress crushed it on her breast, and you would surely be at her disposal afterward.' ... Now that I am warned, I will not fall, and you can sleep soundly, assured of my virtue.

The picture dates from Gauguin's second period in Tahiti. The women are dressed in the traditional *pāreu* or *pareo* (wraparound skirt), while the man wears a *maro* or loincloth. The female figure on the right has been developed from the left-hand figure in *Faa Iheihe* (*Tahitian Pastoral*) of 1898 (Tate, London) who holds her hands in the same position, clasping a bouquet of flowers and turning her head inwards. However, this earlier figure wears her *pāreu* over her left shoulder, like the figure on the left of the Edinburgh painting. Both female figures recur in several other compositions of the time, including *Women at the Seaside* of 1899 (State Hermitage Museum, St Petersburg), which also includes a woman nursing her baby.

The picture's first owner was the painter Gustave Fayet, who had acquired it by 1906. Fayet was one of Gauguin's most important patrons and also owned works by Degas, Manet and Pissarro. He came from Béziers in the Languedoc region of France and in 1908 he bought the Abbaye de Fontfroide near Narbonne, where he exhibited many works from his collection. After Fayet's death in 1925 the painting was passed down to his daughter Madame Alban d'Andoque, and was subsequently acquired by the dealer Wildenstein, probably around 1931. In 1936 Wildenstein sold it to the Edinburgh lawyer Alexander Maitland and his wife Rosalind. The Maitlands built up an important collection of Impressionist and Post-Impressionist art, which was left to the Scottish National Gallery following Rosalind's death in 1959. F F

Oil on canvas, 73 × 94 cm (28¾ × 37 in)
Scottish National Gallery, Edinburgh
Presented by Sir Alexander Maitland in memory of his wife Rosalind, 1960 (NG 2221)

42 Édouard Vuillard 1868–1940
The Candlestick (*Nature morte au bougeoir*), about 1900

Vuillard's interest in surface pattern and his subject matter drawn from daily life make him a bridge between Gauguin and the Post-Impressionists and twentieth-century abstraction. He was born near Lyon, but the family moved to Paris in 1878. He studied at the Académie Julian, where he met Pierre Bonnard, Maurice Denis and Paul Sérusier, who in 1889 formed the 'Nabis' group – meaning 'Prophets'. Gauguin's paintings were a critical influence on their work. Maurice Denis voiced their ideas in the celebrated phrase: 'Remember that a picture, before being a war-horse or a naked woman or any other anecdote, is essentially a flat surface covered with colours brought together in a certain order ….'

Vuillard's father died when he was fifteen and thereafter his mother, who ran a small corset and dress-making business from home, became the dominant influence in his life. Vuillard lived with her until he was sixty. His paintings reveal an obsession with pattern, texture and colour, probably as a result of his deep familiarity with fabrics. Whereas during the 1890s Vuillard had often presented the viewer with flattened forms and unexpected juxtapositions and angles of vision, by the turn of the century his work was becoming more naturalistic. Although his work may appear quiet and undemonstrative, it was precisely this obsession with apparently mundane interiors and uneventful episodes in domestic, middle-class life, that mark him out as a remarkable artist. His paintings of this type are often referred to as intimist. The parallel between these works and Chardin's still lifes has often been drawn.

The subject of *The Candlestick* is simply a candlestick and a small vase of flowers on a bedside table, placed against a wall. The square, blue object has been identified as a packet of tobacco. We see the bed to the right and part of a satchel dangling down above the table. Perhaps influenced by the arbitrary compositions generated by snapshot photography, Vuillard often cropped his subject matter in unusual ways, as here where the bag is cut in half. Each element in the composition is given equal weight and the whole surface is unified by little dabs of paint. Vuillard often painted with a dry, sticky type of paint called 'colle' on soft brown millboard, and would leave parts of the board unpainted, as here, most notably under the embroidered tablecloth, to form the neutral tone.

In 1899 Vuillard and his mother moved from a small, dark apartment into a much lighter one at 28 rue Truffaut in Montmartre, in the northern part of Paris. The bright tones of this painting suggest that it was painted after the move, around 1900. It was bought from Vuillard's dealer, the Galerie Bernheim-Jeune, by a private collector in October 1900, and then changed hands several times before passing to the Reid & Lefevre gallery, which had branches in London and Glasgow. The Glasgow industrialist and art collector Sir John Richmond bought it in 1935 for £800. On his death in 1963 it passed to his niece, Mrs Isabel Traill: she presented it to the Gallery in 1979. This is one of six paintings by Vuillard, dating from about 1892 to 1904, in the National Galleries of Scotland's collection. P E

Oil on millboard, 43.6 × 75.8 cm (17⅛ × 29⅞ in)
Scottish National Gallery of Modern Art, Edinburgh
Presented by Mrs Isabel M. Traill, 1979 (GMA 2935)

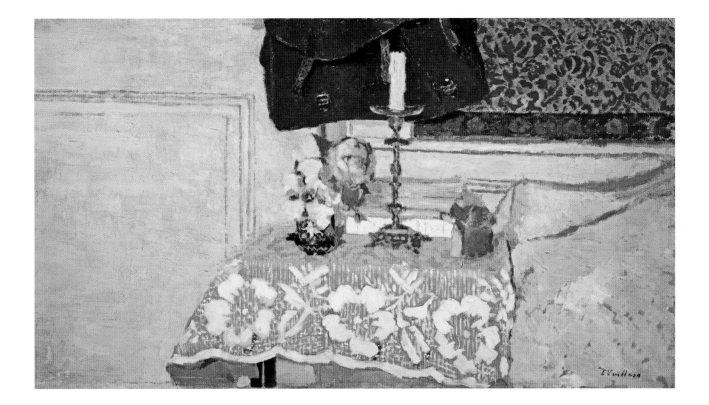

43 Pablo Picasso 1881–1973
Mother and Child (*Mère et enfant*), 1902

The son of an artist, Picasso was born in Málaga, Spain, and studied at the Llotja art school in Barcelona. In autumn 1900, he and his close friend Carles Casagemas travelled to Paris to see the great Exposition Universelle, which featured one of Picasso's paintings. They took a studio for a few months on the rue Gabrielle in Montmartre (coincidentally, it was close to the apartment where, at about this time, Vuillard painted *The Candlestick* cat.42). They returned to Barcelona, but Casagemas, infatuated by a love affair, went back to Paris in January 1901. Following the failure of the affair, he committed suicide in February. The tragic episode had a profound effect on Picasso. He made a number of melancholy paintings of his dead friend and at the same time his palette switched from the bright colours of Van Gogh to a limited range of blues and greens – hence 'Blue Period'. His subject matter now dwelt on themes of poverty, alcoholism, misery and blindness.

Picasso returned to Paris in May 1901 and the following month, when he was still only nineteen years old, he had an exhibition at Ambroise Vollard's gallery on the rue Laffitte. Vollard was one of the most celebrated dealers of his day, specialising in the work of Cézanne and the Post-Impressionists. Picasso worked with incredible speed, painting a couple of canvases a day so that the exhibition featured more than sixty paintings, most of them completed in the previous month or so. Over half the works sold and his reputation began to spread.

In autumn 1901 he obtained permission to visit the women's prison-hospital of Saint-Lazare in Paris, which was run by nuns. He drew the inmates, many of whom were prostitutes and had babies or young children. Picasso said that he was attracted by the availability of free models, but the miserable, depressing place must also have accorded with his state of mind at the time. He seems to have drawn the inmates in their cells, although hardly any of the preparatory sketches survive. A number

of his paintings show the women from behind, with their faces turned away, as if they wanted to protect their privacy. Picasso's close friend Jaime Sabartès wrote that 'The painter has been able to give form to a sigh, to make inert bodies breathe, to infuse life into the dead.' Picasso continued with this theme in Barcelona, where he stayed from January to October 1902. *Mother and Child* probably belongs to this Barcelona period. Stylistically, it borrows much from Gauguin in the simplification of colour and form, and also from El Greco, in terms of the fiery brushwork and the curious stage-like presentation. The shadow cast by the woman suggests that she is indoors, as if on a stage, while the rock suggests that she is outdoors. It is painted on paper which has been stuck onto an old canvas: X-ray photographs show that a landscape painting, almost certainly painted by another artist, lies underneath, on the original canvas. Picasso presumably acquired the other canvas cheaply or free, and stuck his own drawing on top. The style of the signature, in the bottom left corner – briskly written and almost italicised – is much later, possibly added in the 1950s.

The painting was bought in 1954 from a London dealer by Alexander Maitland, a high-ranking legal advocate and QC (Queen's Council), who lived and worked in Edinburgh. He paid £5,300 for it. He gave it to the Gallery in 1960, in memory of his wife. It was the first Picasso to enter the National Galleries of Scotland's collection. PE

Oil on paper laid on canvas, 40.5 × 33 cm (16 × 13 in)
Scottish National Gallery of Modern Art, Edinburgh
Presented by Sir Alexander Maitland in memory of his wife Rosalind, 1960 (GMA 967)

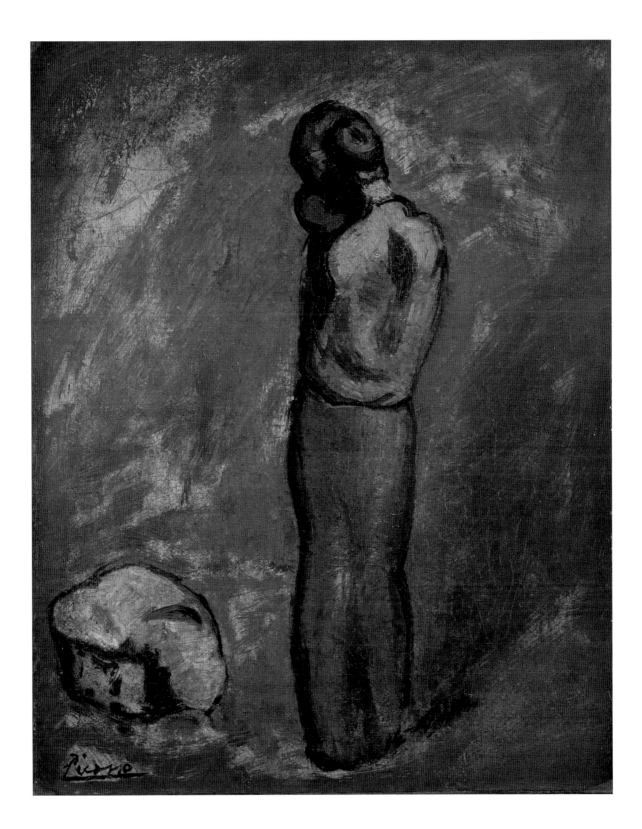

44 Paul Cézanne 1839–1906
The Big Trees, about 1904

The son of a banker, Cézanne was brought up in Aix-en-Provence, but in 1861 he moved to Paris, where he encountered Camille Pissarro and Armand Guillaumin. He exhibited only twice with the Impressionists – in 1874 and 1877 – during which period he lightened his palette, working alongside Pissarro at Pontoise and Auvers. In the early 1880s he returned to Provence and began work on his famous series of canvases of the Mont Sainte-Victoire, and of the *Large Bathers*. In the 1890s he developed a more analytical and synthetic approach to painting, often creating in his later compositions a spatial ambiguity that anticipates the experiments of early Cubism.

This picture dates from the last years of Cézanne's career and is one of a series of works painted in the forested area around the Bibémus quarry and the Château Noir in Aix. The twisting branches of the left-hand tree and the dramatic diagonal of the right-hand tree inject a sense of dynamism into the composition, which is otherwise broadly symmetrical. The upper part of the composition is painted in a restricted range of browns and greens, contrasting with the warm reds, yellows and ochres in the foreground. These colours change and lighten towards the centre of the composition, creating a fulcrum. At this date Cézanne often left his paintings in an apparently 'unfinished' state with, as here, areas of the primed white canvas showing through, representing patches of light.

The motif of tangled branches recurs frequently in Cézanne's oeuvre and there is a closely related work in graphite and watercolour in a French private collection. The drawing was titled *Bare Trees in the Fury of the Wind*, suggested by verses written by Cézanne in 1863, but it is now known as *The Big Trees*. Scholars have commented on the relative naturalism of the watercolour in comparison to the oil painting. The central tree in the study, for example, has spindly branches arising from its trunk, while in the oil it is reduced to a vertical pole. The left-hand tree appears wilder in the oil version, the right-hand tree more geometric, with additional branches, and it is brought closer to the centre of the composition. A line leading dramatically downwards in the study indicates that this tree was originally located farther forward than the left-hand tree.

There also appears to be a relationship between *The Big Trees* and two landscape studies, both sketches of female bathers, one (about 1899–1904) in the Art Institute of Chicago, the other (about 1900–4) in a private collection. Both sketches relate in turn to the *Large Bathers* of 1902 in the National Gallery, London. However, the experimental nature of our painting suggests it was completed at a slightly later date, closer to 1904.

The picture was first acquired by Cézanne's dealer Ambroise Vollard and later, in 1936, entered the collection of J.B. August Kessler, a director of Royal Dutch Petroleum. However, the purchase was almost certainly influenced by Kessler's wife Anne, a niece of the British collector, of Dutch origin, Frank Stoop, who encouraged her taste for modern paintings. Anne F. Kessler formed one of the most significant collections of late nineteenth-century and early twentieth-century French art in Britain. In addition to Cézanne, she acquired (and inherited from her uncle) works by Renoir, Degas, Van Gogh, Gauguin, Seurat, Toulouse-Lautrec, Vuillard, Modigliani, Matisse, Picasso and Dufy. After her death fourteen works were left to the Tate and two – this work and Daumier's *The Serenade* of about 1858 (NG 2453) – were presented to the National Galleries of Scotland. FF

Oil on canvas, 81 × 65 cm (31⅞ × 25⅝ in)
Scottish National Gallery, Edinburgh
Presented by Mrs Anne F. Kessler, 1958; received after her death, 1983
(NG 2206)

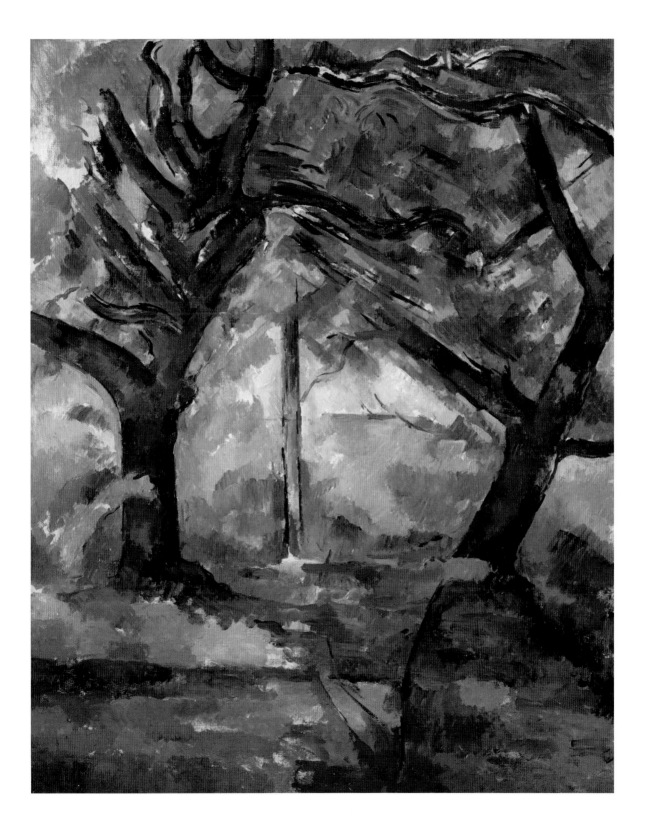

45 André Derain 1880–1954
Collioure, 1905

Derain was born near Paris and became friendly with Matisse and Vlaminck at the turn of the century: the three artists would form the core of the Fauve group. In 1905 Matisse wrote to his friend, urging him to join him for the summer at Collioure, a small port on the Mediterranean coast not far from the border with Spain: 'I cannot insist too strongly that a stay here is absolutely necessary for your work. I am certain that if you take my advice you will be glad of it.'

When Derain joined his friend, he was fired with enthusiasm for Collioure with its dramatic setting, and above all, the powerful 'blonde' light which he described as 'a golden hue that suppresses the shadows'. Working alongside Matisse, he forged a bold new style, simplifying his art to rely on the expressive power of bright, sensuous colour applied with a child-like sense of excitement and spontaneity. For both artists this was an extraordinarily productive few months marking a turning point in their development.

On their painting expeditions during that summer, Matisse and Derain explored various motifs in and around the town and its busy fishing port. The view in our painting is still recognisable today and was taken from the high ground to the north side of the harbour looking over the tiled roofs of a narrow street to a panoramic view of the bay and the coastline. The cylindrical bell-tower of the church of Notre-Dame-des-Anges is just visible in the middle distance; and, beyond, a solitary sail helps to carry our eye across the bay to the distant shore. Derain was familiar with the work of Van Gogh and there is a resemblance here to the fluid paint and distorted forms of some of the Dutchman's later pictures. There are echoes too of Cézanne who had painted views of the bay of Marseilles using a strong contrast between red-orange roofs and the blue sea as the basis of his composition. But Derain successfully fuses these sources into something new, raw and powerful. There is no attempt to use any

finesse in the colour relationships to suggest space or atmosphere. Instead we are confronted with a mosaic of strong colours dominated by glaring oranges and yellows contrasting with the luscious indigo of the sea.

Later that year Derain exhibited some of his paintings of Collioure at the Salon d'Automne in Paris, alongside works by Matisse and other like-minded artists. The reactions were generally hostile and the famous description of the Fauves (wild beasts) used by one critic to describe what seemed like an orgy of colour came to stand for a whole new movement in French art. Derain's paintings were singled out as being crude and puerile, the work of a 'poster artist' rather than a painter. But it is precisely this deliberate naïvety, the effort to abandon convention and to see the world with fresh eyes, that characterises the works that Matisse and Derain produced that summer.

The first owner of the painting was a M. Renou, who probably bought it directly from Derain, who was a friend. After changing hands several times, it was sold at auction in 1972. The Gallery bought it from Waddington Galleries in London in 1973. At £120,000 ($200,000) it was the most expensive purchase yet made by the Gallery and consumed the majority of three years' purchase budget. But it was part of a policy designed to represent the best works of the major movements in early twentieth-century art, and maintain the high standards set by Gauguin, Cézanne and Van Gogh which were already on display at the Scottish National Gallery. P E

Oil on canvas, 60.2 × 73.5 cm (23¾ × 29 in)
Scottish National Gallery of Modern Art, Edinburgh
Purchased 1973 (GMA 1280)

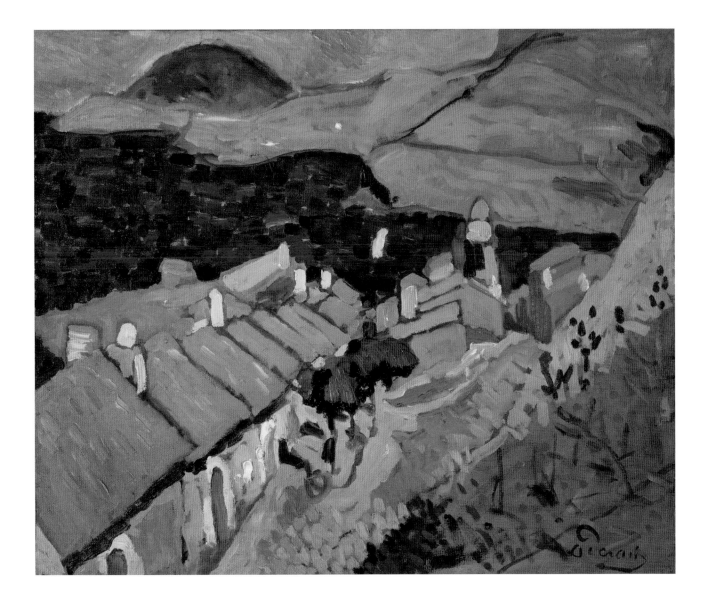

46 Ernst Ludwig Kirchner 1880–1938
Japanese Theatre (*Japanisches Theater*), about 1909

Kirchner was born in Bavaria, studied architecture in Dresden and became interested in drawing and painting at that time, but had very little formal training in art. He abandoned his architectural studies and helped establish the German Expressionist *Die Brücke* (The Bridge) group, which was formed in Dresden in 1905. The original members were Kirchner, Fritz Bleyl, Erich Heckel and Karl Schmidt-Rottluff. The name *Die Brücke* was chosen to suggest the links or 'bridges' which connected the artists of the group, but it also stood for the bridges they hoped to build between art and life, artist and public, decorative and fine art, past and future. Strongly influenced by Van Gogh's work, which featured in several exhibitions held in Dresden from 1905, they rejected prevailing artistic styles as sterile or exhausted and sought to rejuvenate art with new and more vigorous forms of expression.

Painted in about 1909, *Japanese Theatre* is a superb example of Kirchner's early Expressionism. The world of the theatre, cabaret and circus provided a rich vein of subject matter for Kirchner and his colleagues. They were particularly attracted to the vitality and strangeness of non-Western performers, and in Dresden and Berlin they had access to a bewildering array of acts from across the world, from Javanese snake charmers to Chinese jugglers.

The theatrical setting seen in *Japanese Theatre* is ambiguous and potentially confusing. The foreground seems to be a stage, but there is also a view through a billowing curtain to another stage or backdrop beyond. The exact subject depicted in our painting has been a matter of debate. However, the American scholar Sherwin Simmons has recently suggested that it may show Madame Hanako's troupe at the Central-Theatre in Dresden. They performed two one-act plays in May 1909: *In the Teahouse* and *Otake*. The first seems to be the more likely candidate. Hanako (who was under 5 feet tall and was described in the reviews as the size of a 10-year-old German girl) plays a geisha named Murasaki who conspires with her lover to rob and murder an elegant samurai, who visits the teahouse. However, he discovers the plot and kills them in a stunning display of swordsmanship. All of the newspaper reports emphasise the beauty and colour of the costumes and the remarkable elegance (swift and slow) of the actor's body movements. They also mention a scene in the teahouse looking out in the garden in which men and women converse, smoke (the figure on the left of our picture may be holding a pipe), drink tea, and observe the dancing of Otyo, Murasaki's *maiko* (apprentice geisha).

Kirchner was an immensely talented yet vulnerable character. He suffered a physical and mental breakdown during the First World War from which he never fully recovered. He later painted over some of his earlier compositions, but in the case of this canvas he turned it over and, in about 1924, used the reverse for another composition showing a seated nude, a sculpture and a man, which is possibly a self-portrait.

The painting remained with the artist's estate until 1960. The Gallery bought it in 1965 from Marlborough Fine Art in London. It was an unusual purchase for a British gallery – the Tate Gallery in London did not own a Kirchner at the time. It signalled the Gallery's interest in German art, which we have since maintained, and also our tendency to collect work considered at the time to be somewhat idiosyncratic. PE

Oil on canvas, 113.7 × 113.7 cm (44¾ × 44¾ in)
Scottish National Gallery of Modern Art, Edinburgh
Purchased 1965 (GMA 911)

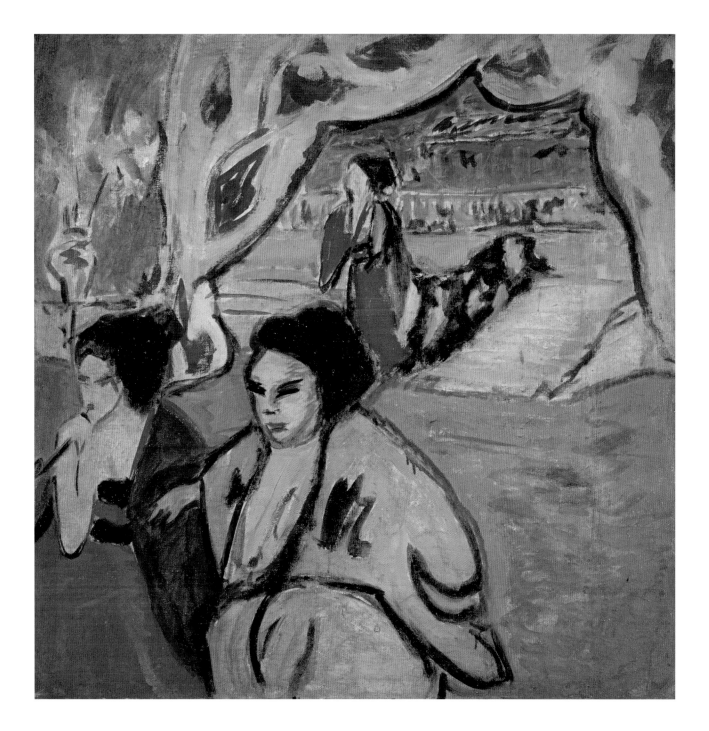

47 Alexej von Jawlensky 1864–1941
Head of a Woman (*Frauenkopf*), about 1911

Jawlensky was born in Russia, and started out on a military career. He began his art studies comparatively late, in his mid-twenties, and in 1896 left the army and went to Munich where he studied art and met another Russian artist, Wassily Kandinsky, who became a close friend. In 1905 Jawlensky spent some time in France, where he was influenced by the work of Gauguin, Van Gogh and the Fauves. He showed several paintings at the famous Salon d'Automne exhibition of 1905, when the Fauves burst onto the scene with such force. Although at the time he was more interested in the work of Van Gogh and Gauguin, the violent colours and broad brushstrokes seen in *Head of a Woman* have an obvious rapport with Fauvist painting, particularly Matisse's portraits, and even with Derain's *Collioure* landscape of 1905 (cat.45). In both paintings it is apparent that the artists have applied the paint in a fairly thin, sketchy way, so that the brown of the canvas, or in this case the board, shows through as a neutral tone.

Jawlensky's painting achieved maturity in about 1911. He later wrote that he painted his best pictures that year: 'in 1911 I found personal form and colour and painted powerful pictures of full figures and heads and made a name for myself with them'. He spent part of that year in Prewow on the Baltic, and *Head of a Woman* may have been painted there. He recalled:

I painted my finest landscapes there as well as large figure paintings in powerful, glowing colours not at all naturalistic or objective. I used a great deal of red, blue, orange, cadmium yellow and chromium-oxide green. My forms were very strongly contoured in Prussian blue and came with a tremendous power from an inner ecstasy.

The great majority of Jawlensky's works are portraits and heads of women, and the artist readily acknowledged that he was working in the great tradition of Russian painting, particularly Russian icon painting (Jawlensky was a devout member of the Orthodox church). His later work became increasingly stylised, with the female head being reduced to a few schematic forms and lines. The identity of the sitter for this painting is not known, but then it is not really a portrait: Jawlensky sought to distil the essence of the head, rather than to capture a physical likeness.

Head of a Woman remained in the artist's collection until it was acquired by his friend the Swiss artist Cuno Amiet. Amiet helped Jawlensky flee to Switzerland when the First World War broke out, so it may have changed hands then. Soon after Amiet's death in 1961 it was acquired by the Roland, Browse & Delbanco gallery in London: the Gallery bought it from them in 1964. It was an unusual purchase at the time – British institutions have tended to see France as the crucible of modern art, and early twentieth-century German and central-European work still remains poorly represented in British collections. This is just one of three paintings by Jawlensky in UK collections: a landscape is in the National Museum of Wales in Cardiff, and a beautiful little still-life painting on paper was recently bequeathed to the Gallery. PE

Oil on millboard laid on plywood, 52.2 × 50.2 cm (20½ × 19¾ in)
Scottish National Gallery of Modern Art, Edinburgh
Purchased 1964 (GMA 896)

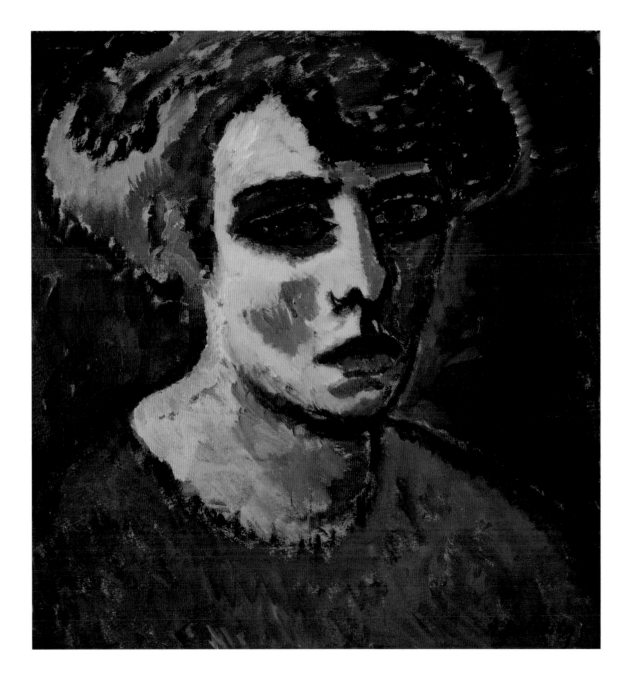

48 Georges Braque 1882–1963
The Candlestick (*Le Bougeoir*), 1911

Alongside Picasso, Braque was the instigator of Cubist painting, which was born in Paris in the years around 1908–14 and had a huge impact on art and design across the globe. By the early years of the twentieth century, photography had taken over art's traditional role of representing things faithfully and the world was changing at incredible speed. With Cubism, artists could recompose and re-create what they saw almost at will, but still remain anchored to the world of visible, tangible things.

Braque was brought up in Le Havre where he trained as a painter and decorator. He moved to Paris in 1900, and within a few years was associating with Matisse, Derain and the Fauves (cat.45). Influenced by Cézanne, from 1907 he abandoned loose brushwork and bright colour for a more structured, geometric style. Reviewing an exhibition of Braque's work in 1908, one critic wrote that he reduced everything to cubes, and the derogatory term 'Cubism' soon came into being, to describe the work of Braque, Picasso and a small band of their followers. Braque and Picasso became great friends around this time and it is often difficult to tell their work apart.

The Candlestick was painted in the summer of 1911, in Céret, in the French Pyrenees. Picasso had friends who lived there and he invited Braque to join him for the summer. Picasso recalled that their working relationship was so close that 'a canvas wasn't finished unless both of us felt it was'.

The Cubists rejected the convention that a painting is like a window on the world. Instead of choosing a fixed perspective, they would paint a motif as if seen from different angles, showing several sides of an object in a single picture. So, in *The Candlestick* we can identify a pair of scissors next to a bobbin of thread on a table in the foreground, and above them a candlestick, a candle and a simple clay pipe – the kind Braque smoked. The candlestick and candle are slightly out of alignment, as if Braque had painted the bottom half from one position,

and had then moved to the left before painting the candle itself. This kind of ambiguity derives from Cézanne, who, particularly in his late works, depicted objects with multiple contours or contours which do not meet up. This was all designed to show that painting is not a matter of copying things, but of re-creating them. In order to rationalise the breaks or jumps in the composition, Braque and Picasso evolved a kind of scaffolding device, whereby they divided the picture using strong, geometric lines.

The letters 'L'In/nt' in the left-hand part of the picture stand for the French-Catalan newspaper *L'Indépendant*, while the number – '5 centimes' – refers to its price. Braque began to introduce lettering into his paintings in mid-1911 and *The Candlestick* is a very early example of this. Just as Cubist painting highlights the complex relationship that exists between the artist and the subject, so Braque's lettering questioned the relationship between words, numbers, pictures and the things they represent. Instead of painting an object, the artist could simply write its name on the canvas. Braque and Picasso went a step further the following year, when they stuck real objects onto their pictures: rather than paint a newspaper, they could simply stick one onto the canvas. This radical approach to picture-making had a profound impact on twentieth-century art and aesthetics.

The Candlestick belonged to Braque's dealer, Daniel-Henry Kahnweiler, a German national who lived in Paris. Following the First World War his stock was sequestered by the French State and sold at a series of auctions. *The Candlestick* was auctioned in 1921 and changed hands several times before being bought by the Scottish National Gallery of Modern Art in 1976. Like the purchase of Derain's *Collioure* (cat.45), the acquisition was designed to show a major movement in modern art at its peak. P E

Oil on canvas, 46.2 × 38.2 cm (18¼ × 15 in)
Scottish National Gallery of Modern Art, Edinburgh
Purchased 1976 (GMA 1561)

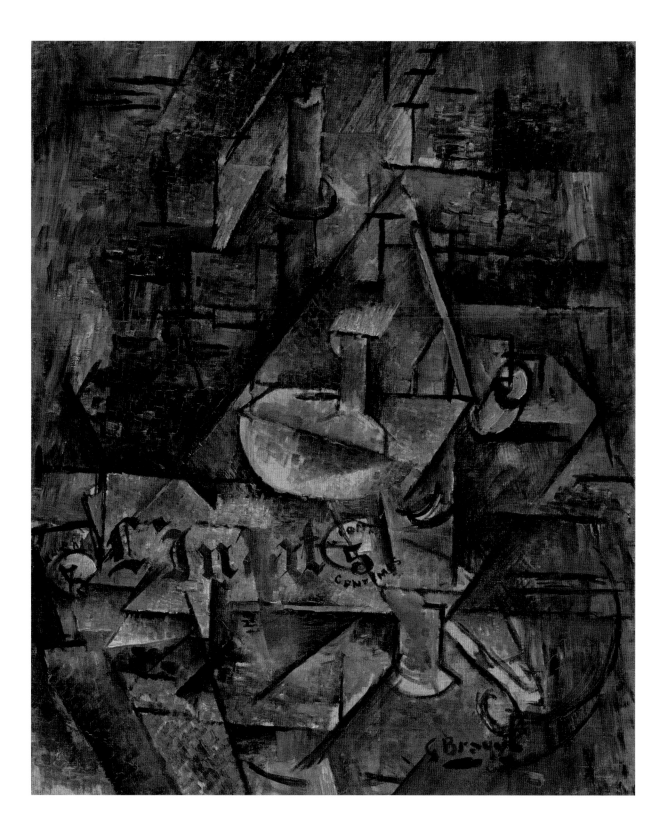

49 Pablo Picasso 1881–1973
Guitar, Gas-Jet and Bottle (*Guitare, bec à gaz, flacon*), 1913

In the autumn of 1912, Picasso and Braque began sticking pieces of paper onto their drawings. Braque was the first to do this, applying a piece of wood-grained paper onto a drawing instead of trying to imitate wood with paint. This technique, known as *papier collé* (stuck paper), in turn affected the way Picasso and Braque painted. In *Guitar, Gas-Jet and Bottle* the vertical strips may look as if they have been stuck on, but they are in fact painted.

Picasso often introduced different techniques and styles into a single painting, as if to say that each was valid and no one approach was better than another. In this work, the gas-jet in the top right corner is presented as an outline drawing in charcoal. The stylised glass, represented as a circular top and bottom superimposed over a transparent container, is scratched into the thick white paint, probably with the blunt end of the paintbrush. The white paint itself has been applied through a stencil device to give very crisp, clean edges. The guitar is seen from both front and side angles, as if Picasso had moved around the object while he was painting it. The long vertical strip in the centre is painted with a gloopy household paint called Ripolin – the antithesis of proper, fine art oil paint. The bottle also combines two perspectives: we look down on the stopper and top and straight at the bottle itself. The paint in the area around the bottle has been mixed with grit – maybe swept up from the studio floor – to give it texture. These different methods of representation call attention at once to flatness, spatial recession and the roving eye of the artist, while the unconventional techniques were a deliberate slap in the face for fine art values (ironically, Picasso's techniques were so influential that his paintings now have the appearance and status of old masters). Using all these tricks, Picasso underlines the artist's role in reinventing rather than copying the visible world.

Famously, Picasso's paintings are closely bound up with his life and loves, although this is not always immediately apparent. John Richardson, Picasso's biographer, has noted that the artist often pictured women in the curvaceous form of the guitar, and did so particularly with his lover from about 1911–15, Marcelle Humbert (better known as Eva). In this way he could depict her while keeping the tryst secret. Richardson sees the gas-lamp as a covert self-portrait, with its phallic form and incandescent flame. Coincidentally, at one time Picasso's dealer, Daniel-Henry Kahnweiler, had the painting fitted into a special frame which could be opened to reveal one of Picasso's early erotic paintings behind it.

Guitar, Gas-Jet and Bottle was bought by the English artist and writer Roland Penrose in 1937. In the late 1930s Penrose assembled a fabulous collection of Cubist and Surrealist work, and owned more than a dozen works by Picasso, who became a close friend. Penrose wrote Picasso's biography (published in 1958, it still remains a standard account) and organised numerous exhibitions of his work. The Gallery bought the painting from the Penrose family, via London's Mayor Gallery, in 1982. This purchase led to other acquisitions from the Penrose Estate, including masterpieces by Joan Miró, René Magritte and Max Ernst. The Penrose acquisitions now form the cornerstone of the Gallery's world-renowned collection of Surrealist art. P E

Oil, charcoal, tinted varnish and grit on canvas, 70.4 × 55.3 cm (27¾ × 21¾ in)
Scottish National Gallery of Modern Art, Edinburgh
Purchased 1982 (GMA 2501)

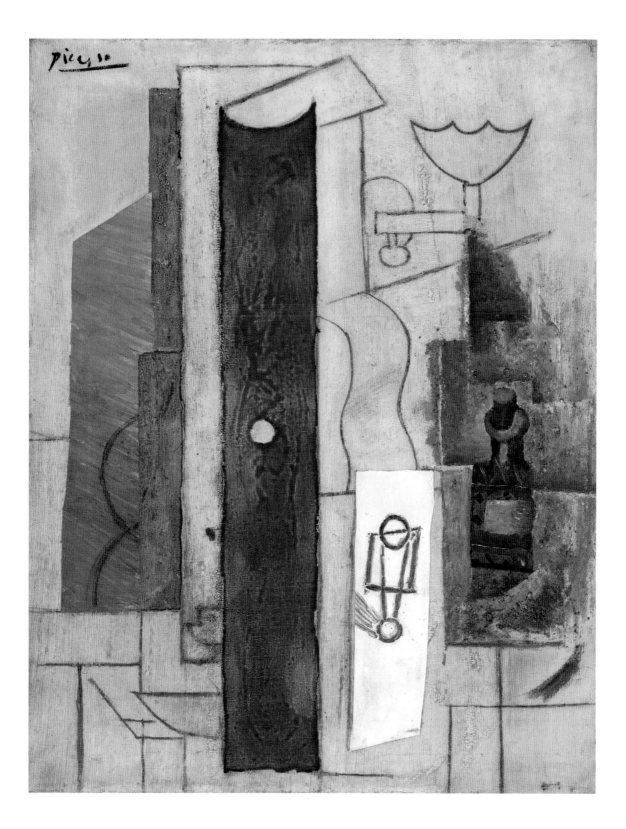

50 Pierre Bonnard 1867–1947
Lane at Vernonnet (*Ruelle à Vernonnet*), about 1912–14

Born in Fontenay-les-Roses, to the south of Paris, Bonnard was destined for a career in law, but decided in the late 1880s to concentrate on painting instead. In 1887 he enrolled at the Académie Julian in Paris, where he met Édouard Vuillard (cat.42), who became a close friend, ally and fellow founder member of the Nabis (Prophets) group.

In 1910 Bonnard rented a small half-timbered house called *Ma Roulotte* ('My Caravan'), at Vernonnet, a village on the river Seine in Normandy; he bought the house two years later. From the back of the house he could see the Seine. The Impressionist painter Claude Monet was a neighbour at Giverny, about five miles to the south. The two artists became good friends, often visiting each other, and there is sometimes an affinity between their work. However, whereas Monet's famous garden expressed his love of an ordered kind of nature, Bonnard's garden and paintings were wilder and less obviously orchestrated.

By the time Bonnard had moved to Vernonnet he had abandoned the dark tonalities of his early work for a vibrant palette of glowing purples, pinks, greens and yellows. Here, in the road in the foreground, vivid yellows and pinks mingle to suggest a baking-hot day, while the buildings to the left cast a mauve shadow. Bonnard later recalled: 'When my friends and I attempted to carry on, even go beyond, the work of the Impressionists we tried to surpass them in their naturalistic vision of colour. Art is not nature. We were more rigorous in our compositions, and found there was much more to be got out of colour.' Although Bonnard moved to the south of France in 1925, he retained the house at Vernonnet until 1939, returning there from time to time to paint in the surrounding area.

Lane at Vernonnet was bought directly from the artist by Bonnard's dealers, Bernheim-Jeune, Paris, in 1914: their records show that the artist made minor adjustments to the colour just after they had bought the painting. It once belonged to Sir Alfred Chester Beatty, the Irish-American copper magnate, who assembled a superb art collection, and it was lent by him to the National Gallery in London in the late 1950s. A number of his pictures were offered for sale, privately, to British galleries in the early 1960s. Fortuitously, at just the same moment, Mrs Hope Montagu Douglas Scott, a Scottish collector, wrote out of the blue to the Director of the Scottish National Gallery, offering to 'buy a picture for the National Gallery ... I could give £10,000 or so.' Within a few weeks, the Bonnard was chosen: it was, as the donor wrote, 'the sort of picture I would want to buy for myself'. It was originally displayed at the Scottish National Gallery, alongside the Post-Impressionist masterpieces, but was transferred to the Gallery of Modern Art in 1984, when it moved into new, larger premises. PE

Oil on canvas, 76 × 65.2 cm (29⅞ × 25⅝ in)
Scottish National Gallery of Modern Art, Edinburgh
Purchased with funds given by Mrs Charles Montagu Douglas Scott, 1961
(GMA 2932)

51 Henri Matisse 1869–1954
The Painting Session (*La Séance de peinture*), 1919

Born in the northern French town of Le Cateau-Cambrésis, near the border with Belgium, Matisse initially studied law. In 1889 he began taking drawing classes, and in 1890, during a period of convalescence, he started painting. The following year he abandoned law, went to Paris, and enrolled at the Académie Julian, one of the leading private art schools in the city. He entered the École des Beaux-Arts in Paris in 1893. With André Derain he was one of the artists whose violently coloured paintings, exhibited at the Salon d'Automne in Paris in 1905, were dubbed 'Fauve' – meaning wild beasts. In the following decade he established a reputation as arguably the world's most respected and admired modern artist, rivalled only by Picasso.

During and immediately after the First World War, Matisse spent several long periods in Nice, in the south of France, staying at hotels or renting apartments near the seafront. Late in 1918 he took a room at the Hôtel Méditerranée et de la Côte d'Azur, which looked directly onto the Promenade des Anglais and the sea beyond. A good but not especially luxurious hotel, Matisse used it as his base in Nice for the next three years, occupying a number of different rooms: the room shown here is thought to have been on the first or second floor of the building, which has since been demolished. *The Painting Session* is one of a series of about thirty paintings of the hotel room which contained, among other furnishings, a dressing table and a decorative oval mirror with little swan-head motifs at the sides. In the other works in the series the table is seen flush against a wall or near the window, with the mirror reflecting the interior of the room, but in our painting the mirror reflects the view seen through the room's French windows: we see a palm tree and, beyond, the pale blue sea and sky. The velvety black background serves to highlight the mirror and give an unusual, almost inverted sense of inside and outside

space in that the 'real' space of the room is dark and flattened while the flat mirror is alive with the reflected flowers, tree and sea.

The artist depicted to the left must be Matisse himself, while the young woman absorbed in her book is an eighteen-year-old model, Antoinette Arnoux. Here again Matisse plays with the notion of representation, in that he is painting himself in the act of painting and, curiously, the artist is sketched in in a very summary fashion, making him blend in with the unfinished canvas he is busy painting. This dialogue between interior and exterior spaces, and between different kinds of representation, was typical of Matisse. Soon after he sold the picture it acquired the title *The Painting Lesson* (*La Leçon de peinture*), though it is not clear who named it and there seems to be no lesson in progress. Some years later, his dealer suggested that *The Painting Session* was a more appropriate title.

Matisse sold the painting to his dealer, Bernheim-Jeune, in June 1919. By the mid-1930s it had passed to the dealer Paul Rosenberg in Paris. It was looted by the Germans in 1940 but returned to Rosenberg's gallery in 1947. It was bought at auction by Sir Alexander Maitland QC and bequeathed to the National Galleries of Scotland in 1965. It remains the only painting by Matisse in the collection, although we own a bronze sculpture and a number of prints. PE

Oil on canvas, 73.4 × 92.2 cm (28⅞ × 36¼ in)
Scottish National Gallery of Modern Art, Edinburgh
Bequest of Sir Alexander Maitland, 1965 (GMA 929)

52 Francis Campbell Boileau Cadell 1883–1937
Portrait of a Lady in Black, about 1921

Cadell is one of four artists known as the 'Scottish Colourists', the others being S.J. Peploe, J.D. Fergusson and George Leslie Hunter. Influenced by French painting – initially the Impressionists and later the Fauves – they brought intense Mediterranean colour into their own Scottish landscapes, still lifes and portraiture. Although the term 'Scottish Colourists' is now in common usage and gives the impression that the four constituted a coherent school, it only became common currency following an exhibition of their work in 1948, when three of the four were already dead.

Cadell was born in Edinburgh, and studied in Paris from 1899 to 1902. He served with The Royal Scots during the First World War. In 1920 he moved to a flat in Ainslie Place in the Edinburgh New Town. His magnificent quarters extended over four floors. The first floor had splendid front and back drawing rooms linked by double doors, and these rooms feature as the central subject of a number of his paintings. The walls were painted lilac and the floorboards were a highly polished black. Furniture was kept to a minimum. Glamorous props such as opera cloaks, top hats, black fans, fine china and his own paintings were added for pictorial effect and reappear in the paintings of the 1920s. During this period he abandoned the loose, impressionistic handling and soft tones of his pre-war work, for more geometric compositions and vivid, acidic colours. He also took to cropping the compositions very tightly, to achieve an angular, almost two-dimensional effect that compares with contemporary Art Deco painting in France by figures such as Georges Lepape and Jean Dupas. It has been said that a typical Art Deco picture should have such a narrow depth of field that it could be peeled off the page like a transfer or a sticker, and Cadell's *Portrait of a Lady in Black* passes that test.

The model in the painting is Berthia Hamilton Don-Wauchope, a neighbour who posed frequently for Cadell from about 1911 to 1925. She would have been in her late fifties when the portrait was painted, but Cadell's flattering and stylish portrait makes her look younger. The still-life painting behind her is also by Cadell. He often included colours in the titles of his paintings, in much the same way that the artist James Abbott McNeill Whistler, one of Cadell's early heroes, had done.

The Gallery of Modern Art has a strong collection of work by the Scottish Colourists, but this painting is perhaps the most popular of them all. Exhibited at the annual Royal Glasgow Institute exhibition in 1921, where it carried the then-substantial price of £250, it was part of a collection of paintings bequeathed to the gallery by Mr and Mrs G.D. Robinson through the Art Fund in 1988. PE

Oil on canvas, 76.3 × 63.5 cm (30 × 25 in)
Scottish National Gallery of Modern Art, Edinburgh
Bequeathed by Mr and Mrs G.D. Robinson through the Art Fund, 1988
(GMA 3350)

53 Fernand Léger 1881–1955
Woman and Still Life (*Femme et nature morte*), 1921

Of all the Cubists, Léger was the one most inspired by modern machinery and new technology. Born in Normandy, he moved to Paris in 1902 and early in his career was apprenticed to an architect. His first Cubist paintings date from 1909, and in the years just before the outbreak of the First World War he produced a scintillating series of near-abstract works in which the human form is rendered as an array of metallic tubes and cylinders (this style earned the half-mocking name 'Tubism'). For Léger, machines had a dual appeal: they were beautiful, with their crisp functional forms, and they also offered the hope for a new utopian order, in which workers would be freed from dull, repetitive tasks.

Léger fought at the Front in the First World War, and was discharged in 1918. Back in Paris, his paintings continued to reveal an obsession with modernity, man and the city. However, in 1920 they took a new turn. In place of the controlled cacophony of his pre-war 'contrast of form' paintings, and the dynamic cityscapes which threatened to suffocate the human figures within them, his work acquired an almost classical sense of order. This shift was part of a broader 'Return to order', within the French avant-garde. Picasso did something similar, painting neoclassical figure compositions alongside his more radical Cubist work. All of a sudden, the avant-garde seemed to be obsessed with classical nudes. The motives for this switch are much debated, but two reasons seem important: firstly, the machinery of war had led to millions of deaths, and machines now had a more problematic iconographical status; and secondly there was a feeling that Cubism was somehow German, or at least foreign, and that French art should return to the traditional, national values of order, restraint and classicism.

The subject of the passive nude woman reclining in an interior was a standard exercise for artists from the Renaissance through to the classicists of the nineteenth century. Between 1920 and 1921 Léger made a series of

paintings of a reclining nude woman and a still life. Some versions include a second woman standing in the centre-foreground, next to a table and still life. In our painting, the woman and the still life in the foreground have merged into a single abstract, vertical form. Léger introduced mechanical elements into his paintings not by copying machines but by constructing his compositions with the rigour and clarity of an engineer. However, the grid-like structures here probably reflect the influence of Piet Mondrian, whose spare, geometrical abstract paintings Léger first saw in 1920. The series of nudes in interiors reached its culmination in a large painting of three women called *Le Grand Déjeuner*, 1921 (Museum of Modern Art, New York.

Woman and Still Life was bought by the Gallery in 1966, once more in an effort to represent key moments in the history of modern art with a fine, typical work. It cost £15,000 ($25,000). Two outstanding later works by Léger were added to the collection in the early 1980s, just before the prices for classic modern art rocketed: *Tree Trunk on Yellow Ground*, 1945 (GMA 2310), and *Study for 'The Constructors': The Team at Rest*, 1950 (GMA 2845). PE

Oil on canvas, 65.5 × 92 cm (25¾ × 36¼ in)
Scottish National Gallery of Modern Art, Edinburgh
Purchased 1966 (GMA 962)

54 Max Ernst 1891–1976
Max Ernst Showing a Young Girl the Head of his Father
(*Max Ernst montrant à une jeune fille la tête de son père*), 1926 or 1927

The Scottish National Gallery of Modern Art has an outstanding collection of work by Max Ernst, one of the giants of the Dada and Surrealist movements. We own eleven of his paintings and collages ranging in date from about 1914 to 1937, as well as a number of drawings and prints and illustrated books. Ernst was born near Cologne in Germany. After the First World War he became the leader of the Cologne Dada group. He stated that:

Dada was a rebellious upsurge of vital energy and rage; it resulted from the absurdity, the whole immense stupidity of that imbecilic war. We young people came back from the war in a state of stupefaction, and our rage had to find expression somehow or other. This it did quite naturally through attacks on the foundations of the civilisation responsible for the war.

He moved to Paris in 1922 and became a central figure in the Surrealist movement, which was launched two years later. A leading exponent of collage, he was also a pioneer of accidental effects in painting and drawing. In the large and majestic *Max Ernst Showing a Young Girl the Head of his Father*, the forest (a favourite subject of Ernst and indeed of German Romantic artists in general) is executed via a technique known as *grattage*, which means scratching or scraping and is an extension of the frottage technique meaning rubbing, when applied to drawing. Here, Ernst has laid the painted canvas over rough wooden boards and scraped the paint to produce a rich, grainy texture. This technique, which Ernst said he discovered by accident when making a drawing over floorboards in a hotel room, allowed chance – which was much revered by the Surrealists – to play its part in the creation of the painting.

Ernst's Oedipal conflicts with his father seem to be highlighted in *Max Ernst Showing a Young Girl the Head of his Father*. The French title is slightly ambiguous: it could refer to the head of 'his' father or of 'her' father. The 'young girl' could in fact be Ernst's dead sister, in which case it

is the head of their father, and an incestuous triangle of father, son and daughter is implied. However one interprets the painting, it was clearly important in Ernst's own eyes, because he alluded to it in '*Au-delà de la Peinture*', an autobiographical essay written in 1936 and published in Paris the following year. Having just described his discovery of the frottage technique, its relationship to automatic writing, his own 'passivity' when creating his work, and his desire to become a 'seer', Ernst goes on: 'It was then that I saw myself, showing a young girl the head of my father. The earth quivered only gently.'

The painting's first owner was the Belgian artist Victor Servranckx. By 1969 it had passed to Gabrielle Keiller. Through her father's family, who were American, she inherited a share in 400,000 hectares (a million acres) of cattle grazing land on either side of the Palo Duro Canyon in Texas. The sale of her share allowed her to indulge her passion for collecting. In 1960 she met Peggy Guggenheim in Venice and, inspired by her, began to collect modern art, with a special emphasis on Dada and Surrealism. On her death in 1995 she bequeathed her entire collection – including major works by Bacon, Magritte, Tanguy and Dalí – to the Gallery of Modern Art: this was by far the most important gift in the Gallery's history. Three works, including this Ernst, came via a slightly different route in order to settle her Estate duty. PE

Oil on canvas, 114.3 × 146.8 cm (45 × 57¾ in)
Scottish National Gallery of Modern Art, Edinburgh
Accepted by HM Government in lieu of Inheritance Tax on the Estate of Gabrielle Keiller and allocated to the Scottish National Gallery of Modern Art in 1998 (GMA 3972)

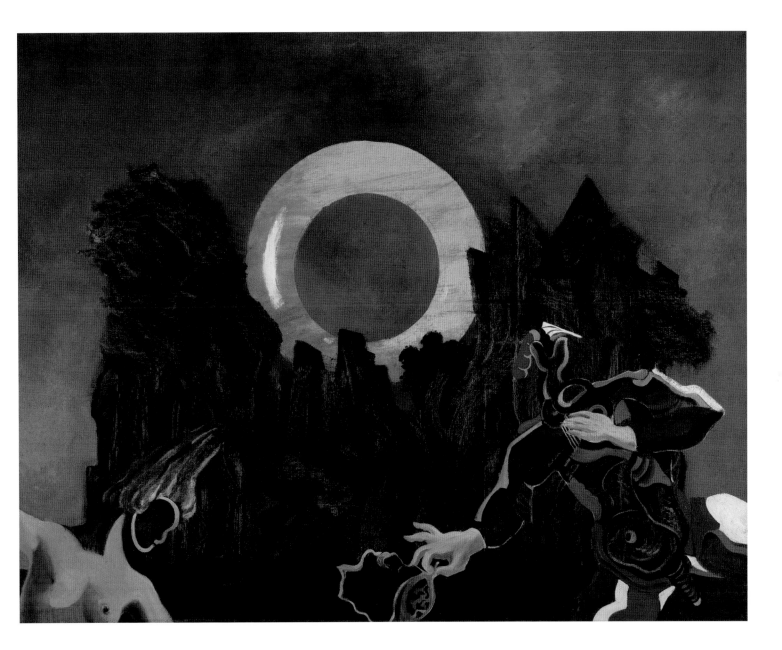

55 Piet Mondrian 1872–1944
Composition with Double Line and Yellow, 1932

Piet Mondrian's spare, abstract paintings were the product of intense study and thought. Each line and brushstroke was a battle, and paintings could be worked and reworked over many years before he was satisfied with them. He was born in Amersfoort in Holland. His father was a qualified art teacher, and with his parents' encouragement Piet also studied art. He became the leading artist of the De Stijl (The Style) movement, a group of Dutch artists advocating a rigorously spare form of geometric, abstract art. Although Mondrian's paintings are extremely pure and simple, they develop from a complex set of ideas. He was strongly influenced by, and was a member of, the mystical, quasi-religious Theosophical movement. Theosophists championed the spiritual above the material, and one branch of the movement saw existence in terms of polarities, of male and female, positive and negative, horizontal and vertical. This notion is embodied in Mondrian's grid paintings in which opposites are united in a balanced harmony.

Mondrian's paintings have a machine-like rigour, yet they grew out of his study of natural forms, again an important source for Theosophists. For example, a series of apparently abstract paintings made up of criss-cross lines developed from the study of trees and branches. A critical influence on Mondrian was the Cubism of Braque and Picasso, in which the motif is subjected to geometric restructuring and simplification (cats.48 and 49). Mondrian lived in Paris from 1912 to 1914 and again from 1919 to 1938, so he would have been familiar with their work.

Composition with Double Line and Yellow is one of the earliest of Mondrian's so-called 'tram-line' paintings. Before 1932 he had used single transecting lines, but he then began pairing them in order to achieve a sense of optical movement. This is one of just two 'tram-line' paintings dating from 1932. The effect the double line gave him was a revelation and completely changed the direction of his art: suddenly, instead of achieving stability, the double line created a new kind of rhythm, what Mondrian called a 'dynamic equilibrium'. Thereafter, he became concerned with establishing a sense of dynamism in his work. He also began to carry the coloured patches over the edge of the canvas and on to the sides. This device suggested that the painting extended beyond the boundaries of the canvas itself and into the real space of the room in which it hung.

The painting formerly belonged to the British artist Winifred Nicholson. She was married to the artist Ben Nicholson but they split up in 1931, following Ben's affair with the sculptor Barbara Hepworth. Thereafter she spent much of her time in Paris. She bought it directly from Mondrian, who was a friend. Mondrian sold it to her for less than half price and accepted payments in instalments. Winifred hung it at her home in Cumbria, in the north of England. Somehow someone managed to spill ink on it the year after it was purchased – Mondrian described the episode as 'evil spirits fighting against the new spirit'. However, it was taken to him in Paris and he managed to clean it.

The painting was acquired by the Gallery from Winifred Nicholson's family in 1982. With war imminent, Mondrian, like several other leading avant-garde artists, moved from Paris to London from 1938 to 1940. Henry Moore, Ben Nicholson, Naum Gabo and Barbara Hepworth lived close by and for a short period London was at the centre of the art world. Consequently, at the Gallery of Modern Art, Mondrian's painting is often shown in the context of British abstract art of the 1930s. P E

Oil on canvas, 45.2 × 45.2 cm (17¾ × 17¾ in)
Scottish National Gallery of Modern Art, Edinburgh
Purchased 1982 (GMA 2502)

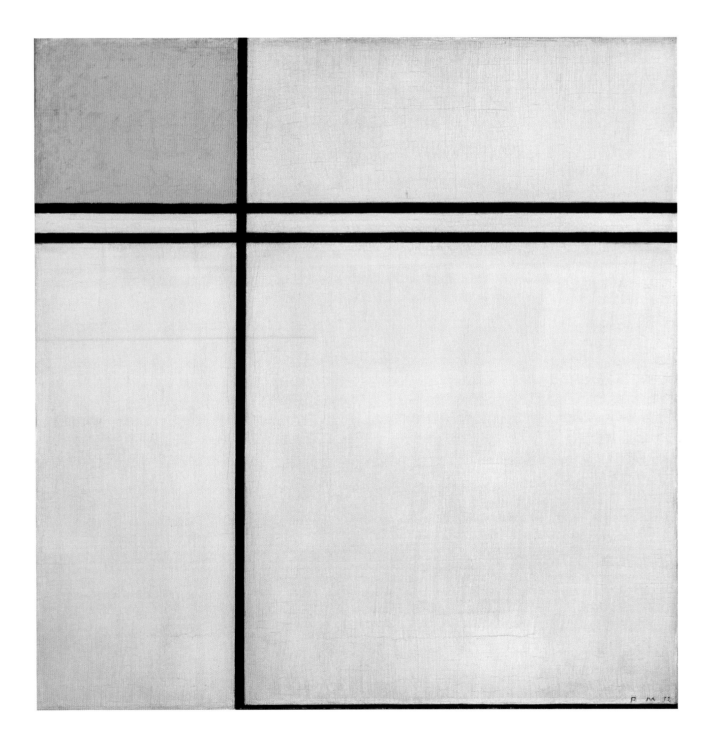

Index of Artists

Key to Contributors

Copyright & Photographic Credits

Published by the Trustees of the National Galleries of Scotland to accompany the exhibition *Botticelli to Braque: Masterpieces from the National Galleries of Scotland,* held at the de Young, San Francisco from 28 February 2015 to 24 May 2015, and at the Kimbell Art Museum, Fort Worth, Texas from 28 June 2015 to 20 September 2015.

ISBN 978 1 906270 77 3

Designed and typeset in Elena by Dalrymple
Printed on Perigord 150gsm by Albe De Coker, Belgium

Front cover: Sir Henry Raeburn, detail from *Reverend Robert Walker (1755–1808) Skating on Duddingston Loch,* about 1795 [cat.23]

Back cover: Piet Mondrian, detail from *Composition with Double Line and Yellow,* 1932 [cat.55]

Frontispieces: Sandro Botticelli, detail from *The Virgin Adoring the Sleeping Christ Child* ('*The Wemyss Madonna*'), about 1485 [cat.1]; Georges Braque, *The Candlestick* (*Le Bougeoir*), 1911 [cat.48]

Pages 22–23: Claude Monet, detail from *Poplars on the Epte,* 1891 [cat.39]

FINE ARTS MUSEUMS OF SAN FRANCISCO

Presenting Sponsors: Cynthia Fry Gunn and John A. Gunn, and Diane B. Wilsey

President's Circle: San Francisco Auxiliary of the Fine Arts Museums

Curator's Circle: The Bernard Osher Foundation and the Ednah Root Foundation

Patron's Circle: George and Marie Hecksher

Supporter's Circle: Andy and Carrick McLaughlin and Mrs George Hopper Fitch

The exhibition is supported by an indemnity from the Federal Council on the Arts and the Humanities.

For a complete list of current publications, please write to: NGS Publishing at the Scottish National Gallery of Modern Art, 75 Belford Road, Edinburgh EH4 3DR, UK or visit our website: www.nationalgalleries.org
National Galleries of Scotland is a charity registered in Scotland (no.SC003728)

NATIONAL
GALLERIES
SCOTLAND